My Road

to Microsoft

Jon, I hope you like
the book.

2003

My Road
to Microsoft

One Woman's Success Story

Soraya Bittencourt
with
Paula Martinac

Library of Congress Number: 2003091661
ISBN : Hardcover 1-4134-0107-4
 Softcover 1-4134-0106-6

This book was printed in the United States of America.

To order additional copies of this book, contact:
Xlibris Corporation
1-888-795-4274
www.Xlibris.com
Orders@Xlibris.com
18390

Contents

PART III

1993-1999—Seattle

This book is dedicated to my parents, who always sacrificed themselves on behalf of our family, to my sisters and my extended family, who many times did not understand what I was doing but were there with me, and to my partner of 20 years Lucila, without her I would have never gotten to where I am.

I also would like to thank my friends who read the first manuscript and gave me suggestions on how to make it better: Ann Webster, KD Hallman, Agueda Sanchez and Monica Correa.

Thanks to all of you!

I have to say that writing and reading about your life, brings a number of emotions to the surface, and at the same time, gives you a unique perspective of where you have been and who you are.

I hope that the lessons I learned can also help you.

Enjoy reading the book!

Soraya Bittencourt

Prologue

Bill Gate's Office

In Seattle, it rains nine months out of twelve, and the day I broke into Bill Gates's office, it was as damp and gray as all the others.

It was March of 1994, and I had been trying to get to Gates for four months, ever since I moved from Boston to work in Microsoft's new interactive television division. Through most of 1992 and 1993, Microsoft had tried to lure me away from Lotus by offering me different and progressively more interesting jobs.

And all that time, I kept saying no. I'd been in the industry long enough to know that Microsoft was the Evil Empire, bent on crushing its competitors. In contrast, Lotus had a totally different reputation—more like R2D2 than Darth Vader.

But then I had this dilemma: When someone keeps wooing you, even someone you're not interested in, it's hard not to be flattered. And, if they're rich and famous and powerful, eventually you might even start to get a little intrigued. So I was curious about where a courtship with them could lead.

In the fall of 1993, I agreed to an interview at their headquarters in Redmond, Washington, just outside of Seattle. When I say "an interview," I actually mean a full day of back-to-back interviews, meeting one manager after another for a grueling

ten hours. Each manager I saw measured a certain skill, then sent me to the next manager to measure another skill, and so on down the line, until I started to wonder if I had any skills left. Then there was dinner, which was really just more interviewing, more measuring, more sizing up. Back in my hotel room at the end of the evening, I was wrung out like a dishrag, and I thought Microsoft probably knew what I could do almost better than I did.

Although it was a mind-numbing trip, the thing that struck me was how smart everyone at Microsoft was. At Lotus and just about everywhere else I'd ever worked, I'd always been the whiz kid, the girl genius, the star. But at Microsoft, I realized pretty quickly that everyone was a star. That scared me a lot, but the possibility of working with so many really smart people was also kind of alluring.

And then, in that seductive way the company is famous for, Microsoft put an offer under my nose that included a lot of shares in the company.

What can I say? Forget the Evil Empire. Forget that I had instantly hated Seattle and all that rain. Forget that I was in a long-term relationship with someone who couldn't pick up and leave Boston right away. Shares are shares, and I wasn't going to get the financial package Microsoft offered me anywhere else.

And besides the stock, of course, there was Gates himself, the man I badly wanted to meet.

I'll be the first to admit that I was pretty naïve back then, assuming that all I had to do was get onto the Microsoft payroll in order to have access to Gates. I had no idea how protected he was, how untouchable. So, the week after I arrived in Seattle, when Microsoft threw one of its quarterly banquets for new staff members, I thought the dinner would provide the perfect chance for me to corner Gates and wow him with my really big idea.

Well, that might have worked if I'd been the only one invited to the party. But there were about 50 new employees in the Bellevue Hotel ballroom that night, all dressed up and dreaming of the places they'd go. I expected Gates to eat with us, but

throughout the four-course meal, he was a no-show. Finally, he appeared out of nowhere after dessert and took his place on the dais. While we were still tinkling our spoons in our coffee cups, Gates started his official welcome-to-Microsoft pep talk. The truth is I was barely listening to him. I was busy planning exactly what I would say to grab his interest. Glancing at the faces around my table, I was aware that I was one of the only women in the room. That didn't surprise me, of course: I was almost always one of the only women in the room when computer geeks got together. The boys' club atmosphere meant that I had to try harder to make myself heard.

So the second Gates stepped down from the podium, I jumped out of my seat. Unfortunately, almost everybody else in the dining hall that night had the same idea. And I'd forgotten that they were stars in their own right. A couple of dozen eager rookies, all from good companies or schools, all with big ideas and all anxious to impress Gates, flew out of their seats and swarmed around him as he left the stage.

I waited patiently in the crowd for my turn to introduce myself. At any minute, I knew Gates might slip out the door and disappear as quickly as he'd arrived. I was one of the last people to approach him, and I had to nudge my way ahead of a few others to get my chance. But at long last, I was extending my hand.

"Mr. Gates, I'm Soraya Bittencourt, I came from Lotus to work on the interactive TV team. I have this CD-ROM I developed independently that I think you might be interested in. My idea is to produce multimedia travel guides . . ." I was trying to get it all out in just under a minute, the way my interactive CD-ROM would change the travel industry forever by allowing people to research their travel destinations on their home computers and then shop for the best airfares and hotel prices online.

But I'd no sooner gotten the basic concept out of my mouth than another zealous new employee was already cutting in, pumping Gates's hand and throwing out his name and division at the company, his spectacular idea. And I realized I hadn't caught Gates's attention at all.

"Run it by Charlotte in the consumer division," was what Gates said to me. Not "That's the best idea I've heard in months" or "Call my secretary—I want to talk about this more." His unfocused look suggested that mine was just one of ten pitches he'd heard in the last twenty minutes.

I was disappointed, but not deflated. First thing the next morning, I followed up with an e-mail to Charlotte Guyman in Consumer: "Bill Gates suggested I talk to you . . ." The truth was, though, that the only way Bill Gates would be able to pick me out from the crowd of newcomers to Microsoft was by my gender. Still, "Bill Gates suggested I talk to you" had a nice, authoritative ring to it, and I assumed it was what I needed to get people interested in my idea.

Like I said before, I was naive. Weeks went by, and I didn't hear a word from Charlotte. She probably got dozens of e-mail messages every day that started out, "Bill Gates suggested I talk to you . . ." She probably deleted all of them, maybe accidentally on purpose. In her seat, I might have done the same thing.

So I was back to square one. I decided that Gates himself was my only real hope. First, I thought of sending him an e-mail, but by this time I'd met more people in the company and learned a lot about the inner workings of Microsoft. Like any corporate bigwig, Gates is surrounded by handlers who read his e-mail messages, delete the dreck, then filter the important stuff through to him.

The second plan I cooked up was, on the surface anyway, as bad as trying to talk to him at the new employee dinner. But at the time it was all I had. I decided to hang around Building 8, the X-shaped building where Gates has his office and which is located on what's called the Main Campus. I guess the phrase "has his office" is misleading: Gates's suite actually takes up the entire front wing.

I started carrying my CD-ROM with me in my bag or coat pocket, and whenever I was on the Main Campus, I'd casually drop into Building 8, just to look around. I never got past the two receptionists on duty, who guarded the way to Gates's inner

sanctum and who more than once glanced at me suspiciously, even though I wore my Microsoft badge in a prominent place. They left me alone, though, maybe because I don't look like your average obsessed fan or celebrity stalker.

If you hang around any place long enough, you start to learn what's what, and I soon discovered that the receptionists in Building 8 were off on the weekends. Even so, security was tight. Hidden cameras were tucked away everywhere. Doors were fitted with blaring, high-pitched alarms. From a command post in the basement of Building 8, security guards surveyed activity all over the campus, and especially around Gates's office, on a wall full of television monitors.

But I've never been one to give up easily. Call me persistent. Or stubborn.

My plan shifted to the weekends. Every Saturday, after I'd put in a few hours in my own office, I'd amble over to the Main Campus and slip into Building 8. When I was sure no one was watching, I'd give a surreptitious push to the door leading to the hallway where I was pretty sure Gates's suite was. Not enough to jog the alarm, but just enough to test the lock. And every Saturday, the door resisted. I'd come back the following day or the following Saturday and try again, and again the door would stand firm. I never really expected it to be any different, but every weekend I tried just the same. This went on for several soggy weekends, until one of those weekends something happened that brightened things up a lot.

It was a Saturday afternoon, and I was on my usual stroll over to Building 8 after finishing up in my office. As I approached Gates's suite, I could see right away that something was different about it: The main door to his lobby was wide open, and a uniformed maintenance guy was up on a ladder, fiddling with the alarm. He never noticed me slip by him into the lobby. He never noticed when I gave my usual push on the door to the corridor leading to Gates's suite. And he never noticed when the door gave under the gentle pressure of my hands, because all the alarms had been switched off for repair.

I was in!

I slinked through the main corridor, knowing it was only a matter of minutes before I made my debut on closed circuit TV and the guards in the basement realized I didn't belong there. It wasn't as hard as I thought it would be to find Gates's office—an old photo on the corridor wall of Gates and Paul Allen, the co-founder of Microsoft—gave the location dead away.

With sweaty palms and a nervous glance over my shoulder, I opened the door and stood on the dark threshold of Bill Gates's office.

The space had the look and feel of a library in a venerable old law firm, or maybe more accurately, an exclusive men's club. There were custom-made wooden bookshelves lining the walls, a massive desk, a roomy and comfortable leather armchair. Gates's PC held a place of honor on top of his desk, and it was hard not to give in to the desire to sit down and boot it up. Scattered everywhere were framed photos of the company's history, going back to 1975 when the 19-year-old Harvard drop-out founded Microsoft with his boyhood pal.

I was awed, and, under different circumstances, I would have loved to just stand there and absorb it all. But it was the loud thumping of my heart that reminded me how little time I had, how long I'd already been standing frozen at the entry to his office. In the semi-dark, I quickly crossed the room and accomplished my mission: I carefully laid my CD-ROM—with my Microsoft business card and a personal note attached—onto Gates's soft leather chair. It would be the first thing he saw when he tried to sit down Monday morning. I could almost hear his voice: "What the . . . 'Dear Mr. Gates, I know you'll be interested in this if you just take a look at it. I'd love to talk to you about my ideas on how Microsoft can revolutionize the travel industry.' Soraya Bittencourt."

In fact, I did hear a voice that afternoon, but it wasn't Gates's and it wasn't in my imagination.

"Hey, what do you think you're doing?"

The office lights flashed on, and I was caught.

He was a standard-issue private security guard, complete with badge and navy blue uniform, a little chubby, kind of short. Because he wasn't physically threatening, he used his voice and attitude to intimidate me. And he used them well.

"Who are you?" he demanded, then began rapid-firing a string of questions at me. Where was my ID? Where did I work? How did I get in? What was I doing in Mr. Gates's office? What did I leave on his chair? Why didn't I use the inter-office mail, like everybody else?

I stretched the truth a bit. "Mr. Gates wanted to see my CD-ROM," I said, looking down at my sneakers because, like most people, I'm a bad liar. "It's a very important project, and he asked me to drop it off myself the next time I was in the building."

"Mr. Gates isn't here this weekend," the guard said, inspecting my Microsoft badge as if it were counterfeit.

"I didn't know . . . He didn't tell me. I mean, so many people work on weekends here." It was true. We all put in 60-or 70-hour weeks.

He snatched the CD-ROM out of my hands, examined it front and back. "Brazil," he read aloud from the jewel case, "An Exotic Journey." The word "exotic" caught his attention, and one furry eyebrow shot up. "If this is something dirty, you're gonna be in big trouble, Miss . . ." He read my badge again. " . . . Bittencourt?" He shoved the CD-ROM into his side pocket. "I'll just take this downstairs and have a look."

I spent a lot of time imagining how disappointed the guy must have been when he saw that "Brazil: An Exotic Journey" wasn't pornography but really a multimedia travel guide, and a G-rated one at that. Aside from a few gorgeous women in bikinis on the beach at Ipanema, it was pretty tame stuff that even won a K-12 educational award.

I never found out how my software made its way back onto Gates's chair, but it did. Maybe the guard took pity on me. Maybe he showed it to another guard, who always wanted to visit Brazil and thought Gates should take a look at it. Or maybe the guard was afraid I was telling the truth and that he'd get in hot water if

he didn't put the CD-ROM back where it belonged, on the big boss's chair.

After I got away from the guard, I made a final stop at the Consumer Division, where people were busy working, and I dropped off a two-page memo on the travel market for Charlotte Guyman. I also left a copy of the CD-ROM for Mary Ord, an acquaintance of mine who had expressed interest in the project. When weeks passed, though, and I hadn't heard from Gates, Charlotte, or Mary, I began to worry that nothing would come of my adventure in Building 8.

Just when my break-in had become simply a good story to tell my friends, and just about the time I'd started to wonder what step to take next, Mary Ord popped into my office unexpectedly. "You busy?" she asked.

I shook my head, my heart starting to pick up speed.

"We've decided to move forward in the travel market," Mary said casually, and I had to stop myself from screaming out. "We're putting together a team—would you like to be on it?"

That was the first breath of life for my brainchild—the software that became, two years later, Expedia.com and that made me a millionaire.

PART I

1960-1986—Brazil

1

Slide Projector

"November 26, 1976: The trade name 'Microsoft' is registered with the Office of the Secretary of State of the State of New Mexico."

—Key Events in Microsoft History

What kind of woman breaks into Bill Gates's office? You might say I was ambitious or daring, but then again, you might say I was crazy.

At one time, even my parents thought I was nuts. That's probably because I was not like other girls in Rio de Janeiro, Brazil, where I grew up in the 1960s and 1970s. I wouldn't conform. I played on the streets with the boys. I traded my dolls for soccer balls, and I idolized Pelé, the Brazilian soccer star. In school, I excelled at math and science, and I won a competition for correctly naming and locating all the bones in the human body when I was only eleven. I loved winning so much that if I didn't come in first in a game or contest, I got visibly upset.

And I was really, really good with machines—better than I was with people. One of my favorite activities was taking apart household objects and making something completely different

out of the pieces. My parents didn't have a lot of money to spend on toys, and I was bored by the crying baby-dolls I got second-hand from my wealthy cousins. So I taught myself how to make what I really wanted—my own machines.

I drove my mother crazy by grabbing things in the garbage or old tools left over on drawers to use in my creations.

"I found this in the bathroom trash," I said, holding up a plastic covered soap dish, the kind you use for travel. It was old and still had some dried soap inside that would have to be cleaned out. "Can I have it?"

"Soraya, I thought I told you to stay out of the garbage," my mother warned me.

"But I need this!"

"What you need," she replied, "is to stay out of the garbage!"

I pocketed the soap dish anyway. What my mother didn't understand was that I had decided to make a slide projector. Not that we had a huge slide collection to show on it; that wasn't the point. In school, we were reading about photography, and I wanted to see if I could make a working projector out of things that I found lying around the house or in the trash.

Besides the soap dish, I discovered a small flashlight in a kitchen drawer. Poking around in the hall closet, I unearthed a box of old cameras and equipment—a Brownie Hawkeye my grandfather had owned; the flashbulbs that went with it; an early Polaroid Instamatic; a carton of slides; lenses that didn't seem to belong to anything or anyone anymore. For me that box was a goldmine, and I dragged it into the room I shared with my sisters.

When it comes right down to it, a slide projector is a pretty simple machine. It's basically a casing, a lens, and a light source. After I found all the parts, I painstakingly cut a hole in the top cover of the soap dish with a penknife and fit the camera lens into place. The lens could rotate and the cover could move up and down, both of which helped focus the image. On the inside of the soap dish I calculated the correct positioning for the flashlight behind the lens.

The final step was cutting a gash through the top and the

bottom of the dish, which would snugly hold one slide at a time. Although the projector wasn't automatic, I could manually insert the slides with no problem. "What is it?" my sister Tania asked, circling my new machine curiously. "A project for school?" I had already taken a plain sheet and draped it over my bed as a screen. "Turn the lights out and you'll see," I instructed. "Wow," Tania said as I slipped in the first slide and a picture emerged on the sheet—upside down. "What is it?" she asked again, bending over to try to figure it out. I quickly flipped the slide around. Magically, we were transported to downtown Brasilia, the ultra-modern city that had become the capital of our country in April 1960, just a few weeks after I was born. Neither Tania nor I had ever been there, but we'd seen pictures and heard stories. My grandfather had gone to Brasilia's dedication ceremonies, and he'd taken slides to show my parents when he got back. Because Brasilia was an eight-hour drive from Belo Horizonte, where we lived, and because I was less than a week old at the time, my parents missed the biggest celebration that had ever happened in my country. And Brazilians like a party.

Since he had once been so interested in Brasilia, I figured my father might like to see the slides again. But what I really wanted to show him was how smart and clever his oldest daughter was. I was actually able to make a working slide projector, all by myself! I couldn't wait for him to see that I'd inherited his mechanical abilities. After all, he had built his own house from the ground up when he was dating my mother. I was the closest my dad ever got to a son, but instead of appreciating me, I felt that he always tried to force me to act "like a girl."

I asked Tania to invite him into our room to see the show, because I thought if she did the asking instead of me, he might actually come. At Tania's request, he did come, although I could hear him in the hallway groaning, "This better be important."

"Look, Papa, Soraya made a slide projector out of a soap dish," Tania said excitedly. "Isn't it nice?"

"Here are Grandpa's slides of Brasilia," I pointed out, pinching out one slide and replacing it with another. My father stood in the doorway of our room with his arms crossed in front of him, staring at the picture on the sheet. Every few seconds I'd change the slide, hoping he was being quiet because he was just so moved by the images. But all of a sudden, he flipped on the overhead light and crossed the room to where I was sitting with the projector. He took it roughly from my hands and inspected it front to back before speaking.

"This is my flashlight, Soraya," he said. "I've been looking for it. I'll give you five minutes to put it back in the drawer. You do not take things that don't belong to you." Then he stormed out of the room.

Tania started to cry—she was three years younger than I was, and still little—but I didn't. I knew from experience that instead of showing affection or pride, all my father could do was bark out orders.

"Soraya, don't play with boys in the street," was his favorite command.

"Why?" I'd ask.

"What do you mean, 'Why?' I'm your father, and I say so. That's why." But I would ignore him and go play with boys in the street anyway. And I'd suffer the consequences when I got home. I got slapped around more than I like to remember.

The day my father made me take apart my slide projector, though, I gave in without a fight. My accomplishment meant more to me than his approval—I'd built a slide projector, and it worked.

My father's strictness should have broken my spirit, but I was as stubborn as he was and as hardworking, too. The punishments he doled out only made me more steely and determined—to study hard, to take chances and risks, to think big. All with the idea of becoming self-sufficient and breaking free from my family.

In fact, making money became my big goal as a kid. But I

didn't just want to make some money; I wanted to be rich, like my grandfather, my aunts, my cousins—like everyone in our extended family, in fact, except us. My mother's father, Dorgan Nicolau Cuba, had been a well-to-do manufacturer of men's linen shirts. My first name, Soraya, comes from that side of the family, which was of Syrian descent. When my mother, Aziza, and her three younger sisters were growing up, they had the best of everything—a beautiful, three-story home in Belo Horizonte, expensive clothes, a first-class education. Their father and mother expected them to marry men from their own social and ethnic background—what we Brazilians call *patricios*, or "neighbors from the same land." But my mother was a renegade.

My last name, Bittencourt, is French—my father's heritage. My dad, Enio, was also from Belo Horizonte, but he came from a big, lower middle-class family. Enio started bringing in money when he was a little kid of only seven. He had very little schooling and he never learned to appreciate the cultural things my mother was taught to love. In most ways, he was the exact opposite of all the rich, polished bachelors Aziza was accustomed to meeting. Maybe that made him all the more attractive to her.

Aziza spotted Enio for the first time when she was 15. At that time, her family lived not far from my dad's family, and my mother used to see him watering the plants in his garden. Enio was 19, very handsome and physically fit, charming, and, as it turned out, a terrific dancer.

They used to stare at each other from a distance, and Enio began watering the plants more than he had to, just so he could see her. He asked around, got Aziza's name and her family's phone number, and invited her out to talk. In those days a good girl never went anywhere alone with a man, so Aziza had to manufacture excuses for going out.

"I'm going to confession!" she'd call to her mother on her way out the door.

"I've been blessed," Rosa told everyone. "My oldest is so devout, she goes to confession every week without fail."

After a few months of secret meetings with Enio, Aziza became afraid of getting caught. So she devised a plan: She held a neighborhood party at her house and invited her new boyfriend. Her parents weren't too happy when she introduced Enio to them, since it was obvious there was a magnetic spark between the two. "Who is his family?" my grandfather demanded. As it turned out, Enio's father, Epaminondas, had once worked for Grandpa Cuba's company, making my father's family the social inferiors of the Cubas.

"What does he do for a living?" my grandmother chimed in. When she heard Enio was "looking around" because the industrial freezer company he worked for had gone out of business, Grandma Rosa rolled her eyes and said a prayer that Aziza would soon tire of her handsome young man.

Even though my parents were worlds apart socially, there was an intense sexual attraction between them. They could barely keep their hands off each other. But kissing got them steamed up, and fooling around wasn't an option for a good Catholic girl in the late 1950s. So Aziza and Enio married against the wishes of her entire family when she was just eighteen and hadn't even finished high school. She got pregnant right away, and I came into the picture on April 16, 1960. They had three more girls after me and no sons, though my father always really wanted a boy.

My parents' life together was hard for a long time. After he lost his job, my father had a rough time finding another position. Eventually he found work as a sales rep for a clothing company.

To complicate things, my sister Claudia was born just a year after me. Two babies that close together in age would have been hard enough for a young couple who were really just kids themselves. In addition, Claudia had suffered brain damage at birth. As an infant, she had frequent convulsions and often had to be hospitalized. Although Brazil had national health insurance, the state-run hospitals didn't cover Claudia's condition and she had to go to private doctors. Because of this, her medical bills were a huge financial strain on my parents. When my mother

wasn't watching Claudia and me or doing housekeeping chores, she also took in sewing to help pay the bills.

Some of my earliest memories were of seeing my mother at her sewing machine building stuffed animals to sell, and praying for Claudia. Because I was bright and quick, the exact opposite of my sister, I felt guilty. I used to pray, too, but mine was a different prayer from my mother's: "Please, God, take away some of my intelligence and give it to Claudia." I wanted Claudia to get better so my parents would have it easier.

In the early 1960s, Grandpa Cuba lost his fortune from gambling, including his shirt factory. He had to start from scratch and decided to move to Rio de Janeiro. Because there were more economic opportunities in Rio and he knew my family was struggling to make ends meet, my grandfather invited my father to come along and manage the retail store that he planned to open in downtown Rio.

My dad didn't want to leave; it had taken him two full years to build our house, and he was very proud of it. But he and Mom were so strapped by the high cost of Claudia's medical care that they knew they had to grab the opportunity and make the 250-mile move to Rio.

People in the United States hear "Rio de Janeiro" and the name conjures up adjectives like "rich," "sparkling," "sun-drenched," "romantic." It's all that. But what Americans don't generally know is that there's also terrible poverty. You may have seen beautiful travel photos of Rio, with the mountains rising up as a backdrop to the city and the South Atlantic Ocean glistening like a jewel. What you probably didn't see are the hovels of all the poor people stacked onto the hillsides, in contrast to the luxury apartment buildings that rim the beautiful beaches.

Virtually the entire time I lived there, Brazil was under a corrupt military regime that ruined the economy and crushed all dissent. To disguise Brazil's severe economic problems, the dictatorship rigidly controlled the country's image. What the rest

of the world saw were our glitzy, high-profile events like Carnival and soccer championships. My childhood in Rio was not a picture postcard. We lived in a small, crowded apartment in a working-class section of town, and that was the big reason I had to play on the streets. Throughout my early life, I envied my cousins, who grew up wealthy because my mother's sisters had married rich men, just the way their father wanted them to. My Aunt Regina, who is also my godmother, lived in a fancy apartment building a block from Ipanema Beach, and I used to go to visit her family on weekends and during school vacations. My cousins and I enjoyed the beach a lot. We body surfed, played volleyball, soccer and generally had a good time. But my cousins didn't really understand my family situation, and did not even perceive how hard it was for me when they got new toys, bikes, and vacation trips to Disneyworld. I knew I would never be able to get those types of presents from my parents. Since then, I knew what I wanted: to have a life like my cousins had, with no worries about money.

The big question for me was how I was going to make my dreams of success a reality. There were not many career paths for women and girls in Brazil in the 1970s, as I soon learned at the Catholic girls' school I attended. And none of the designated "women's jobs" were very appealing to me.

"You're a devout girl, and you may find you have a calling to be a nun," Sister Angela suggested, when I asked for counseling. She smiled in a hopeful way, but even though I worshipped Sister Angela, I couldn't imagine myself deliberately taking a vow of poverty. I shook my head firmly.

"Well, teaching is an extremely rewarding career," she went on.

"Teachers don't make any money," I replied quickly. I knew that teaching would leave me scrambling financially with no hope of ever getting out from under my father's thumb.

"Well, there's always nursing," the nun continued. "That pays much better than teaching."

I shivered at the thought of all that blood.

And that was pretty much it for women's opportunities. Unless, through my intelligence, I could somehow break into an unconventional field for women—it could be done, although the odds were greatly against it. I knew there was a public high school in Rio that specialized in technical training and that would give me the skills I needed to make a good living, even without going to college. The problem was it was tough to get into that school: 100 kids applied for every available spot. To be admitted, I would have to pass a rigorous and highly competitive test. The exam itself didn't worry me, because I was smart and knew how to study hard. What worried me more was that I would have to pay for an expensive, private course to get me ready for the test—a little like the Kaplan or Princeton test-prep classes here in the U.S., only mandatory.

My dad, of course, thought the course and the technical school were both a waste of money for a girl. "You'll just take a place in the school away from a boy," he said. "And men have to earn a living to support their families. Cooking classes would make more sense for you."

I was lucky that my mom saw things differently. Maybe because she herself had gotten married before graduating from high school, my mother wanted a good education for her daughters. So, when I voiced my desire to attend the technical high school, she marched into one of the test-prep companies and convinced the dean of admissions to give me a partial scholarship.

"The girl will be famous one day," my mother assured the administrator. "She's a crazy genius. She can make a machine out of a plastic soap dish! I'm telling you, they'll write about her in the newspapers. And everyone will say that you were the one who gave her a chance."

I didn't let my mother down: I took the course and, thanks to my prep class, I passed the high school entrance exam with high marks.

My years at the technical school readied me for what became a continuing theme in my work life, all the way through until I

landed at Microsoft—being one of the only girls surrounded by boys. I was one of four girls in a class of fifty, and the other girls and I always had to prove we could perform just as well as, if not better than, the boys. But the school also gave me a good foundation in teamwork, which is how everything gets done at Microsoft. Even as a teenager, I was getting ready for the future in the world of technology.

At seventeen, I did something you might find incongruous with everything I've told you about myself—I got married.

It's really not as out of character for me as it sounds. Osvaldo was a boy from my electronics class at the technical school. I thought he was a nice guy, handsome and fairly intelligent, though a little complacent.

But why get married? By then, I was over-anxious to get out of my parents' house and start my own life, but Brazil's economy made that almost impossible for single people. Everyone stayed at home until they got married. Not only was it hard to get a job, but everything from rents to groceries were priced sky high. At one point right before I emigrated, inflation was an incredible 1,000 percent. So the quickest way for a girl or boy to get out from under their parents' control was to find someone to marry.

The other thing that factored into our decision was sex. Osvaldo and I were both very curious, and our virginity hung on us like weights. But, just like my mother before me, I was a good Catholic girl who wouldn't dream of going all the way without a marriage license.

Osvaldo's parents were furious that he wanted to get married, and our battle with them was as tough as the one my mother had faced with her parents eighteen years earlier. Osvaldo was supposed to go on to college, and his parents thought I would start having babies right away and hold him back. They seriously underestimated me: I was more ambitious than Osvaldo about an education and a career, and my plans didn't include getting pregnant, although I didn't admit that.

His parents eventually came around, and a few months before

my eighteenth birthday, we had a traditional Catholic wedding with a big church ceremony, attended by 500 people. Most of the guests were my extended family and friends from school. My father's oldest brother, who was a priest, traveled for ten hours just to officiate at the mass.

To cut down on the cost of the celebration, I wore a hand-me-down wedding gown from my aunt, which I had altered to fit me. The reception was a small, family-only dinner at my parents' apartment. The biggest expense was the photographs, in which I look really happy. I was finally an adult! I was gaining my independence!

But then came reality—the wedding night.

We tried to have sex; after all, that was the point of us getting married. But it's funny now to think about our inexperience. As good as we were with machines, neither of us could figure out how to make our own parts fit together without hurting. So, instead of enjoying a wild, romantic night, we ended up frustrated, horny, and blaming each other.

When I woke up the next morning, I had a fierce headache, and not from all the champagne I drank the night before. "I've made a huge mistake," was what kept running through my mind. That and the sick realization that I had no choice but to make the best of it.

Our sex life did improve over time. Once we got the hang of it, we actually had a lot of fun in bed. The porn magazines Osvaldo used to buy for us and the triple-X movies we went to see together helped a lot.

But it was the rest of our time together—the time out of bed—that was the problem.

The way I see it, Osvaldo's parents had held tight reins on him all his life, especially when he was a teenager. Once we were married, Osvaldo sort of lived out that old saying about the kid in the candy shop. When he was finally unsupervised, he decided to do whatever he wanted. That included having sex with anyone anywhere anytime and forgetting he was married.

I found out about his affairs because friends of mine told me

and encouraged me to leave him. But Osvaldo lied when I confronted him, and his lies caused vicious arguments that exacerbated our problems. Within a short time, I realized how immature Osvaldo was and how little I could trust him.

I guess I should have divorced him then and there, and, in fact, I did try to leave him three times. But each time I returned to my family's apartment, furious and determined never to go back to Osvaldo, one or the other of my parents would intervene.

"Does he beat you?" my mother asked.

"No."

"Is he a drunk?"

"No."

"Then what are you complaining about?"

"He sleeps with everyone in the universe and says he doesn't!"

That seemed like a strong enough complaint to me, but amazingly, not to my mom. "It's all in your mind, Soraya," she said, shaking her head at me sadly. "You're just like your father— so jealous and so imaginative!"

Instead of divorce, then, I decided to stop caring what Osvaldo did outside our home. Not an easy task—I had to shut down a part of myself for the next five years. And then the rest of me started drinking and smoking a lot and throwing myself headfirst into my work. In fact, keeping busy became a pattern in my life, so I wouldn't have to deal with all my feelings and worries.

On top of having to deal with Osvaldo's antics, I was stressed out by my hectic schedule. I worked full-time and attended college at *Universidade Gama Filho* in the evenings, studying for my B.S. in electronics engineering. Because it was an hour's drive to my classes, my days began at 5:30 A.M. and didn't end until midnight.

Soon after my high school graduation at CEFET/RJ, I had gotten a prestigious job in the engineering department of Souza Cruz, the biggest tobacco company in Brazil. I'd like to say I got the job because I was the best in my class or because I was the most deserving applicant. But in fact, I got my foot in the door the way most people got jobs in Brazil at that time—because

somebody who knew somebody made the recommendation. In my case, one of my best friends from Catholic school, Barbara, introduced me to her dad, who was an executive at the tobacco company. He then passed my name along to the Human Resources manager, who arranged for my interview and a battery of tests that I passed easily.

Once I was hired, I worked with a team assigned to improve the reliability and speed of the machines that produced cigarettes. But there were so many machines at the plant that I'd never seen before, including some that made parts for other machines. The men who worked on my team harassed me about not knowing how to operate the equipment.

"Hey, Soraya, did you get lost on your way to the kitchen?"

"Yeah, maybe you should stick to a machine you know—like a stove!"

One day the guys devised a contest. They gave Antonio, one of my team members, and me the same blueprint for making an aluminum machine part, and whoever could turn it out in the shortest time and the most accurately would win. They were confident about the outcome and even placed bets on us, most of them laying their money on Antonio. And by rights, he should have won. After all, he was ten years older than I was and had worked at the plant for years.

The whole team watched while Antonio and I stationed ourselves at our machines. Antonio smugly asked me if I wanted a head start which I, of course, turned down. "You can't say I'm not a gentleman," he grinned at the other guys.

Then someone yelled, "Ready, set, go!" I blocked out the sounds of the pep squad cheering Antonio on, and I stayed focused on the plan in front of me.

What none of the guys realized was that I had always had a talent for teaching myself—I could read about how to do a task and then simply do it. So with a blueprint to guide me, I had no problem making sense out of that aluminum part.

After a short time, I became aware that the guys had started grouping around my machine instead of Antonio's.

"Hey, she's going to do it!" one of them shouted.

"Antonio, you better speed up or you'll get whipped by this little girl . . ."

And then, finally: "Come on, Soraya!"

It must have deflated Antonio's confidence when suddenly all the cheers were for me. I finished a few minutes ahead of my opponent and with a better-made part in hand. To Antonio's credit, he took the loss better than I would have if I'd been the one to come in second.

From that point on, none of the guys on my team teased me about stoves.

The work at the tobacco plant was challenging, and I made good money. Within a year, I was promoted to management. And ever since the contest with Antonio, I had the respect of my team.

But then something unexpected happened. The general manager of the plant noticed me—which was actually bad, not good.

"You know, you have gorgeous eyes," he said to me one afternoon when I was in the middle of talking to him about a problem on the line. The inappropriate compliment took me off-guard.

"Thank you. Now . . ."

"You're a very beautiful woman," he went on quickly, "and I'd like to get to know you better."

"Well," I replied, trying to cut off the exchange so we could get back to work, "I'm sure we'll get to know each other over time. Now, as I pointed out before . . ."

But after that, my situation at work just kept getting worse. He'd routinely ask me to come into his office to "discuss" something. When I got there, he'd invite me out for dinner and make suggestive promises about what would happen if I accepted. "I'm good to the girls I have affairs with," he assured me.

I kept thinking he'd give up if I graciously turned him down enough times, but he never did. It became a power play with him—the more I said no, the more he asked. He'd even harass me in front of other employees; that's how confident he was that he could get away with it.

I ended up giving in, but not to sex with the boss. What I did was quit that really good job with only a risky plan about starting my own business. Once again, my family thought I was crazy. And my dear husband Osvaldo actually suggested to my parents that I should be committed to an institution.

The truth is I had handled just about any trial or challenge my job had to dish out: tight schedules; problems on the line; tests of my knowledge; arguments with members of my team. But, unless you've been sexually harassed at work yourself, you might not understand how stressful and demoralizing it is to face that every day when you're just trying to do your job.

I got a lot out of my job at the tobacco company, even though it ended badly. While I worked there, I routinely read *Popular Electronics* magazine to keep up on what was going on with technology in the United States, where everything was happening. In the mid-1970s, Intel had developed the 8080, an exciting new programmable microchip. Using that chip, Micro Instrumentation Telemetry Systems (MITS) had created a small computer called the Altair. By 1975, anyone could purchase an Altair kit for under $400 and build his own "microcomputer." Until Apple burst onto the market and IBM invented its first PC, the 8080 chip ruled supreme. Spurred by the new technology, thousands of computer-geeks-in-the-making like myself, found ways to use it.

Early in my stint at Souza Cruz, I talked one of my bosses into purchasing the 8080 for my team, and he had one shipped all the way from the U.S. to our plant. Late into the night, while Osvaldo was out doing things I didn't want to think about, I studied the instruction book and taught myself the tedious, repetitive process of programming the microchip. Later, I instructed the rest of my team and together we created an electronic device, the first of its kind, to automatically control the amount of raw tobacco fed into the cigarette-producing machines. It was a big step toward our goal of making one continuous assembly line of connected machines. You'd feed tobacco into a machine at one end and get

filled boxes of cigarettes from a machine at the other end—the ultimate in productivity.

At the same time I was helping innovate cigarette production in Brazil, thousands of miles away Bill Gates and Paul Allen had been inspired by the 8080 and the Altair to dream of affordable, user-friendly "personal computers" in every home. I didn't know it in 1980, but I'd have my own part to play in their dream.

2

Laser Girl

"November 10, 1983: Microsoft unveils Microsoft
Windows, an extension of the MS-DOS operating system
that provides a graphical operating environment."

-Key Events in Microsoft History

Looking back now, I realize it was a good thing I left the
tobacco company when I did. I wouldn't have wanted to make
my mark on the world by creating easier, quicker, and more cost-
efficient ways to produce cigarettes. That might have been a good
accomplishment twenty years ago, but it would hardly make a
great epitaph today.

I tried to come up with other ways to make a living and
considered what I knew best. Since I'd taught myself to program
Intel's 8080 microchip, I thought maybe I could offer classes to
teach others how to do it, too. But people close to me said there
wouldn't be any money in that, and I wanted to think of a project
with the potential to return a profit.

I thought, "OK, Soraya, you're good at making things." So
my next idea was to go into the manufacturing business,
producing timers for home appliances—something that no one

in Brazil was doing in 1980. I thought it would be valuable, for example, to be able to program a lamp or a fan to go on at a certain time. But because manufacturing was a lot more expensive an undertaking than simply offering a computer course, some of my rich relatives had to help me finance the start-up costs of my new venture.

It was a sound business idea, and it would have worked, too. But I was still just a kid, and someone I naively trusted took advantage of my inexperience. I was led to believe that a department store in Rio had placed a COD order for several hundred timers. It would take three months and all my capital to fill just that one order, but the profit from the sale would be enormous.

To me, this looked like my big break. So I drove all the way to Sao Paulo to buy parts and spent whatever reserve money I had for labor. For three months, I pushed my workers like a madwoman. When the day of delivery arrived, we had completed all the units on time. I got ready to go to the store and drop off the shipment in person so I could pick up the payment check, which I badly needed.

You can imagine then how hard and fast my heart sank when I heard this from the store's appliance buyer: "I have no idea what you're talking about, young lady."

"I'm telling you, we had a guaranteed order if delivery was made today," I insisted. I held out the page of my date book, with the store's name and the deadline clearly marked, as if that would prove the order existed somewhere outside of my imagination.

"And I'm telling you, young lady, this store never placed such an order."

"Stop calling me that," I snapped. "I'd like to speak to the general manager." I waited while he tried to get his boss on the in-house line, and I kept staring down into my date book, hoping the answer would somehow magically turn up on its pages.

"He's in meetings all afternoon," the buyer announced, hanging up the phone with a shrug. "I'm afraid there's no one here who can help you, and you'll have to leave."

And that's how six months after it started my business collapsed. To pay my debts, I had to sell everything I owned of value, including my motorcycle and a new windsurfer that I really loved. At the tender age of twenty, I had my first taste of failure. Actually, it was more like a huge swallow. I was furious at myself for not making that one little call to the store that would have told me right from the start there was no order pending, that I'd been tricked into believing what I wanted to believe.

The worst part of the whole humiliating mess was the way my parents looked at me when I told them the news about how I'd been duped. They both got really quiet, and their faces registered disappointment and disbelief, as if to say, "Mary Mother of God, she really is crazy."

To this day, I cannot stand the sound of a timer going off.

My father took pity on me for "screwing up" my business, as he sympathetically put it. He offered me a job at his men's clothing store in downtown Rio, and against my better judgment, I took it.

My mother shook her head when I told her I'd accepted the job. "When you two kill each other," she said, "don't come crying to me."

My father's store was located on a cobblestone street in an old section of the city, where beautiful colonial houses had all been transformed into retail stores. The store was small and disorganized, because my dad's heart had never been in any of the details involved in the daily management of a business. Instead, he preferred "public relations" and was very good with customers. Besides that, he carried a .38, and more than once he caught burglars while they were trying to rob other stores in the neighborhood. Local business owners loved him and named him president of the Lebanese retailers' association, the Sahara. As their leader, my father got them to pitch in for the construction of public restrooms on the street for shoppers and the neighborhood's homeless people.

Which I realize now, was all very good. My father was, and is, a big-hearted guy. But at that time, I couldn't see that. I only knew that I was supposed to be managing the store's bills and its bank account, and I couldn't find anything when I needed it.

"Where do you file the invoices?" I asked him my first day on the job, after I innocently answered a call from a supplier furious about an overdue bill.

"The what?" That should have tipped me off to my father's "system."

"The invoices. The bills. What suppliers send and we have to pay."

"Oh, sure. Well, let me think . . ." He took a sip of his coffee and scratched his chin, thinking hard. "You know, Soraya, you don't really need the bills. You can just call up and get them to tell you the amount we owe over the phone."

In my job, I did a little bit of everything. At the end of the day, I was in charge of counting up the money from the change drawer. I asked my dad for the combination to the office safe, and he stalled for a few minutes before telling me what it was. I soon found out why he hesitated—inside the safe were moneybags stuffed with birdseed.

"Where's all the money?" I asked him.

"The money?"

"Yeah, the money. You know, the stuff that keeps the store in business? That pays the rent?" My voice was getting higher and louder.

He sat down at his desk, leaned down, and sighed, as if being tortured with stupid questions. Bringing up an old shoebox from under his desk, he held it out for me to take. I lifted the lid and saw that it was bulging with cash.

"What, are you crazy?" I said. "You keep the money in a shoebox and birdseed in the safe?"

"There's a lot of crime in this area," he replied. "Think about it, Soraya. A thief would never imagine we kept money in a box under the desk when we've got such a big safe!"

I didn't kill him, but I wanted to. In fact, there were many close calls over the next six months that I worked for my father. I drove him crazy, too, because I was always pushing for changes he saw as unnecessary, like keeping anything else but birdseed

in the safe, or moving merchandise with lower profit but fast out of the shelves.

"I've been in business twenty years, Soraya," he said to me. "I think I know what's best."

One morning I just couldn't stand the thought of going back to work at the store, so I called my father and said I had to quit. The reason I gave was partially the truth and partially made up to spare his feelings.

"You know, I'm just not going to be happy until I find something in my field," I explained. "I've spent all this time and money training to be an engineer, and yet I'm working in retail."

There was a long pause before he finally responded to my news.

"If you think that will be best for you, fine." he said, and hung up.

And once again, I was out of a job.

I regret that it took me 32 years to really understand my father and to develop a good relationship with him.

Because science was one of my passions as a kid, I always loved going on school trips to the Gávea Planetarium in Rio. Back then, its main attraction was the celestial sky show, a popular entertainment invented in Germany in the 1920s and then imported to the rest of the world. There was real magic when you slouched down low in your chair, crooked your neck, and watched the planets and stars twinkling in the dome over your head—kind of like traveling in space.

By the time I was in high school, however, a lot of people considered sky shows old-fashioned, and planetariums all over the globe started losing visitors and money. To broaden their appeal to teenagers and adults, they began offering novelty shows that synchronized colored laser beams with either rock or classical music.

In 1981, when I was looking for a job, laser shows were already familiar to audiences in New York City, Washington, Los Angeles, London, and Tokyo, but they hadn't reached Rio yet. An

Argentinean named Willy Feliu decided to rent equipment in the United States and make a bundle of money touring his "Cosmic Laser Concert" throughout Brazil and other countries. He hired an American technician, Dexter Goucha, to operate the laser machine, which was one of only five of its kind in the world and cost almost $200,000 at that time. But Goucha wanted his salary in U.S. dollars, which at that time were worth three times as much as Brazilian cruzados, and after a while that got too expensive. So Feliu decided to replace him with a Brazilian, and he advertised in the paper for someone who was electronically proficient and knew music. And who would, of course, work for Brazilian money.

Not surprisingly, I was the only woman who applied for the job. The day of the interviews, I had to stand in line with a few hundred men, some of whom I'd gone to school with, and wait my turn. When Feliu saw me there in the sea of male faces, he looked me up and down dismissively and tried to reject me on the spot.

"You need training in electronics for this job," he said coolly, moving quickly past me to the guy behind me in line.

I offered him my application, which outlined my qualifications, but he still looked skeptical.

"This isn't an easy job. It takes technical skill and manual dexterity. You have to take a test in English about electronics, and then one to prove you can coordinate the music with the laser light," he pointed out, still thinking I was unqualified and that I'd back down.

Instead, I said, "I'm ready. Give me a chance." How could he refuse when I was so persistent?

After I passed the tests, Feliu must have realized that I was the ideal person for the job. I not only had the technical expertise to operate the laser equipment, but I had also taken up the saxophone as a hobby a few years earlier and had the rhythm to make the laser "dance." And, last but certainly not least, I was an attractive twenty-one-year-old woman. I sold Feliu on the idea of my wearing a sparkly, cleavage-revealing jumpsuit to make me resemble a rock star and draw people into the show.

First, though, I had to learn the equipment, which I thought

was the weirdest piece of machinery I've ever seen. A tower about ten feet tall held the laser lamp, as well as the scanner and mirrors that manipulated the lights. Next to the tower was an elaborate control table, resembling a music studio mixer and equipped with knobs, switches, and a joystick to command the movement of the laser beams.

It took me quite a while to get the hang of it, to memorize which knob or switch produced which effect and to figure out how to swing the joystick to match the rhythm of the music. Operating the equipment was like sitting down at a very sophisticated synthesizer. Instead of musical notes, though, the machine created pictures.

The night the Cosmic Laser Concert opened at Gávea in February 1982, I was scared to death. I had gotten comfortable with the machinery, but I'd never had 150 people watching me work before. The lights dimmed, the music started softly at first, and I began to manipulate the lasers just the way I'd practiced. And suddenly, the audience was connecting with the effects, responding with enthusiastic "oohs" and "ahs." My stage fright lifted, and I hammed it up, tailoring the show to suit the audience's taste. When they applauded wildly and screamed out in response to a certain laser effect, I would keep creating similar combinations to satisfy them.

The show was a tremendous hit that ran in Rio for ten months. Audiences loved the geometric forms, the graceful blend of colors and shapes that the laser image equipment created, all choreographed to quadrophonic music selections ranging from "The Blue Danube Waltz" to Jefferson Starship and Pink Floyd. People paid to see it over and over, because the thirty-minute show wasn't computerized and therefore was never exactly the same twice.

And I was a hit, too. Immediately after opening night, reporters suddenly wanted to interview "The Laser Girl." My name and face were splashed all over O Globo and other newspapers. Even the TV news crews came calling. Sometimes people who'd seen the show or my picture in the paper actually stopped me on the

street: "Hey, it's the Laser Girl! Can I get your autograph?" The planetarium job turned my life around and gave me back my self-esteem. I'd been at a real low point, both unemployed and unhappily married. Suddenly, I was a star—at least a little one. But what really changed my life wasn't those fifteen minutes of fame. While I was working at the planetarium, I met Lucila.

It happened unexpectedly one afternoon in November of 1982, when I was walking into Gávea Planetarium to get dressed and set up the equipment for the evening show. As soon as I walked through the glass entrance, there was a reception table on the right. Sitting there all alone was a beautiful young woman, tall and willowy, with curly dark hair, expressive eyes, and the tiniest waist I'd ever seen. She looked like she must be a model. Maybe, I thought, she was waiting for her husband or her boyfriend to get off from work. I'd never seen her around, so I was sure she didn't work at the planetarium herself.

I asked Angela, who managed ticket sales, if she knew who the beautiful woman in the reception area was. She looked puzzled, as if the lobby was filled with beautiful women every day.

"Long hair, tiny waist?" I continued. "Looks like a model?"

"Oh, that's Lucila," Angela replied. "I don't know her last name. She used to work in the development office—you know, doing events and exhibits and things like that, but she got fired last spring, the day after she graduated from college."

"Why?"

"The boss said that when she got her accounting degree, she was overqualified. He'd have to pay her more, so he fired her instead. Nice graduation present, wouldn't you say?" Angela shook her head. "She comes back every week or so to see her friends."

My first thought was that I wanted to tell Lucila I was sorry she'd lost her job, that I knew all about unfair bosses. But when I went back into the lobby, she had disappeared.

It was a week before I saw her again, sitting right where she'd

been that first afternoon, waiting and glancing anxiously at her watch. A camera bag sat in front of her on the reception desk. This time, I couldn't resist speaking to her; she looked sad, like she'd been waiting too long in the same spot.

"You look beautiful today!" I called out, hoping to cheer her up. It was the first thing I thought of, and I didn't consider in advance how it would sound.

Lucila looked at me, obviously confused because another woman seemed to be flirting with her. "I am beautiful," she agreed. "I'm dressed up today." She turned away slightly, as if to stop the conversation from going further. I wondered if she was offended by my forwardness or thought I was some sort of freak. At the risk of seeming even pushier, I sat down next to her at the reception desk.

The funny thing is she knew who I was. "You're the Laser Girl," she said, smiling. "It's a good show. But you know, your costume's kind of slutty."

That made me laugh and blush. "Yeah, but it draws people in. You know, you should come to the show again. It's different every time. In fact, you should see it from the operator's booth," I offered.

"Well, maybe," she said cautiously.

To get her to trust me, I asked a lot of questions about her life. I found out that she was working at an aluminum company as a typist. Since she had a college degree, it was a big step down for her, but she needed the money. She was hoping there would be an opening in the accounting office that she could apply for in the near future.

"And what do you do in your time off?" I got around to asking. I was thinking that maybe we could see a movie or have dinner on the weekend.

"I take pictures," she said, pointing to the camera bag. "I like photography. In fact, I'm waiting for the astronomer, who wants me to take some pictures of the orchids outside."

The word "photography" was all I needed to hear. I had been wanting for some time to take photos of the inside of the laser

tower (there was a door in it that opened for maintenance), so that I could study how it worked.

"Sure, I could do that," Lucila said, when I suggested it.

The day that we picked to photograph the machine, however, Lucila didn't show up. I waited thirty minutes or more, pacing back and forth in the lobby. Maybe I had been too pushy, I thought, and she'd been scared off. Or maybe she just wasn't interested in getting to know me better.

Since I'd gotten all the camera equipment set up anyway, I asked Angela to help me by holding the lights. She grumbled a lot because it was her break, but she agreed to help me out.

"This is some crazy-ass thing you're doing, Soraya," Angela complained, as I put her to work. But just as I was getting ready to start shooting, I heard a distinctive voice behind me.

"I thought you wanted me to do that," Lucila said.

I was so nervous to see her, I almost dropped the camera. "You . . . I didn't think you were coming," I finally managed to say.

"Well, I'm here now," she pointed out. Angela went away happily.

Lucila, in fact, wasn't scared of me or what I thought of her, and she was very comfortable letting me know that. "You're doing it all wrong," she insisted, taking charge immediately. "You're using too much light, and it's not going to work."

That day was the start of our friendship. We talked a lot in the booth—about our jobs, our families, college, even about my marriage—and when we were finished taking photos, Lucila stayed on with me in the control booth to watch the laser show. She had to admit that it was a completely different experience from the operator's vantage point. Sitting relaxed in the audience, focusing on the show, she had had no idea how hard it was for me, the technician, to synchronize the lights with the music, my fingers flying wildly all over the control panel.

When I invited her back the following Saturday, she agreed right away but then seemed to back down when she asked if she could bring "a friend." I wasn't sure if that meant a friend-friend

or a lover-friend, and I felt a sharp pang of jealousy, thinking it was undoubtedly a lover-friend.

As it turned out, though, it was a friend-friend. And as it turned out, I was really, really glad.

I know what you're thinking, because it was the same thing Lucila was thinking: But she's married.

That's true—at least on paper. By 1982, though, after over four years of marriage, Osvaldo and I barely spoke to each other.

And I bet you're also thinking, What's a married woman doing coming on to another woman?

There are a few things I haven't told you yet.

For most of our marriage, I could connect with Osvaldo sexually, but emotionally it was a different story. One of the ways we managed to hold our relationship together was watching porn at the local X-rated theater, then going home and having sex.

"There's a French movie called *Emmanuelle* opening this weekend," Osvaldo announced one evening when we were both at home. "It's being called 'porn for intellectuals.' Want to go?"

"Porn for intellectuals? Isn't that a contradiction?" But I gave the movie a try anyway. After all, it wasn't often that my husband invited me to do anything with him, and, at that point, I still cared.

Emmanuelle was more soft-core than the other porn movies we'd seen together. There were a lot of dreamy shots and fleeting glimpses of naked flesh as the title character, the young, naïve bride of a sophisticated diplomat, embarked on one sexual adventure after another. I was actually starting to get bored, but then Emmanuelle's attention suddenly turned to a beautiful blonde woman. I found myself watching raptly as the woman seduced her. So did Osvaldo, though not for the same reasons.

That night in bed, Osvaldo suggested a new sex game—a fantasy ménage with Sylvia Kristel, the actress who played Emmanuelle. As he whispered in my ear exactly what Sylvia and I were doing together, which was what we'd seen her do on camera with her lover, Bea, I found myself more turned on than I'd ever been.

The next day, the lesbian sex scenes from Emmanuelle were still playing in my mind. I usually forgot porn quickly, so I didn't know what to make of my feelings. I had a friend from school, Sonia, who had had a sexual relationship with another girl, but her experience had always seemed so abstract to me. What was it all about, sex with another woman? Since I was keen on self-teaching, I decided to try to educate myself on the subject through books.

At that time, I was still working at my dad's store, so I spent my lunch break at a bookstore down the street. For half an hour, I scanned the shelves, unable to find anything that would teach me what I wanted to know. Suddenly I heard behind me, "Are you looking for something in particular, Soraya?" Mr. Said, the bookstore owner, was a friend of my father's from the Sahara retail association. He smiled at me kindly.

"No, no, not really," I said, quickly shoving the book I'd been looking at back onto the shelf. "Just browsing." I turned bright red. Titles like *The Joy of Sex* and *Everything You Always Wanted to Know About Sex* seemed to jump out from the bookshelves.

"How's your husband?" Mr. Said asked, glancing at the shelf and then back at me curiously.

"Oh, he's fine."

"And your mama?"

"Fine," I replied, my voice squeakier than usual. "We're all just fine."

Maybe it was the sudden soprano in my voice or the fact that I'd broken out into a light sweat that made Mr. Said raise an eyebrow. After a few more questions about my father and my job, though, he simply bowed his head politely and disappeared through the brown velvet curtain at the back of the store. The moment he left, I grabbed the only book there that I thought might help me and raced to the cashier, a young woman I'd never seen there before and who didn't know me. She never even looked at the title as she slid *Sexual Behavior in the Human Female* into a paper bag.

I read the so-called Kinsey Report in about two days, which is quite a feat—it's not a novel, after all, but a dry treatise filled with charts and graphs. You have to really hunt around for the good stuff. In the edition I purchased, that meant pages 446 to 501, especially the section titled "Techniques in Homosexual Contact." My copy was soon heavily underlined in red pen: ". . . among the females in the sample who had more extensive homosexual experience, simple kissing and manual manipulation of the breast and genitalia had become nearly universal. Deep kissing (in 77 percent), more specific oral stimulation of the female breast (in 85 percent), and oral stimulation of the genitalia (in 78 percent) had become common techniques."

Even after I finished reading the book cover to cover, I was still hungry for details about lesbian sex. So I worked up the courage to call my friend Sonia and get more information about her relationship at school.

"Osvaldo and I saw *Emmanuelle* last night," was how I broached the subject with her. Sonia and I hadn't spoken in a few weeks, and suddenly I was calling her up to talk about lesbians.

"Who's she?"

"No, no, it's this intellectual porn movie . . ."

Sonia laughed.

" . . . and the main character has a lot of sex with women."

"Which reminded you of me," Sonia snickered.

"In a way," I admitted. "Well, I thought you might like to see it. The women were really beautiful, Sonia. But the picture didn't show too much of the sex, you know? It was soft-core, and the sex parts were a little fuzzy. And I was just wondering . . ."

A pause.

" . . . how two women actually do it," I continued. "And I was wondering if whatever they do is really fulfilling. I mean, I wonder if sex could be good without, you know, the equipment."

Another pause, this one much longer than the first.

"You're fighting with Osvaldo again, aren't you?" she asked.

"No, we're actually getting along right now."

"Did he suggest a threesome or something?"

"No, no, nothing like that."

Sonia hesitated for another few seconds. "Look, Soraya, women can give pleasure to each other," she said, sounding a little put out. "There are lots of ways. Women make love with their whole bodies. You don't need equipment."

Since I wasn't getting the information I needed from books or from Sonia, I thought maybe I should find someone who would give me hands-on training. But how to find someone? There were no gay bars in Rio then, and no newspapers, books, or magazines geared toward gay people either. Although many famous Brazilians have been gay, none of them were public about it. For the most part, gay men and women married wives and husbands and then kept secret same-sex lovers on the side.

This was obviously not the best atmosphere for someone questioning her sexuality. So, from the moment I saw *Emmanuelle*, I had to pretty much follow my own instincts.

I decided that all real lesbians must be tomboys, so I was on the lookout for likely candidates. And not long after my talk with Sonia, I met a girl at, of all places, the wedding of one of my co-workers. She was a handsome young woman named Cida, who was visibly uncomfortable in her fancy dress and heels, like she couldn't wait to get home and change back into jeans and sneakers.

We made eye contact across the reception hall. I was one of the bridesmaids, and I rustled across the room in my frilly gown and struck up a conversation with her. Although we liked each other immediately and had a lot of the same interests, Cida's home was sixteen hours away from Rio. Being single, and seventeen, she lived with her parents. She was hardly the ideal person to try out my lesbian feelings on.

We wrote many letters over the next few months, and I spent a lot of my salary on long-distance phone calls. Increasingly, I felt myself getting attached to Cida and wanting to spend more time with her. I sensed, too, that my feelings were reciprocated,

and we made plans for me to visit. Because I wasn't much more than a kid myself—I was only 21, four years older than Cida, and looked younger—no one in her family was suspicious of our motives for getting together.

"I think it's wonderful," Cida's mother said, hugging me and welcoming me to their home, "that my daughter has such a good friend! You'll be just like one of the family, Soraya." Which explains why I was allowed to sleep in Cida's room and share her bed.

The weekend was not what I would call romantic. Cida and I had clumsy sex in her bedroom while her parents were out, and I felt as physically unsatisfied as I did on my wedding night. Still, I experienced an emotional bond with Cida that I had never felt with Osvaldo, not even when he and I were having our hottest sex. Being intimate with Cida felt natural, like the final pieces of a puzzle had slipped effortlessly into place.

That recognition, in itself, would have been worth the trip. If only Cida's older sister, Rachel, hadn't burst into the bedroom without knocking, as we were lying on the bed, kissing and fondling each other under our shirts.

"Aiiiiii!" Rachel started screaming, like she'd come across a murderer in the act of strangling her baby sister. Her wailing sounded a lot like the burglar alarm at my dad's store. When Rachel finally got a hold of herself and was able to speak again, she practically spat at me: "Get out of our house!"

She didn't have to tell me twice. Needless to say, that was my last trip to Cida's house.

When I returned from Cida's, I became less and less interested in a physical relationship with Osvaldo. And as soon as I stopped wanting to have sex with him, our marriage unraveled for good. He didn't even try to get me into bed anymore.

That left me with a problem. With no emotional or sexual connection to my husband and a future with Cida looking dim, I became convinced that love—the passionate, all-consuming kind you see in the movies—was really just a fraud. That was what I told myself, anyway, to avoid disappointment.

So there was no one more surprised than I was when several months later, I found myself in love with Lucila.

She came to the laser show with her friend-friend, but they left right after the performance and we barely spoke. At home that evening, I realized I had no idea how to get in touch with her again, and that made me feel panicky. In my nervousness, I'd never asked her last name or which company she worked for. All I knew was that it was an aluminum company somewhere south of Rio.

There are quite a few aluminum companies outside of Rio. If you ever tried to phone them all, as I did the next morning, you'd know. As I reached each one, I asked for the Human Resources Department.

"I'm looking for an employee of yours named Lucila," I said to what seemed like a million receptionists. "She's working as a typist."

I could hear paper rustling on the other end of the line. "I think we do have a Lucila here. What's her last name?"

"I don't know," I admitted. "Is your Lucila a typist?"

"You don't know her last name?"

Not surprisingly, I was disconnected. Finally, though, I reached an H.R. assistant who took pity on me—but only because I concocted a story to explain why I needed to reach Lucila.

"It's very important that I find her," I lied. "I owe her money, but I lost her address so I can't pay her back!"

I waited to be brushed off again, but instead the woman replied evenly, "Well, I see that we have a Lucila Oliveira in the Finance Department. Could that be her?"

"Yes!" I shouted. Then, more calmly, "Yes, that's her."

I recognized her voice immediately at the other end of the line. I had sort of memorized it.

"Do you know who this is?" I asked coyly. I was trying very hard to be cool and suave, but my heart was thumping so loudly I could practically hear it.

"Y—yes," she said.

"I really liked seeing you Saturday," I continued, "and I'd

like to see you again. Would you like that?" I couldn't believe I was saying these things so brazenly over the phone.

Instead of answering, Lucila asked, "How did you get this number? I don't give this number to people."

"You told me you were working for an aluminum company outside of Rio," I replied. "I called them all. So, would you like to see me again?"

There was a very long pause—it seemed to take about an hour for her to answer "okay" and to invite me to her apartment before the laser show on Saturday. To my surprise, she lived just blocks away from where I worked.

"Will there be anyone else there?" I asked. She had already told me she lived in a cramped, one-bedroom apartment with her mother and two brothers. I had made up my mind to be honest with her about my feelings, and I didn't want an audience for that.

"No," she replied, "just us."

I hoped that Lucila knew how I felt about her and that it didn't scare or intimidate her. Still, I had to make sure. If we'd met in a gay bar or bookstore, like here in the U.S., there would have been no mistaking our intentions. But I wasn't sure we were even speaking the same language.

When I showed up at her apartment right on time, she acted surprised, like she'd forgotten. "Isn't this the time you told me to come?" I asked.

"But you're on time! I've never known anyone in Rio to be on time." Which explained why she'd been thirty minutes late for our first "date" at the planetarium.

In the living room, there was a plate of crackers, black olives, and cheese on the coffee table, with wine to go with them. We sat side by side on the couch—which Lucila said doubled as her mother's bed—nibbling and sipping everything nervously as we exchanged chitchat about our jobs and about how the week had gone. I could barely look at her, I was so scared of the question I knew I had to ask. Finally, I just blurted it out.

"So," I began, "what do you think about homosexuality?"

Her wine went down in a loud gulp, and she stared at the

half-eaten plate of food in front of us. "Oh, I think it's fine," she said vaguely, turning the plate. "My brothers all go skating, and a lot of the guys they hang out with at the rink are gay."

But that wasn't quite what I meant. "No," I said, rephrasing the question, "I meant, what do you think about it for you? Have you ever thought you might be . . . gay?"

She still wasn't looking at me, and the room felt so small, so closed in, so oppressively warm, even though a breeze was blowing through the windows. On the wall, a clock ticked away the moments of torture.

"I've never had a relationship with a woman," she said finally, and I could feel my stomach muscles tightening. "But . . ."

But. The room got larger, and the air felt a little cooler.

" . . . I'm a very open person," she finished. "Personally, I don't think it really matters if you're with a man or a woman."

So I ended up telling her my story—about *Emmanuelle*, about the Kinsey Report, about Cida and how her sister threw me out of the house. We were so involved in talking that I almost forgot I had to go to my job. For the first time, my work wasn't the most important thing in my life.

That evening, Lucila went with me to the planetarium and stayed in the booth through five shows. The first laser concert began at seven o'clock, and the rest followed almost back to back, ending at about eleven at night. I was so high from our conversation that afternoon and from having her there, sitting close to me, that I asked if I could kiss her and she said yes. That night, the laser lights seemed especially spectacular.

3

Satellite Ground Station

"August 12, 1985: Microsoft celebrates its tenth
anniversary with sales figures for the fiscal year of 1985
of $140 million."

—Key Events in Microsoft History

When I say that meeting Lucila changed my life, I'm not
exaggerating. She admired the choices I'd made and thought I
was great just as I was. Her respect for me contrasted sharply
with the way just about everyone else had ever treated me—my
parents, my husband, kids at school, and colleagues at work.

My relationship with Lucila would have been ideal, except
for one not-so-tiny problem: I was still living with my husband
and Lucila with her mother and two kid brothers. We had
absolutely no place to be alone together. Occasionally I invited
Lucila to come along when Osvaldo and I went to a party or a
club, just so she and I could sneak off to the bathroom for a while
and kiss and hug in semi-private.

And that was as far as it went for many weeks. The truth is
Lucila was more eager than I was to get into bed. "You could

borrow a friend's place," she'd suggest. Or "Why don't we take a trip out of town? Friends do that, you know."

But in fact, even though I was the one who had some sexual experience with women, I was scared to death. My affair with Cida had not been sexually fulfilling. What if I discovered that I really didn't like going to bed with Lucila? What if it wasn't any fun? Where would we be then?

My answer was to avoid facing those questions. "Let's wait a while," I said. "I think Osvaldo might go away to visit a friend in Salvador in a few weeks. We could have the apartment to ourselves."

"A few weeks!"

That was when Lucila decided to take control of the situation. Because she worked on the outskirts of Rio, every day she drove through the area of the city where all the motels are. The city's motels aren't for tourists; they're for one thing only. I knew of many heterosexual couples that had used them—in fact, Osvaldo and I had on a few occasions rented a room, when we were trying to spice up our marriage—but I had never heard of a motel that accepted a female couple.

"I want you to meet me tonight at Barra," Lucila instructed me on the phone. "Meet me at the beach at 6:00 P.M. in front of Barramares, and then we'll go . . . somewhere."

I knew what the suggestive and vague "somewhere" meant, and I paused and took my time answering. "Lucila, I don't think . . . I don't know . . ."

"You don't have to think or know anything," Lucila insisted. "Just meet me as 6:00. We'll find a place."

But I was scared to leave finding a motel to chance. Once again I relied on Sonia, my friend from school, for information. Sonia asked around and came up with the name of a motel where the management apparently didn't care if its customers were straight, gay, or something in between.

That night, I met Lucila on the beach. I kissed her chastely on the cheek, and then she got into my car and we drove in quiet anticipation, holding hands across the gearshift, to the motel Sonia

had told me about. And Sonia was right: The night manager barely looked at me as I signed the register with my first initial and middle name only, "S. Cuba."

"Four-eleven," he said through a yawn, handing me a key. I smiled shyly at Lucila, gripping the key so tightly it left a dark red indentation in my palm.

"Relax, Soraya," Lucila reassured me, when I tried unsuccessfully—twice—to unlock the door to our room.

"He must have given me the wrong key!" I complained. "I've got to go back to the front desk."

"Just try one more time," Lucila urged, and the third time the lock slid open easily.

Inside, I had barely gotten the lights on and put my bag down before Lucila pulled me lightly into her arms and planted a long, luxurious kiss on my lips. "At last," she said, "I've got you where I want you—all to myself." The room suddenly got very warm and close, and I pried myself gently out of her embrace.

"I think . . . I need to take a shower," I explained. "I . . . It was so hot today, and I . . . I want to be all fresh for . . . for our . . . you know."

Lucila stared at me with dark, soulful eyes that said, "Why are you doing this to us?" But she didn't protest. "Okay, fine," she said. "Take all the time you need." She probably thought I didn't notice her glance at her watch, worried that both of us would have to go home in a few hours, our relationship still unconsummated.

While cool water coursed over my body, I thought of Lucila and how disappointed she had looked when I said I needed a shower. She was beautiful, I said to myself, picturing her full lips and wild curly mane of hair, her slim hips and waist. She was smart and sensitive and a hard worker, just like me. We were a good match, maybe a perfect one. And she was willing to bypass convention, to put everything on the line and try her luck with another woman. Now she was out in the other room alone, eager and anxious to have sex, and I was a complete idiot—what was I waiting for?

I got out of the shower and dried myself quickly, then walked back into the bedroom wrapped only in a skimpy motel towel that barely covered me. Lucila was lying patiently on the king-sized bed, her hands behind her head, staring up at the ceiling. "Too bad I didn't bring a book," she laughed.

"Oh, I don't think you'll need one," I said with a suggestive smile.

"You've cooled down?"

"No," I said, as I unfastened the towel and let it drop to the carpet around my feet. "In fact, I've never felt hotter."

From that night on, Lucila and I could barely keep our hands off each other. I found I had worried for nothing, that we were as happy and compatible in bed together as we were talking and walking and having dinner. Of course, that made our lack of privacy all the more excruciating.

Then, just when we needed it most, luck came our way. After a few months of us borrowing friends' apartments or finding spare money for a motel room, Lucila chanced into an apartment of her very own. One of her cousins had a two-bedroom flat that she no longer needed because of a divorce, and the flat passed along to Lucila's mother. Lucila could stay on in the small place near the planetarium while her mom and brothers moved to the larger apartment, and that meant we could have a place to be alone—finally. But Lucila wanted more from me and found the courage to tell me so.

"If you love me," she announced one night when I was getting ready to leave her flat and go home to Osvaldo, "you have to be with me. I want us to live together. I've had enough of this sneaking around. It makes me sick to think about you going back to him all the time. I want us to live together."

"You want me to get a divorce?"

"Yes." She crossed her arms firmly in front of her, like she was furious, but her lips trembled like she was on the brink of tears.

"But I'll never hear the end of it from my parents!" I protested. "Every time I've tried to leave him, they always talk me out of it.

They're very Catholic. 'You have to work it out with him,' they'll say. 'There's no divorce in this family.'"

"Then don't tell them," Lucila said, shrugging. "Just do it." Even though she was also Catholic, Lu had a very different take on divorce than I did, because her parents had split up when she was eight.

I mulled over the simplicity of her suggestion for a few moments; it wasn't a bad idea, sneaking away without informing anyone what my plans were.

"Besides," Lucila continued, "they'll get over it. But if you don't leave him, if you keep insisting we meet in secret like this, I won't put up with it. It's me or him, Soraya—you decide."

I took a deep breath and told her I would think it over and then call her. She looked stunned that I didn't just give in to her demands.

"You don't know how you feel right now?" she asked.

"I know how I feel, I just don't know what I think," I corrected her. "Give me three days, okay? I need time to work it all out in my head." In my nervousness to go, I buttoned my blouse all wrong; I didn't discover the mistake until I was outside and noticed a woman looking at my chest in a funny way.

It was a big decision. I wasn't just thinking about leaving my husband; I was thinking about leaving my husband for a woman. That takes a unique kind of courage.

When I got home that night, Osvaldo was out and I roamed around the apartment, contemplating all I was giving up. At that time, we lived in a condo that his parents had bought for us early in our marriage. It was a spacious, three-bedroom place, complete with maid's quarters, on Avenue NS de Copacabana a few blocks from the beach, the kind of chic, luxury apartment I had always fantasized about when I was a kid visiting my rich aunt and cousins for the weekend. It was my dream come true—the big glitch, though, was the person I was forced to share it with.

Over the next few days, I thought nonstop about leaving Osvaldo. Could I really do it and how? I took stock of all of our possessions—our bed, the television and VCR, the stereo system,

the dishes, even the silverware—and realized that most of what we owned had either been purchased with my salary or had been presents from members of my family. If I opted to move into Lucila's tiny place, I'd have to pack light and leave almost everything behind.

While I was considering my options, Lucila was getting nervous because she hadn't heard from me. On the third day, she couldn't take the suspense anymore and called me up one afternoon as I was getting ready to leave for the planetarium.

I said "Alô?" and at first all I heard was a sigh from the other end of the phone. My heart jumped because I recognized the sigh immediately as Lucila's.

"How are you?" she asked.

"I was just on my way to work. Can I call you back later tonight?"

She ignored the question. "It's been three days."

"I know."

"Three long days."

"Yes, three very long days," I agreed, even though I'd been so busy thinking and then thinking some more, I'd hardly noticed the time passing.

"I miss you."

"I miss you, too."

Another sigh. "Then why are you punishing me? Can I see you?"

"I'm not punishing you. I told you I needed three days to think. You gave me an ultimatum, remember? Leave Osvaldo or else?"

"Oh, that. I take that back," she said dismissively. "So can I see you?"

"Just say when and where, and I'll be there." She hesitated, and I figured she needed a suggestion. "How about in forty-five minutes at our usual spot at Barra?" I knew from our many other rendezvous at the beach how long it would take us both to get there.

"Well, actually, I'm at a phone booth at Copacabana and

Figueiredo Magalhaes," she said, mentioning the busy intersection where my building was located. "If you look out your front window, I'll wave to you." Stretching the phone cord as far as it would go, I walked to the picture window and looked down onto the busy intersection. Sure enough, I saw a tiny speck standing at a public phone booth, craning her neck and staring up at my building. When her hand went up slowly in a hesitant wave, I knew for certain it was Lucila.

"Come on up," I said into the receiver, waving back to her reassuringly.

Her knock at the door was shy at first—two slight taps, then two firmer ones. When I opened the door, Lucila immediately grabbed me by the arms, pulled me toward her, and hugged me close. "I thought maybe I'd pushed you too far," she said. "I thought I might have lost you. I thought you would just never call me again!"

"How could you think that?" I asked, surprised that she thought I could be so cruel.

"When things got complicated with your first girlfriend," she pointed out, "you just split."

"This is different," I said, holding on to her tight. "You and me are very, very different from me and any other person."

And I meant it. I'd come to realize that Lucila was the right person for me. With Cida, the girl I'd had the brief affair with, the emotional chemistry was good, but the sex was unsatisfying. It had made me wonder for a while if maybe all my relationships with women would have the same shortcoming. So why, I thought, should I put myself through the upheaval of leaving Osvaldo, only to experience another dissatisfying relationship, this time with a woman?

But the difference with Lu and me was that we clicked from the start, both emotionally and sexually. When things fell into place that way for us, there was no longer any reason to stay in an unhappy marriage when I could find real and complete happiness with Lu.

My decision to leave Osvaldo coincided with Carnaval, that wild four-day blow-out when everyone commits a lot of sins they'll spend the next forty days of Lent atoning for. In Rio, Carnaval means a dizzying, noisy array of balls, samba parades, and street fairs. It's become very touristy—much like Mardi Gras in New Orleans—and many of the cariocas, or natives, leave the city for the duration of the holiday. Osvaldo and I had already made plans to visit some friends in Teresópolis, a small summer resort outside of Rio in the Serra dos Orgãos Mountains.

The day before we were scheduled to leave, though, I knew I couldn't go on with the charade. I took a deep breath and announced to Osvaldo over breakfast that I was leaving him. Despite the fact that we'd spent a lot of our married life arguing, he didn't want me to go. I don't think it was a question of love; it was more that he'd gotten used to us being together and wasn't interested in disturbing his relatively smooth-flowing life.

"We've built a comfortable life together!" he protested. "How can you walk out on all of this?" He waved his arms around dramatically, as if a beautiful and well-furnished apartment in Copacabana was enough to keep me in a loveless relationship.

"I'm not happy," I explained. "I haven't been happy for a long time, but I guess you haven't noticed. I need to make a change."

"But lots of people are unhappy from time to time," he said. "That doesn't mean they break up their marriages. Look, you've got my attention now—maybe there's something we can do to spice things up." For some reason, he assumed I was frustrated with our sex life, when that had actually been the one solid part of our marriage.

"Sex isn't the problem," I replied. "It's . . . other things." I was purposely vague, and the argument ground on for most of the day. Even while I was packing up all my clothes, books, and records, Osvaldo followed me around the apartment.

"You're just bluffing, I know it," he'd say, as he watched me pile books into boxes. "You've threatened to leave before, and you never do."

"This time it's different," I insisted.

He was so sure I wouldn't go through with it; that Osvaldo left for Teresópolis early the next morning, the first day of Carnaval. "I'll see you Tuesday night," he said, in denial about our marriage breaking up. "You won't," I replied, but he ignored me and slammed the door on his way out.

Because I didn't want my family dropping in on me while I was packing and transporting my belongings to Lucila's, I phoned my parents to tell them that Osvaldo and I were both going to Teresópolis for the weekend. My mother was relieved and happy: "I'm so glad to hear the two of you are getting along!" she said. "Marriage is hard, but you need to keep trying to make it work. You have the same hard-to-deal personality as your father, you know. I've told you about the time I was so mad at your dad that I . . ."

"Mm-hmm," I said, letting her ramble on and on, telling a story I'd heard many times. After all, it kept her from trying to get any more information out of me about my trip with Osvaldo.

All that Saturday, I filled the trunk of my car with boxes and suitcases, drove across town, stacked them in Lucila's tiny living room, and then returned to Copacabana to get more of my stuff. By evening, after several trips, I collapsed exhausted onto the sofa, surrounded by my possessions, and cracked open a beer to celebrate my new life. When Lucila came home, she could barely open the door to get inside the apartment.

I smiled and raised my bottle to her in a toast. "I'm here," I said.

As I expected she might, my mother called the condo several times over the next week to find out how Osvaldo and I had enjoyed our trip to Teresópolis. "It's so cool there in the mountains," she said. "I'm envious of you!"

Osvaldo was embarrassed to tell her about my moving out, which he knew would be a scandal for my devoutly Catholic family, so he hedged. "She's in the shower," he told my mother the first time she phoned.

"I think she stepped out to get some groceries," he said the second time, even though my mother was suspicious because I hadn't called her back.

"She must be still at work," he said when my mother called later that night.

"But she's always home from work by now," my mother insisted. "Why is it that she's never there when I call? What are you hiding from me, Osvaldo? What's going on over there? Tell me the truth. You know you can't keep it from me."

"Nothing's going on. Soraya's just very busy. She's even gotten herself a beeper." I had signed up for pager service just a few days earlier, so I would be accessible to my family and to the people at my job while I was in transition to my new life.

But my mother didn't buy Osvaldo's story. "Give me that beeper number. I'll find out what's going on!"

Around midnight, my mother paged me. I had finished the last laser show of the evening and was sitting in a restaurant near the planetarium with Lucila, trying to have a relaxing dinner even though we were both on edge about keeping the secret of my "running away from home." We had different ways of expressing anxiety: Lu was pushing her food around her plate without eating it, and I was devouring mine without speaking. As I glanced down at the number on the beeper, I must have groaned because Lucila immediately guessed, "It's your mother, isn't it?" In fact, we'd been dreading her call for a week.

From a pay phone in the restaurant, I told my mother I was tired and couldn't talk. But she didn't let me off the hook so easily. "You get yourself over here right now and tell me what's going on with you and Osvaldo!" she demanded.

"It's very late, Mama," I said. "I'll call you tomorrow." Before she had a chance to protest, I hung up the phone. Afraid that she'd keep beeping me all night long, I brazenly turned off the pager.

My mother, of course, persisted and eventually found out that I'd left Osvaldo. I was never sure what made her angrier: that I was disgracing my entire family by getting a divorce, or

that I'd left behind the bed she had given me, the silverware from my uncle, the wedding dress that had been my aunt's. Allowing Osvaldo to keep so many valuable things without a fight was, to her, incomprehensible. "It's that girl who encouraged you to leave your husband, isn't it?" my mother screamed at me. "That new friend of yours? You act like you're under her spell!" And for years after, my mom blamed everything on "that girl." Even before I came out to my mother as gay, she wouldn't speak to Lucila and barely acknowledged her existence.

Lucila and I had a rocky time when we first started living together, and there were quite a few fights. We were young and really didn't know each other that well; we had moved in together after only three months. We'd fight about silly things that bothered us and that we'd never known about each other when we were just meeting for afternoons or evenings in motels—like leaving dishes in the sink or forgetting to turn off the lights when we went out. Once, we said such harsh things ("I gave up everything for you and this is how you treat me! You drive me crazy!" "Crazy? You're the crazy one!") that Lucila ended up slamming out of the apartment.

I was immediately sorry, because she was going to work and we wouldn't be able to talk for many hours. I worried that when she came back, she'd still be seething and want to pack her bags.

So I thought about what I could do and ended up falling back on my engineering skills. I wired the front door so that when it opened the stereo would begin playing "Te Amo Espanhola" from Sa e Guarabira, one of Lucila's favorite songs, and the lights in the apartment would dim. The first thing she'd see would be the dinner table set for romance with wine glasses and candles.

That evening, when I heard her keys turning the locks, I hurried to the bedroom and waited for her to come in and get the full effect of what I'd done. On cue, the music began playing and

the lights softened. I heard her say, "Oh!" from the door in a delighted tone unlike the angry one she'd used just hours earlier. Then she said, "Soraya?" and I appeared gingerly from the bedroom.

"You did all this for me?" she asked.

"For us," I replied. "So we could talk." She smiled, and I took her hand and led her into the dining room, where we made up slowly over dinner.

I was learning—how to compromise, how to overlook small annoyances, how to say I'm sorry, how to please my lover and make her happy. In short, how to have a relationship.

My personal life started to calm down, but at the same time my professional life took an unexpectedly bad turn. My boss had rented the laser equipment from an American company for two years, and there were only a few months left before it was due to return to the United States. During that time, I was scheduled to leave Rio and tour the show in other cities—Porto Alegre, Brasilia, Goiania, Salvador, and then a final stint in São Paulo.

I was on the road for several months before the show hit São Paulo, where the director of the planetarium suddenly decided he didn't want to host the laser show after all. "I don't think it's cultural enough," he told Feliu, my boss. "I've heard that it's more like a rock show, and we just don't do that sort of thing here." I pictured him saying it with his nose raised up a couple of inches in the air.

Instead of looking for a final spot to host the show, Feliu decided simply to close down and return the equipment a few months early. He'd made more than enough money from the enterprise and was satisfied with his hefty profits. As for me, the night I gave the final performance to cheers and whoops of delight from the audience, I felt like someone had kicked me in the stomach and then, when I went down, kicked me once again for good measure.

That was a low moment for me. I didn't have any income or any prospects for a job, and Lucila had to support me for a while—

a struggle, since the rent on our apartment was a lot for one person to carry on her own. I tried applying for jobs I saw advertised in the paper, but without an "in," I didn't have much hope of getting anything good via that route.

One of the advertised jobs especially intrigued me. Embratel (Empresa Brasileira de Telecommunicacoes), the state-run telecommunications company, was looking for engineers and computer programmers to train for the launching of Brasilsat-I, the first Latin American communications satellite. The ad used words like "mission," "rocket," and "satellite station." I immediately imagined myself outfitted in a puffy space suit, kissing Lucila goodbye before putting on my helmet to board the Starship Enterprise.

"Pretty cool, huh?" I said when I showed the employment ad I had circled in red to Lucila. She smiled noncommittally, since she knew as well as I did that simply mailing in my resume for such a prime position was like tossing it directly into the trash. Government jobs were the hardest to get in Brazil—everyone wanted them because they paid well and, once you got a civil service slot, you could never be fired.

Needless to say, I heard nothing from my first application to Embratel. But one day, I was moaning to my Aunt Rosita on the phone about my sad state of unemployment. She had asked me how my job search was going, and I gave her an earful. "It's so unfair that you can't get your foot in the door without knowing someone," I complained. "Take this really good job at Embratel— I could do that job, I know I could, and it would be a great opportunity for me. But they won't even call me to take the exams, because I don't know anybody there."

"My upstairs neighbor does something at Embratel," my aunt remembered suddenly. "He's a friend of your uncle. Maybe he could do something for you."

"Oh, I don't know," I said hesitantly. It sounded so casual the way she phrased it, like her neighbor might be head janitor at the space station.

"He's director of something, I'm not sure what," she went on.

"Your uncle would know. It's some big shot job, that's all I know." The words "director" and "big shot" jumped out of the phone line, making my pulse pick up speed.

"I know what," Rosita continued. "Bring me over a copy of your resume. I'll make some excuse to visit upstairs, and I'll give it to him personally."

The guy turned out to be not just "director of something," but a military general at the Satellite System Operations Center at Pedra de Guaratiba outside of Rio. As a personal favor to his downstairs neighbors, my aunt and uncle, the general got me admitted to the Embratel exams.

The *Brasilsat-I* mission was crucial to the expansion of the country's phone service and television reception. Up until that time, Brazil had relied on Intelsat (International Telecommunications Satellite Organization) to take care of its telecommunications needs, but the country's rapid growth necessitated the launching of its own satellite.

It's no surprise, then, that the process of getting a job at Embratel was a rigorous one, more intensive and demanding than when I interviewed at Microsoft ten years later. There were approximately 2,000 job applicants, and all of us had to submit to a barrage of challenging written tests on programming, electronics, COBOL language, and logic. In addition, we had to undergo in-depth psychological testing. I had to stare at a series of Rorschach drawings, tell a humorless government psychologist what I saw in them, and hope that responding, "That looks like a horse" didn't remove me from consideration by somehow suggesting paranoid schizophrenia.

The grueling elimination process took several weeks. Based on our exam scores and our interviews, the initial number of applicants got whittled down to 120, only two of whom were women. Then, little by little, and after more and more testing, our numbers kept getting smaller—60, then 40, and so on, until we reached a core group of 10-five to staff the communications center, and five (including me) to work the space control center.

For the next eighteen months of training, a chauffeured limousine picked me up and drove me to the ground station every morning, which for security reasons, was located in the isolated Guaratiba flatlands, one hour south of Rio. As you approached by car, there was absolutely no one or nothing in sight but the big white building of the station. Like a military fort or a castle, it was surrounded by a thick wall and had a guarded entrance gate.

For eight or more hours a day, the Brazilian government paid me to study everything from telecommunications to satellite technology. Our teachers were engineers from Hughes Aircraft in the United States and Telesat in Canada, the two companies with whom Brazil had contracted for the purchase of the satellite and the overseeing of its launch. Because the satellite cost millions and Brazil was cash poor, the government brokered a clever deal: Canada fronted the money, paid the Americans in dollars, and accepted repayment from Brazil in bananas and papayas. That's a whole lot of fruit, and Brazil is still in debt from the deal, having to pay the satellite off banana by banana.

The procedure for launching a satellite is a little like an extremely complicated and tricky soufflé recipe—there are very specific, predetermined steps, and if they aren't followed, the satellite mission falls flat. Throughout our training then we were carefully scrutinized by our instructors, who needed to determine who was best at which steps, like tracking radio signals, positioning antennas, and computer programming. The Telesat team tested and graded us constantly, creating a performance profile for each one of us.

The single most important person in the Brasilsat mission, we soon learned, would be the technician chosen to fire the apogee motor of the satellite. This action would happen once *Brasilsat* was ejected from Ariane-3, the European rocket set to carry it into space; it was crucial because the freed satellite had to be "geosynchronized"—that is, placed precisely so it would orbit at the exact same speed as the revolution of the Earth. Geosynchronizing would allow *Brasilsat* to stay in a fixed position

over the equator, at an altitude of 36,000 kilometers, and deliver uninterrupted radio signals to stations on the ground. If the technician chosen for firing the motor did anything wrong, the $250 million spent on the satellite plus the $100 million that the ground operation cost would be lost.

Because of this intense responsibility, the technician would be publicly recognized, appearing on TV newscasts and in newspapers around the world. I'd relished the fifteen minutes of fame I'd gotten signing autographs and appearing on television as the Laser Girl, so I immediately decided I had to be picked for that plum assignment.

My instructors quickly recognized my abilities and assigned me to manage the computers. At a u-shaped control table lined with terminals, I ran programs, entered parameters, monitored the computer logs, and crosschecked the positions of all the other satellites in space. I was a good choice for firing the motor—fast reflexes, in case something went wrong and the satellite had to be recovered; excellent computer programming skills; and a good command of English, which I would need to communicate with other ground stations worldwide, who would be following the progress of *Brasilsat*. When our training was nearing completion, the Telesat and Hughes team unanimously recommended me to the higher-ups at Embratel.

What my instructors didn't count on, though, was old-fashioned, unabashed Brazilian machismo.

"You want a woman to fire the motor?" the manager of the satellite station exclaimed.

"She's the best qualified," the chief Canadian instructor replied.

"But it's too important a job. We can't have a woman's picture in all the papers!" the station manager protested. "It's one thing to have her here at the command center, helping out. After all, she's a smart girl, and I've heard good things about her. But having her at the controls, firing the motor on such a historic occasion? My God, I'll be the laughingstock of the country!"

"You want to reject her because she's a woman? Tell me you're

kidding." The instructor squirmed in his seat, and there was a prolonged silence while the station manager tapped his pen on his desk and came up with an alternative plan.

"Now, you know, the general has a nephew, Alexander, who's in the training program, too," he continued. "He's a very bright boy, and I see he's done well on his exams. He would be a much better choice for this job."

In fact, Alexander was good at tracking radio signals, even better than I was. But that wasn't the main qualification for firing the motor, and Alexander didn't have all-around skills. In the first place, he wasn't very proficient with computer software. And more importantly, his English was slow and faltering. In our training classes, which the instructors conducted in English so we'd learn it faster, Alexander was always leaning across the aisle to me and whispering, "What did he say?" in Portuguese.

"We can pick Alexander, if you want," the Canadian said thoughtfully. "But you should keep something in mind. If you don't take our word for it about Soraya and something goes wrong with the launch, the insurance won't cover it and—forgive my language, sir—you'll be in deep shit. To the tune of about three hundred fifty million dollars."

Well, the mention of money was all it took to convince the Embratel honchos that I was the one for the job.

The launch of Ariane-3, the rocket that would carry *Brasilsat-I*, was set for February 8, 1985. The rocket was owned and operated by the European Space Agency (ESA), which had been placing telecommunications satellites into orbit since 1979. Launched from a site at Kourou in Guiana, just north of the equator, Ariane-3 had had tremendous success at geosynchronizing the satellites it brought into space.

Fifteen days before the countdown, the core of technicians controlling the space center of the Guaratiba ground station had to go into Star Trek mode. We left our comfortable apartments in Rio and moved into spartan military barracks set up at one end of the station, little more than a dormitory with bunk beds,

bathrooms, and a mess hall. Fear that a terrorist attack would sabotage our mission meant that there were no phone calls permitted to or from the outside world, no contact with anyone but our colleagues at the station. Our loved ones hated the isolation, but those two weeks were one of the most exciting times of my life. For 24 hours a day, we were locked in, working 12-hour shifts, counting the minutes by military time, living and breathing the launch—much as I imagine astronauts in space must live right before a mission.

Finally, on the 8th, Ariane-3 blasted off the Kourou launch pad with a deafening whoosh at exactly 2022 hrs (8:22 P.M.), carrying *Brasilsat* on board. There was a loud cheer from the command room, as we watched the rocket shoot into the heavens, coloring the evening sky a brilliant, fiery red. Elation was followed by a hush of tension and nail biting, as we waited for the next milestone—the release of *Brasilsat* from the belly of the rocket.

It felt like two or three days at least, but it was actually only about twenty minutes later that Ariane ejected *Brasilsat-I* into space, also without a glitch. There were a few audible sighs of relief, but we all knew we weren't out of the woods yet. The hardest part of our job was yet to come and still about a day away—the firing of the apogee motor that would position Brasilsat correctly above the earth.

Astronomers had plotted the course of the satellite in advance and estimated several windows of opportunity when we could ignite the motor—that is, there were certain times over the next three days when the satellite would be in the right latitude/longitude coordinates for the motor to be fired and the satellite correctly positioned. The Brasilsat motor was equipped with a half-ton of solid fuel, which when fired, would burn for a set amount of time, carrying the satellite forward and then holding it steady at an exact altitude of 36,000 kilometers. Our goal was to activate the motor in the first window.

Needless to say, a nerve-wracking wait followed Ariane's release of *Brasilsat*, as the satellite orbited the earth on an elliptical path and from time to time, when it was too distant, we lost contact

with it. We stayed in touch with satellite stations all around the globe, which delivered reports of sightings. Twenty-seven minutes after Brasilsat was ejected, the Yamaguchi station in Japan was the first to pick up tracking signals from the satellite and to inform us of the satellite's progress. Other reports followed over the next two days: "We've got it on our screens now in Sydney." I'd hear through my headset and then convey the information to my colleagues.

The first window of opportunity was shortly after noon on February 10. As the time approached, I was getting more and more pumped for the actual firing, my adrenaline racing. At exactly 12:34 P.M., as the satellite neared its 36,000-kilometer height, I gave the all-important command for the firing of the motor. With my finger poised over the button, I took a deep breath and pushed down firmly, igniting the solid fuel. At the ground station, we were able to verify right away that the motor had successfully ignited, because of the sudden change in the satellite's speed.

Mission accomplished! By firing the motor within the first window of opportunity, we were ahead of schedule and had actually added a couple of years to the life of the satellite by preserving fuel.

We still had some small maneuvers to perform to place the satellite in its final position. Within the next few days, the satellite reached its permanent mark, latitude 4°5' and longitude 143°44', over the village of São Gabriel da Cachoeira in the Amazon region. From there, the antennae would be lifted, and *Brasilsat* would begin transmitting television and telephony signals to the entire country.

After we secured the satellite's final position, it was time to celebrate and to bask in our triumph. A camera crew from Jornal Nacional, the biggest broadcast news program in the country, was admitted to the satellite station to interview the launch team and report live on the progress of *Brasilsat*. "It was a success!" were the first words the reporter announced to the country.

As a concession to the station manager who had not wanted a woman to fire the apogee motor, the reporter interviewed Alexander, the general's nephew, first, as he monitored signals from the satellite. After Alexander spent a few seconds explaining signals and then drawing a diagram of the satellite's orbit, it was my turn for recognition.

"Now the firing of the motor was the most important moment in this operation since the launch," the reporter noted, moving toward my seat at the central table of computer monitors. "And it was done by this woman here, Soraya Bittencourt, only twenty-four years old, a telecommunications technician with Embratel." He turned to me, holding out the mike, and asked how I actually felt when I fired the motor.

"It's indescribable," I said, then went on to describe it anyway. "First, it's the nervousness of checking the equipment and figuring out if everything is working the way it's supposed to. And then your heart starts pumping harder and faster, until you fire it and you're sure everything went just fine, that we all did a very good job."

Seated at my command post, looking official and impressive, my picture appeared in all the papers. But the reporters always interviewed male technicians and engineers, too, just to let everyone know that the mission hadn't been run entirely by a woman.

The fame I enjoyed right after the launch was short-lived. Two weeks later, no one even remembered that Brazil had launched its first satellite and that we no longer had to rely on Intelsat for phone and television service.

And there was a bigger downside—after the satellite was in position, there wasn't much to do at the ground station. Most of the work I performed over the next few years I worked there was automated. The biggest task I had to do after the launch was to switch the satellite's batteries on during the equinox, when *Brasilsat* passed between the earth and the moon and couldn't get needed energy from its solar panels. There was just no

comparison with the excitement I'd experienced in the months and weeks leading up to the *Brasilsat* mission.

In fact, we all got pretty bored at Guaratiba, and job dissatisfaction was high. Most of the original team of technicians chosen for the satellite mission left for other, better-paying jobs, including Alexander, who went to Intelsat. At Embratel, we were making only $450 a month, while the Canadians and the Americans who had worked side by side with us were getting almost ten times that amount.

That's when I started thinking seriously about emigrating to someplace where my skills would be better appreciated and compensated and where there would be hope of advancement in my career. If I stayed in Brazil, I would never be able to go much further professionally, and I wasn't even twenty-five yet.

Oh, my government job would be secure for life, and the limo would still come for me every day. But as a woman, I'd never get to be manager of the satellite station—a job that I coveted— and pushing the button to launch *Brasilsat* was probably the greatest accomplishment I would ever know. And I'd only managed to achieve that because of outside intervention. What would happen after the fair-minded Canadians and Americans went home? They were the only ones who valued people based on their skills, not on their gender. Maybe, I reasoned, I should move to Canada or the United States.

From my geography lessons in school, however, I remembered that Canada was a bitterly cold place, and I was used to Rio, where "cold weather" means 65 degrees Fahrenheit and the favorite costume of cariocas is a bikini or Speedos. I quickly ruled out Canada and settled on the United States.

With that decision behind me, though, I still faced major obstacles—first of all, how to approach Lucila with the plan. Then, if she agreed to my idea, I would still have to figure out how to legally immigrate and what I would do once I got to my new country.

4

Immigration Plans

"March 13, 1986: Microsoft stock goes public at $21 a share, rising to $28 per share by the end of the first trading day. The initial public offering raises to $61 million."

—Key Events in Microsoft History

Lucila and I shared many of the same goals in life, but immigrating was not one of them.

"That may be a good move for an electronics engineer," Lucila said, when I broached the topic of moving to the U.S. one night while we were eating dinner at a restaurant. I figured she couldn't yell too loudly or make too much of a scene if we were out in public. I was wrong. "You could work for Microsoft or one of those other computer giants. But what would I do there? I don't even speak English! I won't be able to get a real accounting job. I'll have to work as a maid or in the kitchen of some restaurant."

"You can learn English," I said, skipping over her fears about work. "You can take classes, and I'll help you. We'll speak English all the time with each other until you're fluent."

"But I don't know the culture either," she protested. "I don't

even like rock 'n' roll! You're the Beatles fan, not me. You know how I love everything Brazilian." I didn't bother to point out that the Beatles were British, not American.

"We wouldn't have to give up Brazilian culture if we moved," I said.

She raised her eyebrows, knowing very well that just playing some Gilberto or Jobim records in our new home in America wouldn't feel even vaguely like home. "Okay, here's something you won't have such a fast answer for," she said. "What about the weather? I don't want to live someplace that's cold, and America is very cold."

"No, it's not," I contradicted her once again. "Maybe parts are, sure, but we don't have to go where it's cold. Marcel says that New York is pretty temperate all year round. Or better yet, we could go to San Francisco." Even as far away as Rio, we'd heard about the mecca of the gay world.

Still, Lucila wasn't buying my immigration scheme. "Look, Soraya, I just don't want to leave," she said finally. "It's your dream, not mine. Don't try to force it on me."

I didn't have a comeback for that. But my disappointment must have shown clearly on my face. I loved Lucila and didn't want to leave her. And also, I'd thought that I'd be able to get my way. But with something this important, this life-changing, Lucila wasn't going to give in. If I wanted to immigrate, I realized, I was going to do it all alone.

There was a long, awkward silence between us, broken only by the rhythmic clink of our forks against the dishes as we ate. Lucila eventually yielded, but just a fraction. "I'll tell you what," she said slowly. "You go first. You try it out and see if you like it there before we both move. If it works out, then I'll come later."

My face flushed with relief. Of course it would work! Of course I would like it in America! "You promise?" I pursued.

"I promise."

Right away, I began investigating how I could make my dream a reality. Unfortunately, it's not as easy to immigrate to the United States as you might think. You don't just decide, "Oh, I think I'll

move to the U.S. now," and the next week you're gone. It took me two years to actually carry through my plan to leave Brazil for the dream to eventually succeed in America.

The first step was finding out about the U.S. immigration laws. I went to the U.S. Consulate in Rio and asked questions of the personnel, but they weren't very helpful.

"Well," one ineffectual diplomat after another hemmed and hawed, "there's no standard way to immigrate to the U.S. You'll have to do research to see what you qualify for." They pointed me to the consulate's library and to shelf after shelf of musty, leather-bound legal texts that would take weeks to digest. My English may have been better than average, but legalese isn't real English; even most native-born Americans don't understand it. So every week for several months, I sat at a long wooden table in the library, surrounded by other Brazilians hoping to immigrate, and pored over the stuffy tomes.

One by one, my compatriots in the consulate library slowly disappeared as they found a classification that fit them. But one by one, I had to eliminate all the immigration categories that didn't apply to me:

I had no husband or immediate family in the U.S.

I wasn't from a Communist country.

I wasn't being persecuted or tortured by my government (though with the high inflation rate, it felt that way).

Brazil wasn't at war.

And maybe most sadly:

No U.S. company was sponsoring me for a job.

Since I had worked with American and Canadian engineers for several years on the *Brasilsat-I* launch, a company sponsorship should have been my most likely option. But when Embratel signed the satellite deal with Hughes Aircraft and Telesat, the contracts clearly specified that neither of those two companies could hire Embratel employees for a period of ten years after the launch. The Brazilian government did this because it was scared

that foreign companies would try to recruit away the best native-born engineers for jobs in the U.S. and Canada—and they knew many of us would go in a heartbeat. Since I couldn't wait ten years to start my new life, all I got from the Canadians and Americans who trained me for the *Brasilsat* launch and were so impressed with my work were a couple of strong letters of recommendation.

The final path to immigration was to become a student. You can get an F-1, or education, visa if you're registered as a full-time student at an American school. The visa lasts as long as you're enrolled. The second you graduate, you've got to find another way to stay legally in the country—like getting a job and a company sponsorship, for example, or getting married—or risk staying illegally.

Although an F-1 visa seemed to be the only way open to me, I was already as educated as I'd planned to be. I had a B.S. in electronics engineering, an M.S. in telecommunications and computer science that I had earned while working at Embratel, and seven years of practical work experience. Still, I guessed that I could spend time getting a second M.S. if I really had to, though I would probably be bored stiff. I wrote to MIT, but when I finally heard from them after six months, I discovered that their elite graduate engineering program was way beyond my price range, about $7,000 a semester in tuition alone. The same thing was true of other good graduate programs in my field in the U.S.

"You should look into another field, just to get you into the country," Lucila's brother, Zé Luis, suggested. "You play the sax pretty well. How about Berklee College of Music? They accept a lot of foreign students. They call it the 'MIT of music,' but it's a lot cheaper."

The only school by that name that I knew of was Berkeley in California, which was an exciting prospect. San Francisco! Maybe Lucila would change her mind and come with me after all.

But when I looked it up, I discovered that Berklee, as opposed to Berkeley, was actually in Boston, a city I knew very little about. Berklee was one of the premier colleges in the country for studying

contemporary music, especially jazz, and it had an international reputation. American musicians I was familiar with, like Quincy Jones and Branford Marsalis, were Berklee alumni, as were many Brazilian artists. Pat Metheny, the famous jazz guitarist, had taught there.

Now it's true, I didn't have any ambition to be the next John Coltrane. Music was just a hobby with me, although one I was pretty reasonable at. I'd taken up sax as a teenager and still played for fun, sometimes jamming with Lucila's brother.

But if sax was what it would take to get me to America, sax it would be.

Unlike MIT, Berklee College of Music was quick to respond to my letter of inquiry, promptly sending a list of what they required for admission. In addition to transcripts and letters of recommendation, I needed materials that it would take some time to create, like a demo tape showing my performance skills and an original musical composition.

Time was one thing I had plenty of, because I had to save money in order to immigrate. I had to have enough for tuition and books and also for supporting myself while I was studying, since my education visa wouldn't allow me to work legally and I'd probably end up taking odd jobs that paid badly.

In Brazil in the mid-1980s, it was no easy feat to save that much money quickly. By then, we were no longer living under a military dictatorship, but our democratically elected leaders had proven inept at managing our huge national debt, which hovered at around $100 billion. At some points, inflation ran anywhere from 300 to 1,000 percent, and my modest government salary barely stretched to cover my share of rent and food.

For two years, then, I performed financial acrobatics, devising an elaborate scheme for saving every spare cruzado. Every time I got my paycheck, I cashed it immediately at a bank and stuffed the money into my bra. On the walk home, I stayed in the middle of the street so no one could corner me against a building or in a doorway and rob me.

At my apartment, I kept envelopes for all the regular bills that had to be paid—rent, phone, food—and parceled the cash out according to the different categories. Whatever was left over— sometimes as little as $10 or $20—I would take to one of Rio's many luxury hotels, where I'd approach a bell captain or doorman who I suspected had been tipped in dollars by American tourists. "You want to sell any dollars?" I'd ask the guy. If he was willing, we did the transaction in a quiet area of the lobby where no one could see us, almost like I was buying or selling drugs. Lots of Brazilians exchanged currency on the black market, since you could only legally change $1,000 and needed to show your visa and a plane ticket to do so. The hotels were a lot quicker, too, than waiting on long lines at official currency exchange counters—doormen always wanted to get it over with fast because they were on duty. At home, I concealed my precious dollars in various places around the apartment where I thought burglars would never think to look—in cartons of sanitary napkins, for example, and inside cereal boxes—and I changed the hiding place at least once a week.

With Brazil's economy in constant flux, we had numerous tricks for saving money. The cost of grocery items changed daily, sometimes doubling or tripling in one week. To keep food costs down, Lucila and I would hoard money for a few months, then go to a wholesale supermarket and stock up on rice, beans, and other canned and dried goods, buying in bulk and transforming a small room in our apartment that had once been for a middle-class family's maid into a pantry.

Then in February 1986, Brazil's president, José Sarney, instituted a price and salary freeze called the Cruzado Plan, which was supposed to curb inflation and give wage earners some measure of relief. But in fact, all it did was create severe shortages in a country where a very small number of rich industrialists and farmers tightly controlled the production and distribution of just about everything.

For example, here's what happened with meat. The wealthy cattle barons decided to protest the government price freeze by

withholding meat products from the supermarkets and selling them instead on the black market at enormous mark-ups. So, although you couldn't find any beef on the supermarkets' shelves, right outside the stores young kids working directly for the cattle ranchers sold steaks and roasts at costs three or four times the prices the government had established. Needless to say, that turned a lot of people like us into temporary vegetarians.

In the end, though, there was something good that came from all the economic craziness. When the Cruzado Plan went into effect, Lucila finally woke up to reality. Although the whole country believed it would be the solution to control inflation, Lucila with her accounting background was not too sure that the price freeze was going to work. She was thinking that when the plan was lifted, inflation would return and cause an even greater economic hardship. That was why, just months before I was scheduled to leave for Boston, Lucila changed her mind about the United States.

"I want to go with you," she announced. "There's no future for me here."

"Are you sure?"

"Yes, I'm sure." Even as she said it, she looked like she could cry—it broke her heart to make the decision to leave Brazil forever. Lucila was a true nationalist who loved her country. Raised in a family of artists, she had a deep appreciation of Brazilian culture. Still, she feared that the economy would only get worse and that working people like us would bear the brunt of it.

By this time, Berklee College of Music had enthusiastically accepted me as a full-time student. The admissions committee had raved about my demo tape, on which I'd recorded myself and a band playing "Corcovado" by Brazilian artist Tom Jobim and also an original composition for bass, guitar, sax, and piano, which I had named "Breath of Life." I was scheduled to begin classes there in January, 1987.

By early 1986, I had saved about half of the $10,000 I'd set as a goal for myself. I was also planning on selling everything I owned right before I left Brazil—some silver, my clothes, a few

bronze artifacts from Lebanon that had been wedding presents. But I hadn't figured on two of us living on my savings, and if Lucila came along we'd need a lot more money. Besides that problem, however, there was a bigger obstacle—getting Lucila a visa.

We began frantically searching for a university that would accept her as a full-time student—not an easy task, since she had considerably less money than I did and didn't speak any English except for a few words like "chair" and "dog" that she'd picked up in high school. How would she ever survive in an American graduate school? She couldn't even read the applications she needed to file for admission.

With time running out, it became clear that Lucila would have to go a different route to get her F-1, so she enrolled in full-time ESL classes at Smith College in Boston.

When I told my mother I'd decided to immigrate, she clutched her chest dramatically, like she was having a heart attack.

"Are you losing your mind?" she cried. "You don't quit a government job—you die first! How can you ruin your life like this, after all I sacrificed to get you and your sisters a good education?"

"It's a dead end for me in this country," I explained. "There's no advancement for women."

"And what will you do when your savings run out?" she asked. "You won't have working papers, and you'll end up a maid. Remember Carlos Ribeiro, our old neighbor? He's a mathematician, but when he and his family immigrated to America he had to work as a janitor because companies didn't recognize his degree from the University of São Paulo. Americans don't make it easy for foreigners, you know."

"So I'll work as a maid for a while. So what? That won't last forever."

With that, she crossed herself. "Jesus, Mary, and Joseph," she whispered. "My daughter is throwing her life away to work as a maid in America!"

"I'll get my papers eventually," I insisted. "Then I can work as an engineer again."

"Eventually," she said sarcastically.

But when it got closer to the time when we would leave and it was clear that my immigration plans were for real, my mother surprised me by announcing that she and my father were giving me a going-away present—a one-way ticket to New York, where Lucila and I were going to stay at my friend, Marcel, for a couple of weeks before heading off to Boston. Marcel was an actor I'd known in Rio who'd fallen in love with an American woman and moved to New York. My mom was crying when she told me about the ticket, and I started to sniffle, too.

"Since you've made up your mind and you're really going through with this," she said, "I want to help you."

"That's really sweet of you," I said, touched because I knew how much she disapproved and also how little money my family had to spare. "I won't disappoint you, you'll see."

"I know," my mother said quietly. It was a big deal for her to admit it. "I don't know how you do it, Soraya, but you always land on your feet."

Lucila's parents also presented her with a plane ticket, but they had less money to spare than mine did and could only afford a one-way from Rio to Miami. We would have to pay for the connecting flight to Kennedy Airport.

Lucila was grateful for the gift but scared, too. "You'll be in New York, and I'll be in Miami!" she said, panicking. "How will I read the signs? How will I find my luggage? How will I know where to get my flight? What if I have to go to the bathroom? I'll be lost, and all I'll be able to say is 'dog' and 'chair.' That'll be a big help."

"I'll think of something," I said, trying to calm her. Since I'd planned every detail of our immigration so carefully, I wasn't going to let this one glitch get the best of us.

After a lot of thought, I decided to come up with a variety of questions and phrases that Lucila might need to use in the Miami and New York airports. I wrote the questions in Portuguese on

index cards with the English translations underneath—kind of like her own personalized Berlitz flash cards. In the days before we were due to leave, I drilled her mercilessly on the questions and their correct English pronunciations. Her lessons happened right before we went to sleep, because I hoped the phrases might sear their way into her head unconsciously overnight.

"Quanto custa?" I began.

"How much doze eet cost?" she translated, stifling a yawn. "Eu gostaria de comprar um bilhete para viajar para Nova Iorque."

"I would like to buy a teecket to New York."

"Muito obrigado."

"Tank you very much." She frowned. "And what if I'm talking to a woman?"

"It doesn't matter in English," I replied. "Aonde esta a minha bagagem?"

That one stumped her, so I started mouthing the words. She smiled and said slowly, "Ware ees my luggage?"

"Good! Por favor, aonde é o banheiro?"

"Escuse, ware ees the bathroom?"

"No, it's excuse me, where is the bathroom?"

"Escuse me, ware ees the bathroom?"

"No, don't accent it like that! It goes like this—Excuse me, where is the bathroom?"

And so it went through a dozen or more phrases until poor Lucila was so tired she fell asleep sitting up in bed with the lights still on. I rifled through the cards anxiously, making sure I'd come up with every phrase that a tourist might need to say in a strange airport while waiting for a connecting flight. The last wrinkle in our plans had been ironed out—or so I imagined at the time.

Lucila and I left Rio right after Christmas, 1986, on different flights on different days and to different cities. We were both just shy of twenty-seven years old, and it was the biggest adventure of our young lives. Boarding the plane for New York overwhelmed

me with excitement and sadness, because I was gaining something and losing something at the same time. When I waved goodbye to my parents and sisters at the gate, my eyes clouded over with unexpected tears. I realized I had no idea when I would see them again, or if I ever would.

When I think about it now, we were like all the other immigrants who have come to this country over the years, looking for something better—the Irish who emptied out of their country after the potato famine, the Eastern European Jews who fled the pogroms, the Cubans who made the dangerous boat trip to Miami after Castro's takeover.

We sold everything we owned, including our clothes and my saxophone. What little was left we rolled up and stuffed into backpacks, the kind that weigh campers down on long hikes. We also brought along one bedsheet apiece; a blanket; a knife, fork, and spoon; a towel; a pillow; several pairs of canvas sneakers; and about ten sets of eyeglasses, which we'd heard were very expensive in America. We had no books, no music, nothing that would weigh us down any more than we needed to be.

With me, too, was $10,000 in cash—our security blanket for the next year. But that was way too much to carry in my bra—I'd have looked like Mae West. I had to devise a way to carry it on me safely and without customs finding it, since I was only legally allowed to bring $1,000 out of Brazil. Where would someone never look for money?

A plan occurred to me on a day when I was, of all things, having menstrual cramps. I was buying Midol tablets at a drugstore and came across a display of Always sanitary napkins, the kind that come in individual plastic sleeves. Those sleeves are supposed to be for modesty, but everybody knows what's inside them. Cooking up a scheme on the spot, I snatched a box off the shelf and bought it.

At home, I meticulously slit each sanitary pad open, removing most of the cotton batting. Then I stuffed the casings full of bills, glued the pads back together, and returned them to their plastic sleeves. My clever ruse worked. When the customs agent opened

my shoulder bag at Kennedy, he quickly closed it again, embarrassed at finding all those sanitary pads. To the agent and anyone else who wanted a peek inside my bag, I was a woman having a very heavy period.

While my trip to New York was smooth and uneventful, however, poor Lucila was having a more difficult time in Miami. I'd been careful to prepare her questions, but we both completely forgot that she might not understand the answers.

So when she arrived in Miami alone at 2 A.M. and asked a porter in her rehearsed English, "Ware ees my luggage?" and he replied, "Downstairs in baggage claim," she drew a blank.

"Downsteers?" she repeated. "Wot ees baggage clem?"

"Over there, over there!" he said hurriedly. She followed the direction of his hand, which was indicating an overhead sign with English words and an arrow pointing down. When she recognized some of the other passengers from her plane heading in the direction of the arrow, too, she followed them and located her backpack in Baggage Claim B.

But there was still another obstacle to overcome—buying her ticket to New York. "I would like to buy a teecket to New York."

"Roundtrip or one way?"

Luckily, I'd taught her the difference between the two. "One way just," she replied.

But when the ticket clerk said, "That'll be a hundred and sixty dollars, miss," which was not the price we had anticipated and so not the one listed on her flash card, Lucila panicked. She decided to repeat her demand, hoping the right answer would come out of the guy's mouth eventually. "I would like to buy a teecket to New York." This made her seem like a crazy person instead of just a woman who didn't know English, and the people behind her in line began to grumble.

The clerk replied with annoyance, "Like I said, miss—that's a hundred and sixty dollars." Lucila continued to stare helplessly at him, then down at her cards, and the clerk finally understood the problem. He scribbled "160" on a piece of paper and handed

it across the counter to Lucila, who by now was sweating and having heart palpitations. "A hundred and sixty," he said patiently, pointing to the number.

"Oh, okay!" she said, counting out the correct amount of dollars. The clerk wrote down the gate number for her on her ticket envelope and pointed her toward it.

Lucila arrived in New York a day and a half after I did, although she started out a day ahead of me. She was tired and tense from her experiences in the Miami airport and at JFK, where she had to get a taxi to Marcel's apartment in Queens. Fortunately, she had his address written on a piece of paper that she simply handed to the cabbie before collapsing exhausted in the back seat. Marcel had warned her the trip should cost no more than seventeen dollars, so there were no surprises about the fare.

She'd been traveling for 24 hours straight, so we rested on her entire first day in New York. But over the next couple of days we were real tourists, taking in St. Patrick's Cathedral, Radio City Music Hall, Forty-second Street, the New York Public Library, and the Empire State Building, where the wait to get to the viewing deck lasted about an hour.

Of course, we expected the weather in New York in late December to be a big change from Rio, where summer sizzled 365 days a year. When we'd left home just days before, Rio had been enjoying a tropical 110 degrees. But we had no idea what extreme cold would actually feel like, and we'd never seen snow. Those few days we spent in New York, we learned everything about northern winters firsthand. The temperature in the city plunged to-5, and snow blanketed the sidewalks, drenching the canvas sneakers we'd brought from home. Our lightweight jackets wouldn't do, and we had to buy secondhand winter coats at Canal Jeans.

But what mattered was that we had made it safely to our new country. We played like kids that first week, pummeling each other with snowballs and relishing our carefree time before the reality of being new immigrants set in. And then we got to see much more snow on our five-hour train ride to Boston the next week.

PART II

Boston, 1987-1993

5

Uncle Sam's Land

"September 8, 1987: Microsoft ships its first CD-ROM
application, Microsoft Bookshelf, a collection of ten of
the most popular and useful reference works on a single
CD-ROM disk."

—Key Events in Microsoft History

The view from the train window kept getting whiter and whiter
as we traveled north through Westchester County, Connecticut,
Rhode Island, and finally into Massachusetts. Lucila and I had
plenty of books and magazines for the long trip. In *Forbes*, I read
with envy about the day Bill Gates became a billionaire, the first
ever in the personal computer industry. We munched on the
sandwiches and chips we'd brought with us so we wouldn't have
to buy expensive train food, and we watched the wintry landscape
rush by. At some point we fell asleep, with me leaning against
the window and Lucila leaning against me. The conductor's
distinctive accent was what finally jerked us awake: "Next and
last stop—South Station, Bahston!"

Suddenly we were at the end of our journey, in a city where
we knew no one, where I could speak the language but Lucila

had to rely on me to get around. In the train station, I stopped three different people to ask where the lockers were, because we wanted to stash our luggage before setting out on foot into the city. My question got first a blank stare, next a shrug, and finally an "I dunno," in that order, so I gave up and we wandered around and located the lockers ourselves.

"They're as rude as New Yorkers!" Lucila observed about the first Bostonians we encountered. We were accustomed to the graciousness of Brazilians, who go out of their way to lend a hand to friends and strangers alike.

There had been no way to arrange for our housing in advance while we were still in Rio. Berklee advised its incoming students to visit Boston and secure housing at least a month before the semester started, but that, of course, had been impossible for us. So from the moment we set foot in Boston we were homeless, and our first order of business was finding a place to live.

Marcel had contacted Amy, who was an old college friend of his wife and who lived in Boston. Amy agreed to give us a crash introduction to the city and to let us sleep on her floor for a couple of days while her roommate was out of town. That meant we had only forty-eight hours to hunt down an apartment and no idea how to do that in a strange town.

Amy suggested that we start at Berklee, since all colleges had housing offices to help students. She jotted down a list of what neighborhoods to steer clear of, either because they were dangerous or too far away from Berklee, and she also outlined the rudiments of getting around on the T, Boston's public transit system. I was hesitant, however, to spend money on tokens. At that moment, though, when we were facing the prospect of having to spring for a hotel room in two days or be out on the street in the frigid weather, I decided it was more important to save time taking the T than to walk all that way to spare a couple of dollars.

Lucila stayed at Amy's apartment resting and guarding our money, because we hadn't yet been able to open a bank account, and I took the Green Line to Berklee, pressed up against other people in the packed commuter car and worried all the way that

I'd miss my stop. When I heard the conductor call out "Prudential Center," the stop before mine, I eased myself toward the door so I could jump out at Symphony.

In my hand, I clutched a map of the Berklee campus that I'd torn out of the course catalog the admissions office had sent me. Luckily the school was small and contained within a few buildings, so the Housing Office was easy to find on my own. There were two women working there, but when I entered the room neither of them looked up, even though the door closed behind me with a loud click and I cleared my throat to let them know I was there. The younger of the two picked up the phone and started dialing before I could speak.

"Excuse me," I said to the other office worker, a dour gray-haired woman who looked like she'd worked there all her life. She kept her head down in her paperwork. When there was no acknowledgment from her, I waited a few moments more. "Excuse me," I repeated. "I need some help."

The woman finally glanced in my direction and said gruffly, as if I'd bothered her at home on her day off, "Don't we all? Hold your horses." She had as strong an accent as the conductor on the train from New York, and "horses" came out "hahses."

I waited again, trying to be patient as precious minutes ticked away on the wall clock. When she finished with the forms she was pushing around her desk, she looked up at me as if I'd just then entered the room. "Yes?"

"I'm Soraya Bittencourt, and I'm starting classes here this semester," I explained. "Jazz saxophone. I just arrived here from Brazil." I paused in case she wanted to jump in and offer a word of welcome. But she only stared at me in unsympathetic silence.

"I need to find an apartment, and I thought you might have some suggestions," I finished.

"You don't have an apartment yet?" she asked incredulously. "You're in big trouble! Y'know, classes start next week."

"I know that," I said, remaining cool but beginning to feel testy. "Like I said, I just got here from Brazil and . . ."

"You should've arranged for housing a lot earlier than this,"

she went on, frowning. "Our catalog clearly advises students to visit Boston at least a month in advance and get their housing all taken care of. You can't come the week before classes start and expect to find a decent place to live."

"I understand, but I was in Brazil . . ."

"I can't tell you how many times this happens," she said disgustedly. "You young people get here late from wherever you're from and expect this office to do all the work for you. Like this is a real estate agency or something! Like I have that much time on my hands!"

"I know this isn't . . ."

"Look, our listings are over there," she continued, motioning toward a large bulletin board covered sloppily with index cards and scraps of paper torn out of notebooks. "There's one section for available apartments and one for people looking for roommates. You can post something saying that you need a place, but you'll never find anything that way." I thought I saw the corners of her mouth turn up a little, like she was enjoying my dilemma. "And that's about all I can do for you. I'm not responsible if you don't find anything. If there's nothing on the board for you—and at this late date, there probably isn't—you'll have to try the *Globe* or the *Herald*." And then she sat down smugly, seemingly content that she'd "helped."

Just as she had made clear, the listings on the bulletin board weren't of any use. Most were from the fall semester and had never been taken down. A few new listings were probably still available, but one was in Cambridge and the other in Jamaica Plain, both of which Amy had advised against because of their distance from Berklee. In desperation, I scribbled down my own listing on a corner of my Berklee campus map, tore it off, and tacked it onto the board with a pushpin. Glancing over my shoulder first, I moved around a few outdated listings to make room for mine:

> URGENT!—2 female students new from Brazil need apartment near school. Neat, quiet, hard workers, speaking English. Soraya, Box 540, Berklee.

But no sooner had I hung up my notice than the grumpy woman called over to me loudly, "You can't just tack something up there. You have to have your listing approved first."

Frustrated and pretty sure that no one would call me anyway, I ripped down the listing and left the office in a huff, feeling even more homeless than I had when I walked in.

By scouring the *Boston Globe*, Lucila and I managed to find a studio that had seen better days at the corner of Worthington Street and Huntington Avenue. It was one unfurnished room, kind of dark and in need of a paint job, whose best feature was that it was close to Berklee, just two T stops away. On days when there wasn't a blinding snowstorm, I could easily walk to my classes, saving money on transportation. Subtracting what we needed for tuition and for food from the money we'd brought with us, we had enough to pay for three months' rent (at $440 a month, a lot in those days) plus a one-month security deposit. And three months, I figured, would give us plenty of time to find jobs.

"We'll take it!" I told the landlady, Mrs. Conlan. I was sad that we could only afford one room but glad we wouldn't be homeless after all.

"I'll need a month's rent in advance and a security deposit," she said. "And, of course, you'll have to have a co-signer on the lease."

I was just about to hand over an envelope full of cash, a copy of my acceptance notice from Berklee, and a letter of reference from Marcel. But the word "co-signer" stopped me cold.

"What does this mean, a co-signer?"

"I can't rent to students without a co-signer," Mrs. Conlan said, raising an eyebrow at us suspiciously. "You need someone who can guarantee the rent in case you can't make your payments."

"Oh, don't worry, we'll make the payments," I reassured her, smiling and holding out the money and documents.

"That's not good enough," she insisted, her arms folded in front of her. "I rented to students once before, and after two months they stopped paying rent 'cause they spent all their money on,

well, God-knows-what. I had all these legal hassles trying to evict them. It was a nightmare, and I lost a lot of money. So now I always ask for a co-signer."

Lucila didn't understand what Mrs. Conlan was saying, but she could tell something was wrong by the crease in my forehead. "What's going on?" she asked, and I told her in Portuguese that I'd explain later.

"But we're new to the city and . . ." I started to tell the landlady.

"That's even worse!" she continued. "How do I know how long you'll stay?"

"We left Brazil for good," I said. "We even gave up our apartment there. I'm enrolled at Berklee studying sax. We definitely plan to stay." But she had probably heard similar stories before, and she shook her head.

"Okay," I bartered, "what if I give you three months rent in advance, plus the security?"

"No can do," the landlady said firmly, navigating us out of the studio that had been so close to being ours. The drab room now seemed like a palace.

"Please . . ." I begged. We were both exhausted and beaten down from a full day of running around the city, hunting down apartments that were either too expensive, too run-down, too far away from school, or already rented by the time we arrived. "We need this place."

"Okay, look," the landlady said as she locked the front door of the apartment behind us. My heart picked up a beat, as I expected her to drop the co-signer requirement out of kindness. "I'll tell you what. You seem like nice girls. I'll hold the place for you for twenty-four hours. You get a co-signer, and the place is yours."

Though I'm sure she thought she was being generous, the landlady's offer wasn't any more helpful than asking us to turn over a year's rent in advance.

To clear our heads, Lucila and I started walking aimlessly around the neighborhood, trying to come up with a plan. We

passed the Museum of Fine Arts twice, made the circle of the Berklee campus three times. We couldn't rely on our families or on Marcel, since they were all in Brazil. Where were we going to find a co-signer nearby who could guarantee that much money in rent?

In desperation, Lucila called her father in Salvador for ideas. She had a vague memory of hearing about a cousin who had emigrated to the U.S. and lived somewhere in New England. Luckily, Lucila's father confirmed that Cousin Pedro lived in Springfield, Massachusetts, about 90 miles from Boston, and that he had made a small fortune there as a physician.

"Call him up," Lucila's father suggested. "From what I hear, he can help you."

"But I've never even met him," Lucila said.

"It doesn't matter," her father insisted. "Family helps family."

Our experience with Pedro explains a lot about Brazilians and their generous nature. When Lucila called her cousin, detailing how she was related to him and how desperate our situation was, Pedro was big-hearted and gracious, even though she was a virtual stranger to him.

"Of course I'll help you, Cousin!" he said. "Come to Springfield, meet my wife Karen and my kids, and bring the lease with you."

I immediately called Mrs. Conlan, told her we had found our co-signer, and asked for a day's grace so we could go to Springfield and get his signature. She hesitated for a moment but gave in when I hurriedly told her that Pedro was a wealthy doctor. "Okay, you've got one day more," she said. "But that's it."

The bus trip across Massachusetts was bumpy and uncomfortable, and Lucila worried the entire way. "We shouldn't act like we're lovers," she decided. "The last thing we need is for him to call off the co-signing because he disapproves of our relationship. If that happens, we'll lose the apartment, and all our savings will go on hotel rooms until we find a place. And who knows? Maybe every landlady in the city will want a co-signer!"

I agreed. "Then let's just say we're good friends."

Pedro and Karen, greeted us warmly in their spacious home in the suburbs of Springfield. We brought our resumes with us to vouch for our reliability, and Pedro was impressed by our accomplishments.

"Embratel!" he said, nodding his approval of my background. "Someday when you have more time, you'll have to come back for a visit and tell me all about the satellite launch, Soraya."

He signed the lease at once.

"It's a wonderful thing for you two girls to be such good friends and be able to share expenses," his wife gushed, hugging Lucila and then me as we were leaving for the bus station. "You're both very lucky." We smiled ear-to-ear with relief—we were lucky, now that the first big hurdle in America was behind us.

You'll notice that I said housing was the first big hurdle we had to jump in this country. The second followed close behind—money.

After I paid the first semester's tuition for me and for Lucila, we had savings left over for food and other essentials. But that money was limited and because we worried constantly about running out, we attempted to spend almost nothing. That meant a lot of scrimping on meals, a lot of walking instead of riding the T. Lucila had brought a diary from Brazil and in it she wrote down every purchase we made, every dime we spent at the supermarket or drugstore. "That way we won't buy anything frivolous," she reasoned.

But as our money dwindled, "frivolous" for us began to mean anything that wasn't on sale. Shopping for food was a particular challenge as we tried to plan meals around what was reduced in price that week. "Tomato soup is on sale," I announced as I scanned the supermarket flyer for deals.

"Again?" Lucila groaned, as she pushed the cart through the aisles.

One day we stopped at the Osco Drug in our neighborhood to take advantage of a special on aspirin and tampons, and my eyes caught sight of a display at the checkout counter—decks of

playing cards for only 75¢. They weren't the expensive Bicycle brand, but some cheaper kind with a picture of a little girl and a lamb on them. I picked a deck up gingerly and sighed, coveting it like a stereo system or a color TV.

"Forget it," Lucila said, taking the deck gently out of my hand and replacing it on the counter. "That's your lunch allowance." Every afternoon, I ordered a glazed donut and a cup of coffee from the Dunkin' Donuts near school, and that was all I ate until I got home in the evening. It was just the right amount of sugar and caffeine to keep me going throughout the day.

"But all we do is go to school and sleep," I said. "We need some entertainment or we'll go crazy!"

Lucila heard the tension splitting my voice, so she quietly took a dollar out of her wallet and handed it to me. At home, she jotted the purchase down in her notebook.

That evening we played back-to-back games of gin rummy with our new cards, betting extravagant items we couldn't afford. "Whoever loses this hand," Lucila said gleefully, "has to buy the winner a VCR!" It was the most fun we'd had in weeks. Later, we curled up on the floor in our sleeping bags, zipping them together so we'd be warmer and closer. When we fell asleep out of sheer exhaustion, we could forget for a few peaceful hours how hard the floor was, how we'd each lost twenty pounds since we'd left Rio, how far we were from our families, and how much we hated tomato soup.

When we were still living in Rio, everyone we knew had a story of some friend or family member who had immigrated to the U.S. and quickly gotten a job cleaning homes or taking care of someone's kids, and for decent pay. The reality of job hunting for us, however, was different—very slow and very anxiety-producing. Every cleaning job I saw advertised in the Boston newspapers wanted applicants to have something called a social security.

"What's a social security?" Lucila asked when I read her the listings of jobs.

"I don't know. It doesn't make any sense. I thought 'social'

meant going to a party or something like that, and 'security' means safety or protection. It has to be some kind of document, but whatever it is, we don't have it."

When I figured out that I wasn't going to get a job through the paper, I started asking students in my classes—many of whom were also recent immigrants—about work. But most of them were scrambling to make money, too, and if they knew of available work, they must have kept the information to themselves. Occasionally, I checked out the job postings on a bulletin board outside the financial aid office at Berklee, but that was about as helpful as trying to find an apartment through the college housing office. One afternoon I was scanning the listings and noticed that the cafeteria was looking for part-time dishwashers and kitchen help. I pulled the ad off the board and shoved it into my pocket.

"Hey there, Soraya. You looking for work?"

It was an American guy in my jazz composition class named Dave, whom I'd talked to briefly a few times. When he found out I was from Brazil, he made a point of letting me know what a big fan he was of composer Tom Jobim. I was pretty sure he was trying to flirt with me, but it really didn't bother me too much because I wanted to make friends.

"Yeah, I need work bad. Do you know of anything?" I asked hopefully. "Lucila's looking, too, and we're getting desperate."

"Who's Lucila?"

"My girlfriend. We came here together from Rio. We've got a place over on Worthington Street."

He nodded slowly, like he was processing the information, trying to decide what kind of "girlfriends" immigrate to a new country together.

"Listen," he said, "I asked if you were looking for work because I do hear about jobs sometimes. You're into computers, right? Well, my friend Ted's got a successful business and he may have something for you."

"Yeah?" I was too excited to ask what Ted's business was or what the "something" might be.

"If you want, I'll invite him over to my place tonight, and you

and Lucila can drop in and talk to him. Very casual. Just to let him know you're looking."

I accepted Dave's invitation eagerly. Even if we didn't get jobs out of it, I thought that he was probably a good contact for us because he seemed to know a lot of people.

When I told Lucila about Dave and Ted, she was immediately skeptical. "What would this Ted guy hire us to do?"

"He's got some kind of successful business," I explained, simply repeating what Dave had told me. "You know, maybe he needs data entry or bookkeeping."

"I wish you'd found out more about him. It sounds funny, Soraya . . ."

"No, Dave's a really nice guy," I interrupted. "He wants to help us. He's the first person besides your cousin Pedro who's really tried to help us."

We took the T to Dave's apartment in Kenmore Square, right near Boston College, that night. The freezing air made the skin on my face hurt as we walked the short blocks from the station to Dave's building. "Wow, you girls look cold!" Dave said when he opened the door to us. "Come on in and I'll get you a drink. That'll take the chill off."

Ted was already there, sprawled on the couch and enjoying a glass of something amber. He was forty-ish, well dressed, not bad looking, except for some pock marks across his cheeks. He had a big gold wedding band on his left hand. "Ted Wilson," he introduced himself. We gave our names all around, and Lucila and I accepted glasses of red wine from Dave, which did warm us up a lot.

"I'm glad you came," Ted said. "I mean, you could freeze your fucking tits off out there tonight."

I stared at him, beginning to get a little worried. It was odd for a guy to be so crude when he'd just met us. But then, I knew I had a lot to learn about Americans.

"Hey, watch your language, Ted," Dave chided him. "Soraya and Lucila are nice girls."

"Lucila doesn't speak much English," I said, because I could

tell she was trying to follow what we were saying and couldn't. "So maybe you could tell me something about your business, Ted. Dave says you might need some help."

Dave and Ted exchanged a slow glance. "Well, the fact is, Ted and I have a proposition for both of you. Together," Dave said. He paused and took a swig of his drink. "We'd like to . . . What we had in mind was actually fun, not work, but we're willing to pay you for it. I rented some movies to relax us all a little, and then I thought Ted and I might . . . that we all could, you know, get it on . . ."

I knew enough American slang to get his point and even if I hadn't, the titles on the video boxes on the coffee table—*Co-ed Lesbians and Sorority Sluts*—made his intention crystal clear. I put down my wine glass and grabbed Lucila's hand, speaking to her softly in Portuguese. That was against the rules we'd set up for ourselves when we got to this country—we tried to speak to each other only in English, so Lucila could learn the language more quickly. But I needed her to understand exactly what the problem was, and fast.

"What!" Lucila cried out in Portuguese, then to Dave, "Pig!"

We ran down the staircase and all the way to the T station, where we collapsed on a bench and waited for our train to come. "I don't want you to ask anyone ever again about jobs!" Lucila said breathlessly. She was still speaking in Portuguese, a sure sign that she was upset.

"But then we'll never get one," I protested. "That's how these things work. And if we don't get jobs pretty soon, we'll use up all our savings."

"Okay," she said, giving in, "but next time, you make sure you know what the job is first."

That experience began to sour me on our new life. I was tired of counting pennies, and I knew something had to happen soon, since we had already emptied out quite a few of our Always maxipads. Several times, Lucila had to wake me up in the middle of the night because I was thrashing and moaning in my sleep:

"Please don't throw us out of the apartment!" or "No, don't take all my money!"

Usually, the first luxury we gave up was riding the T. But there were a lot of days when it snowed or sleeted and neither of us could face getting wet and cold on our way to school. So we splurged on public transportation.

There was one morning in particular when everyone in Boston seemed to be piled onto our train, all nudging each other for a couple of inches of space. All the faces around us were sad, tired, resigned.

"Okay, everybody move it on back!" A policeman with a fat stomach and a billy club got into the car and started navigating all the passengers to the back. Lucila and I were near the door and didn't want to move, because it was hard to maneuver my sax case and our stop was next. "Move to the back, I told you! Yeah—you!" the cop said, giving me a rough shove.

"Hey, you don't have to push!" I spoke up, stopping myself from adding "you fat slob." He was waving around that stick like he wouldn't mind using it on someone. So I leaned into Lucila and whispered in Portuguese, "What a rude guy! Just because he's a cop he thinks he can push people around." The cop continued to glare at me like I was a criminal in the making.

At Symphony Station, we disengaged ourselves from the mob and hopped off the train. "This afternoon, I'm walking home, no matter what the weather's like," I told Lucila. "I can't face that crowd one more time today."

We were walking together toward our classes when I felt someone close behind us, closer than I liked anyone to get on the street. If we had stopped abruptly, the person would have tripped over us. I was worried that the mean cop had followed us and was going to give us a hard time, ask to see our visas, maybe rough me up.

But when I stole a glance over my shoulder, I saw it was a young guy I had noticed on the T. I distinctly remembered him because he'd poked me with his elbow and apologized in thickly accented English. He was slim and nicely dressed and looked as

if he might be gay. I relaxed immediately, but then I felt his finger tapping my shoulder.

"Excuse me, please," he said, and Lucila and I both turned.

"Excuse me, are you two Brazilian?"

"Yes."

"From where?"

"Rio."

"No kidding!" he shouted, breaking out into a big smile. "I'm from Rio, too! My name's Rubinho."

Lucila rolled her eyes at me, code for "Get rid of him." She was wary of strange guys talking to us, even if they were Brazilian, ever since the Dave-and-Ted incident.

But Rubinho seemed nice enough to me, I was picking up gay vibes from him, and I was always trying to connect with other immigrants who might know about work. So I introduced the two of us and then said to Lucila, "Aren't you late for class, Lu? Why don't you go and I'll talk to Rubinho for a few minutes."

She wasn't happy; the firm set of her mouth said, Remember Dave and Ted? But it was broad daylight, we were standing in the middle of the sidewalk right near Berklee, and she must have figured that I couldn't get into too much trouble if she left me alone with him. So she hurried off to class.

"How long have you been here?" I asked Rubinho.

"Six years," he replied. "I live right around the corner. Would you like to have a cup of tea at my place?"

Uh-oh, I thought, wondering if maybe my gaydar was on the blink. "I have classes in a few minutes," I said—which I did, but I still wanted to be cautious. "I study saxophone at Berklee, and Lucila's taking English lessons. We've only been here a couple of months."

"Maybe another time, then," he said with a sigh. "I couldn't help overhearing you speaking Portuguese on the train, and it was so nice, so—well, it was like a little bit of home."

I relented. "Well, maybe we could meet up after my classes early this evening. I'm done at six."

Rubinho shook his head. "I have to work this evening. I

clean a shopping mall two nights a week—the Boston Design Center."

Bells went off in my head. "You have a cleaning job? Do you know of any others? I've been looking for work, but it's so hard to find anything."

"Well, I could use some help tonight," he said, after a moment's thought. "I'm short a helper. It's from seven to midnight, four dollars an hour, and you've got to pay your own transportation."

In my head, I did the math quickly and realized how little money it was. But I knew it might lead to other things if I worked hard and made a good impression, so I jumped at the chance. "Count me in!"

That first gig with Rubinho was my salvation. Initially I did not feel too good about it, an engineer working as a maid, but I have to say that it gave me a new understanding of life. I started valuing things I never did before and realizing that no matter how small a job is, doing it right makes a world of difference. As it turned out, Rubinho had a lot of contacts, and when he saw how thorough and fast I was, he started recommending me to clean houses, shops, offices—any job that he himself didn't have time to take on. My time was so booked with cleaning jobs that it was only a month before I could afford to treat Lucila and me to a rare expenditure: Instead of playing cards every night, we were able to listen to the radio on our own boom box.

It took longer for Lucila to find work, since she spoke and understood very little English. We continued to use only English when we spoke to each other at home, but sometimes Lucila had to act words out, like we were playing charades.

And her problem became a vicious circle. Out of pride and independence, Lucila didn't want to rely on the money I'd saved. "I don't want to be so dependent on you," she insisted. "I'm already relying on you too much because you have to speak for me and interpret what other people say." The $2300 she'd brought from Brazil was dwindling because she was paying for expensive ESL lessons at Smith College. Yet she needed to improve her language skills, or she wouldn't find work.

We had to get creative.

Berklee offered a free ESL class for all its foreign students. I didn't really need it, because I'd been speaking English fluently for years and had easily passed the required TOEFL exam. But I was hatching a plan, and I went to the class anyway. After it was over, I chatted up the teacher, a young woman named Wendy who I discovered had lived in Brazil for five years and spoke Portuguese very well. We hit it off immediately.

"You know, you don't really need this class, Soraya," Wendy told me, after we'd stood outside the classroom talking for almost half an hour about Rio. "You're way ahead of the other students, and it's just a waste of your time. But, of course, you're welcome to come."

"Well, I wanted to talk to you about that," I began. I told her about Lucila and how she was spending all her money on language classes, how she couldn't get work because she knew too little English. "I was wondering . . . I thought maybe . . ."

"Why don't you have her come to class in your place?" Wendy suggested, guessing my question.

So Lucila stopped paying for ESL lessons and starting going to classes at Berklee three times a week. Wendy was a good teacher, and Lu's English gradually started improving, so much so that Rubinho suggested a job at the South Boston restaurant where his boyfriend, Fernando, worked.

"They're looking for a dishwasher," Rubinho told me. "Can she do that?"

"Of course, she can do that," I said, slightly insulted. "She's an accountant! And besides, she loves being in the kitchen."

Lucila's comprehension and speaking had become so much stronger that she was able to call the restaurant and schedule her own interview. Even though the job was low-paying and menial, she was excited that it meant she'd be bringing in money, too.

But when she got home from the interview, she looked like a flat tire.

"What happened?"

"They hired a dishwasher this morning," she replied. "I went all the way out there for nothing."

"Well, did they have any other jobs?"

"I didn't ask," she said, dejected.

"Call them back," I instructed, putting the phone receiver into her hand. "Tell them you know how to cook and that you love it. Tell them you really like their restaurant. Tell them you'll work part-time. Tell them anything. I'll stand right here, and if they say something you don't understand, I'll explain it."

Persistence paid off. Because Fernando had recommended her and because she seemed so eager, the restaurant manager hired her to work as a kitchen helper. What that title meant was a lot of potato peeling, a lot of vegetable chopping, and a lot of hard, monotonous grunt work that no one else wanted to do. She peeled so many potatoes during her first few weeks that her hands started to change shape from gripping the peeler so tightly for hours.

"These aren't mine!" she cried one night, showing me her stiff, arthritic-looking hands. "These are my grandmother's hands! I've got an old lady's hands, and I'm only twenty-six."

"They're beautiful hands," I tried to assure her, bending over to kiss them gently.

"And my ankles have gotten thick," she said, pulling her hands away so she could massage her sore ankles, which were swollen because she stood on her feet hour after hour, day after day. "I'm scared, Soraya. I'm scared of not being the girl you fell in love with anymore."

"You'll always be that girl," I assured her, "and I'll always love you."

Lucila was such a good worker that after a couple of weeks she graduated to assembling sandwiches and after two months more, she became a baker. At the same time that her situation at work was improving, her English, too, got better and better as she added kitchen terms to her limited vocabulary and picked up American slang from her co-workers. I began to catch her singing along with the boom box: "Oh-h-h oh, what's love got to do with eet, got to do with eet?"

But the best part was that now we were both bringing in paychecks, so we were able to take care of our bills, buy some luxuries like a black-and-white TV, and stop worrying about having to go back to Brazil penniless and disgraced. Finally, it seemed like we were on our way, though at that time, we still didn't know where.

6

Bossa Nova and Computers

"June 5, 1989: Microsoft forms the Multimedia Division, dedicated to the development and marketing of multimedia software and consumer products."

—Key Events in Microsoft History

When I immigrated to this country, my career as an engineer got put on a back burner. I missed working with computers a lot, the way an artist would miss her paintbrushes if they were taken away. In the evenings I went to my job as a maid and felt sorry for myself, thinking about how no one who saw me cleaning would ever believe that I'd once played a leading role in the launch of Brazil's first telecommunications satellite, or that my picture had been splashed across newspapers all over my country. That Soraya Bittencourt seemed like a different person, and I wondered when she and I would cross paths again.

In the meantime, I tried very hard to make music work as my substitute career. Unfortunately, life at Berklee was harder than I imagined it would be. On my first day in saxophone class, the professor laughed out loud at the way I held my instrument. "You don't even know how to hold a saxophone!" he snorted. "How

the hell did you ever get accepted to Berklee?" You will have to work very hard to get even closer in proficiency to the other students. Are you sure you want to do that? It means at least six hours of solid training besides your daily class schedule."

"I am sure I can make it. Just give me a chance." I replied confident, even though inside I was feeling really scared of not making it.

An additional frustration for me at school was trying to get into some good ensembles, where I could hone my skills on the sax. Like everyone says, "Musicians are ninety-eight percent perspiration and just two percent of talent".

The college sponsored a wide variety of small bands and choirs, which specialized in everything from jazz to country to fusion to improvisation. I needed to get enough ensemble experience under my belt to qualify for the scholarships that Berklee offered, because without a scholarship, my savings were going to run out pretty quickly.

You had to audition to get into the ensembles. Most of the instrumental groups were all male and determined to stay that way, although no one in them would ever openly admit it. I found that especially true with the jazz ensembles, since jazz had always been (and still is) very male concentrated. "We're looking for a different . . . sound," was the excuse I heard again and again when I auditioned, as did other women trying unsuccessfully to break into jazz. For me, music was proving to be a lot like the field of engineering in Brazil.

What seemed like an answer to my need for performance experience came from Wendy, Lucila's ESL instructor, who had also become our good friend and our housemate in Somerville, where we moved to a duplex apartment in late 1987. Our studio on Worthington Street had been broken into several times, and being safe had come to mean more to Lucila and me than the convenience of being close to school.

In addition to teaching English, Wendy was a folk singer, and she had landed gigs in bars and restaurants in the suburban areas north of Boston, in New Hampshire, and in Maine. "Why

don't we join forces?" she suggested. "Restaurant owners love girl duos and bands. You'll get experience and make money, too."

I knew Wendy liked to play a lot of Joni Mitchell and James Taylor, and that wasn't my primary interest. But when she agreed to a new show that featured both folk and bossa nova, I came on board. Wendy would play guitar and sing the lead vocals. Because sax didn't work for folk music, I would play percussion and sing back-up, occasionally throwing in a solo sax number.

We called ourselves Brazilian Beat. Through Wendy's contacts on the performance circuit, we got a lot of weekend bookings out of town. My favorite gig was the True Blue Café in Portsmouth, New Hampshire, a quaint old seacoast restaurant. The café was a cozy place right on the water, and the audience there really listened to the music instead of eating and talking over it. It also wasn't smoky, like some of the nightclubs we played, where the thickness of the air made it hard to sing.

What I liked best about playing with Wendy was getting an appreciative audience that we could interact with, taking requests, telling them stories about the start of bossa nova in Brazil. The applause was nice, too; it reminded me of the positive experience I'd had as the Laser Girl at the planetarium back in Rio.

At the same time, I slowly began to realize that I wasn't cut out for the life of an artist. It was draining to drive to our gigs, sometimes ninety minutes away, perform two fifty-minute sets, then turn around and drive back home, often arriving after Lucila was asleep. Needless to say, we didn't see each other much on weekends.

But mostly, there was just too much uncertainty in that kind of life. Some weeks, Wendy and I had several gigs and pulled in as much as $100 a show. Then other weeks were completely dry. It depended on the season and on the whim of the bar and restaurant managers. How did struggling musicians deal with it? I couldn't stand the prospect of not knowing if I would be able to meet my monthly bills.

The final nail in the coffin of my musical career, however, was when I was unable to get a scholarship from Berklee after over a year of performing with Wendy. The clubs where we played ran ads in local newspapers to draw in customers, and reviewers came to see us, too. I clipped everything for my scholarship applications, which I dutifully filled out every semester. But even though I accumulated more real performing experience than many other students and garnered a lot of glowing reviews, too, I still couldn't get a scholarship.

So, as I had feared, my savings evaporated, and I made the decision to give up music and drop out of school.

I got back into computers through a stroke of luck and my own sense of timing. Dyna-Maids, the cleaning company I worked for in the evenings, dispatched me to a firm that set up insurance and pension plans for other businesses. After I'd spent a month there, coming in to clean two evenings a week, Gerry, the firm's owner, liked my work so much he proposed that I leave Dyna-Maids and join his small staff full-time.

"You think you could run errands, too?" he asked. All he saw when he looked at me was a cleaning woman with a foreign accent.

"You mean the post office and the bank and things like that?"

"Yeah, things like that."

"Sure," I replied. "I think I can handle it."

It meant a little more money for me, though still no medical or vacation benefits. The big attraction was that I knew the job would get easier over time, since I'd be able to keep on top of the cleaning. So I accepted Gerry's offer.

There were days when it was hard to keep my hands off the office computers. My fingers itched when I noticed a staff member struggling with the system, swearing, and then calling in an outside technician to help. But I couldn't let anyone know about my expertise, because I still didn't have my green card and didn't want to jeopardize my application for working papers, which were close to coming through but still in process.

More than once, Bert, a young man in the office who regularly annoyed me by asking me to "fetch" his lunch, turned around in his seat and caught me standing behind him, staring at the computer screen with a curious look that he misinterpreted. It wasn't that I didn't know what he was doing; I just couldn't believe how badly he was doing it.

"You got computers like this down there in Brazil?" he asked me jovially. "You interested in seeing how one of these babies works?"

"Oh no, not me," I said, backing off and playing the role of unskilled immigrant laborer so well, I could have won an Academy Award.

But then one day, I just couldn't stand by and pretend. I was cleaning the office refrigerator, inspecting old takeout containers and getting rid of the smelliest ones, when I heard Bert cry out, "Shit! Double shit!" from the main office.

The computer network had gone down in the middle of a flurry of printing out insurance plans for one of Boston's largest banks. It was a job Gerry had prided himself on getting, and the entire staff had been racing to meet that day's 5 P.M. deadline. The reputation of the company as one that could deliver to the big boys was on the line.

"Get Matt in here!" Gerry screamed, referring to the freelance computer tech they relied on. "Right now!"

"He's out on a job," his secretary Nancy replied.

"Then beep him, for chrissake!" I'd never seen Gerry so agitated. He paced back and forth in front of the secretary's desk, his neck turning bright red.

"I did, I did," she said. "He's not answering the beep."

"I'm fucked," Gerry said under his breath. Then he turned his rage on Bert. "What did you do to it, for chrissake?"

"Nothing, I swear," Bert said, beginning to sweat. "It just froze on me."

It looked like Gerry might have a heart attack in the middle of the office. The secretary finally reached the computer tech, but he was tied up until later in the day. Even if Matt got there

sooner, it would take him several hours to assess the problem and fix it. There was no way he could repair the system so that the staff could meet the 5 P.M. deadline for the bank.

I was the last person Gerry wanted to talk to just then, but my technical skills far outreached Gerry's and Bert's, and I knew I could fix the problem. From Bert's description of the problem, I suspected there might be too much traffic for the printers on their computer network.

"Uh . . . Gerry?" I said, tapping him on the shoulder.

His words swatted at me like I was an annoying fly. "Not now," he snapped. "Can't you see we're having an emergency here? Talk to Nancy about whatever it is you need."

"No, Gerry, see, I can help with the problem. There's something about me you don't know," I continued, even though I wasn't sure he heard me. Bert did, and made a wisecrack.

"Yeah, I bet you can fix everything," he quipped. But I ignored him and continued trying to explain myself to Gerry.

"I worked as an engineer in Brazil," I said calmly. "I can't work in my field here because I don't have my papers yet. But believe me, I know computers. I can fix the network for you. Trust me."

"Fix the network" were the three magic words that made Gerry take notice. "Is this some kind of joke?" he said with a cautious look. "Did Bert put you up to this? Because if he did . . ."

"No, sir," I replied. "Look, things can't get worse than they are, right? So why don't you give me a chance? If I don't fix the network in an hour, Matt will come here later and do it, but you'll miss the deadline. If you take a chance on me right now, I might get everything back up in time to do all the printouts for the bank by five."

"By five" caught his attention, too. Still, he stood there staring down at his feet, afraid to commit.

"Gerry, you're not seriously . . ." Bert started, but the boss cut him off.

"Okay, Soraya, go for it," Gerry said. "Everyone, listen up— if Soraya needs something from you, you give it to her,

understand? I want your complete cooperation on this." He directed his next words to Bert. "And that goes double for you."

Heads began to nod slowly, but the entire staff was dumbstruck. The pressure had made Gerry go crazy and he'd entrusted his company's reputation to the cleaning woman!

"Let me know the minute you're done," Gerry said to me. Then he went into his office and closed the door. I wondered if he was in there praying.

The problem was a relatively simple one, and I did get the system back up in just under an hour by resetting the printer queue, restarting the service on the network, and printing the files again. From inside his office, Gerry heard the familiar sound of printers at work. "I cannot believe what just happened here," he said, with a smile in my direction that filled his whole face. "I had absolutely no idea."

"Thanks for trusting me," I said. Then I didn't know what to do for an encore, so I quietly went back to cleaning out the refrigerator.

At the end of the day, when a messenger was on his way to the bank with the insurance plan printouts, Gerry hunted me down in the supply room, where I was putting boxes of pens and paper clips in neat order.

"Soraya, I want to thank you again," he said, shaking his head as if he still didn't believe what had happened. "You saved my skin."

"It wasn't too serious," I replied. "But you should keep Bert away from the system." We both laughed.

"I want you to consider changing jobs," he went on, and for just a split-second I thought he was firing me because I'd admitted I didn't have my green card yet. But instead he made me another offer. "I'd like you to become our in-house computer technician. You'll be responsible for machine maintenance, upgrading software, backing up the system, that kind of thing." He named a figure, which was an increase in my salary but just a pittance of what I deserved to make as an engineer. He said he still couldn't give me benefits, because of the "situation" with my working papers.

"Wait . . . you want me to do all that and clean, too?" I asked, confused.

"No, no, no," he said. "No more cleaning."

Those were the three magic words for me.

When I accepted the tech job, Gerry once again needed someone to clean the office and run errands. "You got any other friends from Brazil who need work?" he asked me.

That's how Lucila got out of the restaurant business. It was a good thing, too, because standing on her feet all day, pounding and shaping dough, was killing her. At Gerry's company, she'd be able to sit down part of the time, and the work wouldn't be as grueling.

I couldn't have anticipated, though, that one of the women in the office, Nancy, would take a dislike to Lucila. I had always steered clear of Nancy because she was a smart-mouthed, bossy woman with a tendency to criticize other staffers. For reasons I couldn't understand, Nancy liked to bicker. And when she saw how easily she could rile up Lucila, she singled her out for abuse.

Lucila managed to put up with Nancy for about six months, complaining only to me about her. But then one morning when Boston was completely snow-bound, the two of them got into a serious argument. Lucila called in sick because her knee was bothering her and it would be hard to get to the office on city streets piled high with snowdrifts.

"Oh, please," Nancy snickered. "Tell me another one, Lucila."

"It's true," Lucila protested. "My right knee is bad from all the standing I used to have to do in the restaurant. It's killing me this morning."

"Look," Nancy said, "I don't want to hear any of your excuses. If I can get to work, so can you."

"I'm not lying to you," Lucila said, getting testy. "If you called in sick, I wouldn't give you a hard time."

"The difference is, I'm your supervisor," Nancy pointed out. "Now get yourself in here. I want to see you here by ten, or I'm reporting you to Gerry."

So, because she was above all a conscientious employee, Lucila got herself to the office, limping badly on her aching knee. By the time she made it to work, she could hardly walk.

"My God, Lucila, your knee really is bad," Nancy said, amazed at the sight on Lucila limping. "You should have never come in! Go home and rest."

"But you're the one who told me to come in!" Lucila shouted. "You said if I didn't you'd report me to Gerry!"

"I had no idea your knee was so bad," Nancy said, unapologetic for not believing Lucila on the phone.

"You're crazy!" Lucila said. "If I go home now, I'm never coming back."

"What did you say?" Nancy asked, stiffening.

"You heard me fine."

"Well, now you hear me—I'm the only thing standing between you and unemployment, so you should thank your lucky stars you have this job."

"You should thank your lucky stars you have an accountant working in your crappy office for so little money," Lucila challenged her. "Or should I say, had an accountant. I quit." Then she quickly pulled her personal items out of her desk and shoved them into her bag. Lucila told me later that the look of surprise on Nancy's face was priceless, well worth the cost of quitting her job.

By the time Lucila quit working for Gerry, I had already moved on, too. Not because Nancy or Bert or anyone else treated me badly. It was just that I was tired of working in such a small place where there wasn't a lot for me to do and I didn't have enough work to fill up my hours. Within just a few months, I had organized the entire office top to bottom, updated all their software, and set up a computer system that would get tasks done more efficiently and automatically. After that, I was bored.

But I still didn't have my green card and couldn't look for a full-time position in my field. I knew that Matt, who had done the technical work for Gerry's company before I was hired to do it

full-time, operated on a freelance basis, so I called him up to ask him just how he did it. Although he was now so busy he worked for himself, Matt had gotten his start through an employment agency called CompuTemps, which provided computer-savvy temporary staff to businesses and corporations. What a lot of companies were starting to need, Matt told me, were people who could handle desktop projects on the Mac.

I'd never used a Mac, and the only thing I knew about desktop publishing was that it was a hot, hot field that had recently exploded in the business world. "Take some classes at a technical college," Matt suggested, when I admitted my lack of knowledge. But I figured if I could teach myself to build a slide projector from scratch when I was a kid, if I was able to program the 8080 microchip by studying a manual, and if I could learn to fire the apogee motor so *Brasilsat* was perfectly positioned, I could become proficient on the Mac, too.

One weekend, I went on a shopping spree at the Harvard Bookstore, gutting the store's computer section of instruction books on PageMaker, FreeHand, Adobe Illustrator, PowerPoint, Photoshop, and Microsoft Word—all the programs I needed to master in order to market myself as a desktop pro. "I guess you're into computers," the guy at the checkout counter quipped.

Often when I wasn't busy at Gerry's, I got out one of the desktop manuals and studied. At night, I poured over them instead of listening to the radio or watching TV. But it was clear that I needed hands-on experience, too, which I couldn't get on Gerry's IBMs or at home, where we still couldn't afford a computer. It was one thing to read how to position a drop cap and to crop photos and another to actually be able to do it.

Luckily, stores like Kinko's that rented out computer time for desktop publishing were just starting to crop up. For about $10 an hour, I was able to try out my skills and gauge how fast I was. After a few weeks of practice, I knew I was quick enough on many of the programs to pass proficiency tests, so I gave Gerry my notice and applied for a job with CompuTemps.

"You learned all these programs on your own?" the CompuTemps interviewer asked me. "You didn't take any classes?"

"No, I'm self-taught," I said proudly.

"These are very sophisticated programs," she insisted. "I just don't see how . . ."

"Why don't you let me show you what I can do?" I suggested. "You have tests, don't you?"

She ushered me to a state-of-the-art Mac, probably figuring that I would fumble all their tests for knowledge, accuracy, and speed. Maybe she'd had experience with other "self-taught" people who just hadn't bothered to polish their skills on an actual computer. But whatever she was thinking when I first sat down at the Mac, the results of my tests flabbergasted her, her boss, and her boss's boss, and they hired me on the spot.

I soon rose to top star in the CompuTemps sky, assigned to a long-term temp job with a busy marketing firm called Eastern Exclusives, which put together annual reports and presentations for major corporations and needed speedy, efficient desktop publishing help.

Even though I liked the people at Eastern Exclusives, even though it was a big step over cleaning offices, and even though I was once again working with computers, it was a fairly low-level job that was below the capabilities I'd shown as an engineer and a manager in Brazil. So I was thrilled when I got a call at work one afternoon from out of the blue.

"Is this the Soraya Bittencourt who worked for Embratel?"

"Who wants to know?" I asked. My working papers had still not come through, and I was terrified of a call from the INS, telling me I was being sent back to Rio.

"And who was a special student at the MIT Media Labs?" A few months earlier, I'd enrolled in and completed an MIT course for advanced students and people who were already working in the field of computers and media. I'd heard that American employers didn't take applicants with degrees from foreign universities seriously, and I figured that if I didn't get at least a

few credits from a good U.S. school on my resume, I might never get back into my field.

"Who is this?" I demanded.

The man introduced himself as Michael Lynch and quickly rattled off the name of his company, a string of connected names that sounded like a law firm or a brokerage. "We're headhunters," he continued, when there was no click of recognition from me.

The term was unfamiliar; it still seemed possible that Lynch might be a federal agent. "I don't know who you are," I said, in an icy tone, "or what you want."

"I work for a firm that finds management staff for technology companies," he went on, with a hint of exasperation. "Call it a high-level employment agency. You don't have headhunters in Brazil?"

We didn't. I explained that in Brazil, good job openings are so few and the people qualified to fill them so many, that it's a buyer's market. There's no need for any employer to purposely go out and search for the best candidates, the way it's done in America.

"I can find my own job," I said. "I really can't afford to pay someone to do it for me." In fact, I'd already started scanning the want ads for possibilities.

"No, no, the company will pay me if I get someone for the job," he laughed. "Right now, I'm trying to find a junior-level engineer for Number Nine Corporation, which is an on-the-move company in Lexington. Are you interested in interviewing with them?"

I had eight years of engineering experience, which I mentioned to him politely. "I'm not exactly 'junior level,'" I said.

"But you're experience is all in Brazil, not here," Lynch stated, as if that summed up everything. And it did, in a way—it pointed out a bias against professionals who were educated and trained in South America.

"The truth is," Lynch advised me, "you're going to have to start all over and work yourself up from the bottom rungs of the ladder."

Well, I certainly knew about the bottom rungs, because I'd been hanging onto them ever since I'd arrived in the U.S. So I took the job at Number Nine, the first step on a long climb up.

I was sorry to hear that Number Nine (later renamed Number Nine Visual Technology) went out of business late in 2000, because it was a nice company of just a few dozen employees, and I liked working there. Soon after I started working there, my green card finally came through, so I will always have a soft spot in my heart for the company.

Number Nine made its name as the developer of high-end PC graphics cards, which at that time sold for up to $5,000 apiece and were used primarily for computer-aided design and manufacturing applications (CAD/CAM). Engineers use CAD to make two-and three-dimensional drawings for products like cars and airplanes. CAM is software that helps establish which tools are best for cutting the materials the different parts of these products are made from, like metal and plastic. Macs had been dominating this niche market, but companies like Number Nine were making PCs more competitive by providing the same quality visuals that Macs delivered.

One of my first jobs for the company was creating a demo to take to trade shows, which would indicate to potential customers just how these graphics cards worked. I also had to travel to the conventions, including COMDEX, the largest computer trade show in the world.

It was during one of these shows that my life changed dramatically once again, and in a way I could have never expected. In the summer of 1989, SIGGRAPH, the international computer graphics conference was scheduled to take place in Boston. I was busy trying to finish the demo so I could install it on the computers in our company's exhibit. It was a very hot and humid summer, and I was working 12-hour days and weekends to get ready for the conference. After work, I'd spend another hour a day working out at the gym. I was exhausted all the time.

"I'm worried about you, you don't look good," Lucila said to

me as I set out for the show. "You sleep enough, but you're always tired, and you've lost weight, too. I can see it in your face. I think maybe you should see a doctor."

"I don't need a doctor," I said, brushing off her concerns. "It's just hectic right now because of SIGGRAPH. After the show, I can take a break. You'll see." Lucila didn't bring up that I was always thirsty, too, although she'd commented on it before. I chalked that up to the excessively hot weather. I had a good excuse for everything.

On the second day of the show, I finally finished installing the demo. Everything was working, and I was free to go to a SIGGRAPH seminar I had very much wanted to attend. But I was dead tired and decided to skip the seminar, go home, and relax, like Lucila had been begging me to.

When I arrived at our place in Somerville, I collapsed. I didn't even make it to the bed. Coming up our front stairs, I had a hard time breathing, and, because I was wearing shorts, I could see that my legs had a bluish cast to them. I sat down at my desk to try to regroup, but within seconds I had slumped over, fast asleep, onto a stack of books.

And that's exactly how Lucila found me hours later when she got home from work. "Wake up, Soraya! Oh God, please wake up!" She shook me repeatedly and frantically until she finally roused me out of my stupor.

"Now you're going to see a doctor," she announced.

"We don't have a doctor," I pointed out.

That didn't deter her. She drove me to a small, nearby community hospital. In retrospect, it wasn't the best choice, but all she could think about was that it was the closest medical facility to our apartment. The doctor there asked for my symptoms—even though I could barely breathe and my legs were turning purple by then—examined me, and ordered a chest x-ray, which turned up clear.

"There's absolutely nothing wrong with you," the doctor pronounced. "You can go home."

"You're not going to do a blood test?" Lucila asked.

"No call for it," he said with authority.

"But what about my symptoms?" I wanted to know. It was hard to believe that such serious physical symptoms meant nothing.

"I'm guessing that they're psychosomatic," he said. "Go home, get some rest, and you'll probably feel fine in a couple of hours."

I did as directed, but later that evening, I felt even worse. I could hardly walk, and it was becoming harder and harder to breathe. So Lucila brought me back to the hospital, where the doctor who'd examined me before was exasperated by me.

"There are people here who are really sick, and who need attention," he scolded me. "I told you there's nothing wrong with you. Now go home."

I stayed home from work the next day. Maybe lying in bed, I thought, would ease the pain in my legs.

"I can't leave you like this," Lucila said. "You can't even walk! If something happens to you, I'll never forgive myself."

"I'll call you if I get worse," I promised, sending her off to her job.

But by the time she'd gotten to her desk, her phone was ringing off the hook. I felt like I was going to black out—not like a simple faint, which I'd done a few times in my life, but like losing all control and consciousness.

"I'll come right home," Lucila said.

"No, call an ambulance," I begged her. If I died, I didn't want her to feel guilty for going to work.

But Lucila rushed home anyway. By the time she got to me, I couldn't walk at all, and she had to carry me to the car, crying, "Please hang on, please hang on." She strapped me into the passenger seat, opened the window wide, and stuck my head out, hoping that the wind would revive me. A friend of ours had recommended a good hospital in the Longwood area, which is where all of Boston's best medical facilities are. Lucila drove to Beth Israel like she was in the stock-car race, gunning the car through yellow lights and yelling out the window at pedestrians who got in the way. I couldn't even ask her to calm down, because I was too weak to say anything.

Parking at the emergency room door, Lucila tore inside and got some of the ER staff to bring me into the hospital in a wheelchair. While they were finding an available bed for me, Lucila waited in the lobby, filling out the paperwork and answering questions about my allergies, my habits, my lifestyle, because at that point I couldn't speak for myself anymore.

As soon as I was lying down, a nurse took my blood, and from the color of it alone, she guessed what the problem was. "She's going into a diabetic coma," she instructed the other staff in an urgent tone that made me realize how close to dying I had actually come. "Get a doctor right away!" Then, while one nurse hooked me up to an IV, another ran an oxygen tube into my throat. Not long after, I completely blacked out.

What happened during the next five or six hours I know only through Lucila. Dr. Jarman came and spoke to her in the waiting room, asking what her relationship was to me.

"You brought Soraya Bittencourt in, is that right?" she asked.

Lucila's heart was racing, as she feared that the doctor had come to tell her I was dead. "That's right," she replied in a shaky voice.

"What's your relationship to her?"

"I'm her partner," Lucila answered. But this was 1989, and the term for same-sex spouses wasn't as commonly understood among straight people as it is today.

The doctor looked at her quizzically. "Her partner . . . in what?"

"In life," Lucila said. And, even though at that time we didn't have health-care proxies to document our relationship, the doctor didn't hesitate to go on and explain my condition.

"This is the situation," Dr. Jarman continued. "Soraya has what's called diabetic ketoacidosis, which occurs when the body can't convert glucose into energy and starts to break down stored fat. The next few hours are going to be critical. Her system is completely out of balance, and her body is literally starving because she's lost so many nutrients. We're moving her to the

ICU so we can stabilize her blood sugar and replace those lost nutrients."

"What is the ICU?" Lucila asked, wide-eyed.

"The intensive care unit," the doctor explained.

Lucila took a deep breath and voiced her worst fear. "Do you think she could die?"

The doctor shook her head firmly. "No, I'm happy to say, she'll pull through this," she replied. "I don't often get to tell people that, but in this case, we got to her in time to save her life. The truth is, if you'd brought her in 15 minutes later, it would have been too late. Luckily, we'll be able to bring her out of this. But it will take time, and she's going to have to learn how to take care of herself."

"Can I see her?" Lucila said, blinking back tears.

"Just for a minute," Dr. Jarman said. "Then we've got to start her treatment. You can either wait here or come back in about five hours, and then you'll be able to see her for a longer time."

Lucila peeked in at me, terrified at the sight of me in an oxygen mask, looking so fragile. But she was also encouraged by the doctor's strong assurances that I'd get better. It was scary, too, to have the orderly push past her roughly, saying, "Out of the way, miss, out of the way," as he hurriedly wheeled me on a gurney down the long, white hallway toward the elevators. Lucila told me afterward that she had never felt so alone.

For the next few hours, Lucila sat anxiously in the waiting room, drinking cup after cup of strong coffee, thumbing through old magazines, making small talk with strangers, and trying to remain calm. She also made several unsuccessful attempts to call my family in Brazil by using our AT&T calling card. When she couldn't get through, she thought at first that I'd missed a payment on our phone bill because I'd been so busy and getting sick. But when she contacted AT&T customer service, she found out that because of extensive fraud with phone card calls to Brazil at that time, AT&T was not letting anyone charge calls to Brazil from public phones.

So Lucila had to wait until much later, when she got home, to

call her mother and relieve some of the pressure she'd been bottling up for hours.

When I came to, it seemed to me that a miracle had happened, that I'd been given another chance. It was like I'd seen a car heading straight for me, and then watched it swerve away just before crashing into me.

I left the hospital after a very long, very scary week. Before my release, Lucila and I both had a thorough orientation on what it was actually like to live with Type I diabetes. There was a completely new diet to consider—no more of the sweets I loved so much, like chocolate and ice cream. I couldn't even suck a regular cough drop if I had a cold. I could never skip a meal, the way I'd often done when I was busy at work. We had to keep precise schedules so that I knew when and what to eat, when to exercise, and most importantly, when to inject insulin.

The injections that I had to give myself several times a day to regulate my blood sugar were critical. And they were tricky, too. Today, there are convenient pens that diabetics use to inject precise amounts of insulin. But in 1989, I had to measure insulin from a bottle into a syringe, then inject it under my skin.

It was hard to get the hang of it, but Lucila and I both learned the procedure. We also learned the warning signs that my system was out of whack, which came in the form of mood swings. If my blood sugar was too high, I would suddenly get irritated with everyone around me for no reason at all. If it was too low, I got depressed and lost all my energy. I couldn't think logically, and sometimes, when my blood sugar plummeted, I was in serious danger of passing out.

And there have been many times when I did just that—in the office during a meeting; in my car, driving home. EMS has saved my life more than once, and I was on a first-name basis with just about all the paramedics in Boston and the other cities where I lived.

Although I've become accustomed to dealing with my illness over the years, it's still a shadow over my life, and it continues to

traumatize Lucila. When she went to Brazil for two weeks in the spring of 2000 to visit her family, she called me every single morning from Rio, just to make sure I woke up.

Despite many precautions, I had a serious incident while Lucila was away. At work, I took my insulin in the late morning but then was held up from eating lunch by an unexpectedly long meeting. My blood sugar did a nosedive, and I passed out in the meeting. Although I'd warned several co-workers that, if I passed out, they should get a vial of glucose from my bag and empty it into my mouth, they panicked and called EMS instead. To make matters worse, one of the paramedics missed my vein when he tried to inject glucose, and blood spurted all over him, all over my shirt, and all over the floor.

A second attempt succeeded, and, as always, I slowly came back to normal—physically, at least. Emotionally, I had never felt worse. I told everyone at work not to worry, that I was fine, but I stayed in the office bathroom for a long time, sobbing and trying to clean the blood off my shirt. I kept hearing Dr. Jarman's haunting words when she signed my release from Beth Israel Hospital in Boston.

"Diabetes is a silent killer," she said. "It can kill you very, very slowly."

7

Jeans to Suits

"July 25, 1990: Kicking off its 15th anniversary celebration, Microsoft becomes the first personal computer software company to exceed $1 billion in sales in a single year, with revenues of $1.18 billion."

—Key Events in Microsoft History

I had been at Number Nine about a year when Paul, my boss and the Director of Software Engineering, unexpectedly quit, sending the company into a tailspin. We had all liked Paul, but we realized after he was gone what a poor manager he'd been.

The graphics card that Number Nine produced contained an operating system based on a language called DSP (digital signal processor). Each member of Paul's team, including me, knew one piece of the language. So, for example, one engineer might know the drawing commands for creating 2D files, while another knew all the commands for 3D, and yet another specialized in the AutoCAD commands (a computer-assisted drafting application that is still popular today). But only Paul knew the language in totality.

We all assumed that Paul had documentation for the operating

system stored somewhere in the files. But we assumed wrong, and when he left, the engineering team scrambled to understand the total picture. The president was in a panic. "I'm not sure what we're going to do while we're trying to fill Paul's job," he told the engineering team in an emergency staff meeting. "And I'm not sure who's going to want to inherit the mess Paul left behind. But I'm asking for your help and your patience while I try to come up with a solution." All of us team members looked at each other nervously around the conference table. I expected someone to confidently raise a hand and volunteer to step in as Acting Director, maybe one of the guys who'd been there a long time. But everyone was strangely quiet. That's when I began hatching a plan so that I could rise out of my junior engineer position.

When I was growing up in Rio, my mother had a favorite maxim: "Opportunity only knocks once." But I realized as an adult that, when you think about it, that saying isn't true. Opportunity can knock again and again in a person's life. It's being able to recognize opportunity and seize it that's important. I knew Paul's resignation was my chance to advance at Number Nine to a position that would fully utilize my skills and knowledge, instead of simply doing all the work that no one else wanted to do. And there was no way I was going to let that particular knock go unanswered.

One by one over the next few days, I slowly and tactfully approached the other engineers on the team.

"If you were in charge of hiring the next Director of Software Engineering," I asked each person, "what would you look for?"

"A good listener," was one answer. "Paul was always saying, 'Yeah, yeah,' when I went to him with an idea, but I could tell he wasn't listening to a thing I said."

"Somebody really well organized," was another reply. "Paul was so scattered, and now we're paying for it."

"The manager should help everyone feel like a valuable part of the team," was a third response. "With Paul, we were all working separately and we didn't have a sense of cohesion."

With each colleague, I shared my thoughts on how a manager should work with a team. I explained to each of them how, as a very young manager at Souza Cruz, the tobacco company in Brazil, I'd successfully supervised a team of engineers, many of whom were twice my age. And I offered a lot of other examples, like the time the computer system at Gerry's office went down and I was cool and calm enough to step in and manage the situation.

"I know I can move this company forward and get this department back into shape," I assured my co-workers, "but I'll need your complete support."

By the end of the week, I'd convinced the team that I was smart enough and prepared enough to take over Paul's job. Then I was ready to see the president with my proposal: that I become Acting Director during the time he was conducting a search for Paul's replacement. If at the end of the three months the engineering team was happy and hadn't missed any product deadlines, I would be rewarded with Paul's job. If I didn't do what I promised, I'd go back to being a junior engineer with no hard feelings.

The president thought about it and talked to some of my colleagues before calling me back into his office the following day. As I sat down across from where he sat at his desk and waited for the verdict, my stomach was fluttering. If he said no, I'd be devastated, since I knew I could do the job better than Paul had. But if he said yes, I'd be facing an enormous clean-up job that no one else on the engineering team had wanted. Still, I trusted myself, and, as it turned out, the president did, too.

"Three months," he reminded me, as he promoted me to Acting Director.

I had to hustle to prove myself. The first thing I did in my new position was to make sure each of my engineers knew as much as possible about the operating system and not just one tiny piece of it. We couldn't afford the time or money involved in hiring a writer to try to document the operating system, so I paired engineers and had them teach each other what they knew. That meant that the engineer who worked in 3D would teach it to the

one who knew 2D, and vice versa. In that way, we spread knowledge of the system around the department until more people understood it completely.

After team members became proficient in the entire system, I restructured the department and gave everyone different jobs. I knew from experience that intelligent employees can easily tire of what they're doing. Too often, companies don't encourage learning and innovation among employees because they don't view it as efficient. Instead, if an employee is doing a good job in one area of work—like managing trade show demos as I'd been doing, for example—management tends to leave her in that job indefinitely. But it's actually a very inefficient way to run a business, because pretty soon, the bored engineer is taking calls from headhunters. Because I couldn't afford to lose any engineers while I was trying to establish myself as head of the department, I determined to give my team plenty of chances to learn and grow in the company.

I also had to deal with the team's lingering memories about the indifferent way that Paul had dealt with their ideas and concerns and to show that I was a different kind of manager. So I started having weekly staff meetings, where the engineers could bring to the conference table all the problems they were having and discuss them in an open forum designed to find solutions.

When my three-month probation was up, the engineering team was happier than it had ever been, on schedule for production, and well on its way to being more tightly structured. I'd kept my end of the bargain, so the president kept his, too, and promoted me to Director of Software Engineering.

As full-time boss, I was able to restructure and revamp and reshuffle to my heart's content. In addition, I was learning something new every day, including how to develop a high-resolution graphics card that used multimedia, the hot new item in computer technology in the late 1980s.

But after six months of heading the software team, the new learning experiences for me at Number Nine started to come

further and further apart, until one day I was taking longer to get to work in the morning and coming home at six instead of at eight or nine. I actually started to have a lunch break. And I also called Lucila about a dozen times a day, just to say hi.

"How about we go out to dinner tonight?" I suggested.

"We haven't been out to dinner on a Tuesday night in months," she observed. "Since you took over Paul's job. What's up, Soraya? You must be bored already."

"Well," I sighed, "maybe I could use a little more variety in my job." But I didn't do anything with this sudden revelation. Instead I tried to tell myself that things might change, there might be some new challenge that arose, some new and exciting product to develop.

I probably would have kept on kidding myself, except that one day I got another knock on the door from Opportunity—the second call of my career from a headhunter. Lotus, one of the biggest software companies at that time and a giant of industry in Boston, was developing a line of multimedia products. They'd heard about the work I'd done at Number Nine, were particularly looking for women engineers, and wondered if I was interested in talking to them about a senior development job with the potential to be promoted to development manager in a few months.

"How come in a few months?" Lucila asked when I told her about the offer. "You're qualified for the job now. You don't need a probationary period."

"It's not a probation. There's actually someone in the job right now," I said. "But he's not working out."

"So why isn't he being fired?"

"It's a tricky situation. They need to have someone step in first, and then they need to justify why he has to go. It's hard to fire somebody—you have to be able to document their bad performance so you can avoid a lawsuit. So I'll just have to do my best and wait."

Lucila raised a skeptical eyebrow. She was expressing the same concerns I'd had myself. "That's really weird," she commented.

It was a weird situation and one I didn't like the sound of at first. But still, the chance to head up a Lotus development team was too good to miss. With assurances that the promotion would come through in time, I took the job.

The first thing I had to do before reporting to work at Lotus was buy some new suits. At Number Nine, all the engineers wore jeans, myself included. I knew from my first interview at Lotus though that things were different there; it had a very corporate environment. Lotus was "the big time"—a company with $700 million in sales revenue in 1990, the year I started. All the engineers were decked out in suits, and the employee handbook had a firmly stated dress code. It was no wonder IBM ended up buying Lotus in 1995; the two companies were a perfect match, like twins separated at birth.

I had a couple of pantsuits for interviews and conferences, but I couldn't keep wearing those every day. And besides, the women at Lotus wore dresses and suits with skirts. So Lucila and I went shopping at Filene's Basement. The problem was I never liked skirts—not as a young tomboy playing soccer in the street, and definitely not as an adult who spent most days hunched in front of a computer screen.

"Oh, this wool is really nice. It's so soft," Lucila murmured, as she stroked one of the suit coats I tried on. "Stop squirming, Soraya. I can't see how it looks on you."

"I feel like a mummy," I complained. Suddenly, I was a kid again, forced by my mother to dress "like a girl." "Where does the damn zipper go?" In all the years I worked at Lotus, I never got used to dressing up every day.

But there was something about the company that I got used to really quickly. Lotus occupied a six-story building in Cambridge, right on the Charles River. It was the most beautiful spot for working I'd ever seen.

My boss, Rob Lippincott, who managed all the multimedia research projects, showed me to my office on my first morning. It was a sunny space facing the river, and the view took my breath

away. "This is my office?" I asked, amazed. Number Nine had been a crowded maze of cubicles.

"Yep, this is yours," Rob said with a smile. "Sit at the desk, boot up your computer, get some coffee. Then come back and see me when you're settled in."

For several minutes, I stood at the window, taking in the dazzling view of the sun on the river. "Good morning, Charles!" I found myself saying, as if the river was a very old and very dear friend. To me, it really felt that way. In fact, it became a kind of ritual for me to greet the river that way every morning for as long as I worked at Lotus. And whenever I needed to think through a problem or a tense situation, I'd go outside and take a walk along the riverbank, spending time with Charles. The quiet lapping of the water almost always calmed me so that the solution to whatever problem I was having came more easily.

When I started working at Lotus, the company was facing several serious problems, brought on by the rise of that other software giant—Microsoft.

The hottest and most talked about computer operating system on the market at that time was OS/2, jointly developed for the personal computer by Microsoft and IBM, with version 1.1 released in 1988. OS/2 had a graphical user interface (GUI) called the Presentation Manager, which let users point-and-click their way through commands and "multitask" by running several applications at the same time. Lotus had an agreement with IBM to develop all its software to run on OS/2.

But simultaneously, Microsoft was perfecting its own operating system, which "borrowed" generously from the user-friendly system developed by Apple (which had, in turn, "borrowed" technology from Xerox). Windows 1.0 and 2.0 appeared in 1985 and 1987, respectively. But it was the powerful Windows version 3.0, which debuted in 1990, that seized the operating system market. As a result of Windows 3.0 and its successors, versions 3.1 and 3.11, OS/2 died a quick, painful death and led Lotus to start producing software that would support Windows.

In addition, Microsoft was going after another important piece of the consumer market. In 1987, that company launched a line of consumer-oriented CD-ROMs with the introduction of Bookshelf, a multimedia title that included sound, color photos, and the text of useful works like *The American Heritage Dictionary*, *The Concise Columbia Encyclopedia*, and *The World Almanac and Book of Facts*. Bookshelf was a talking reference library. And although home computers didn't come with CD-ROM drives yet, it was clear to everyone in the industry that soon, it would be standard on PCs.

So, shortly after I started at Lotus, Jim Manzi, the president of the company, called an emergency meeting with my boss, Rob, and our small Research & Development team. "We've got to start developing a new consumer product fast," Manzi urged, "or we'll never catch up to Gates. He's got at least four multimedia products in development. Rob, I want your team to figure out what we can launch that'll put Lotus into the CD-ROM market." It must have been painful for Manzi to remember that in the early 1980s Microsoft had proposed a merger of the two companies, but Lotus turned it down. Now Microsoft was overtaking its once seemingly unstoppable rival.

After the meeting with Manzi, Rob immediately started investigating which of Lotus's already successful products could be improved by the new CD-ROM technology. His research led him to envision an entire line of business and financial products available on CD-ROM, starting with Lotus 1-2-3, the company's flagship product and its most popular. By 1990, millions of people around the world were using the spreadsheet software as a business tool to plan budgets, set up schedules, and track costs. But only the most experienced of those users understood and utilized all of the program's powerful features.

Rob's idea was that Lotus could offer consumers a CD-ROM version of 1-2-3, complete with sound, video, still photos, and animation. A multimedia component added to the "Help" section of 1-2-3 would actually demonstrate to novice users how to perform key tasks. The new product would also incorporate a "Show Me"

movie to teach users the basics of 1-2-3, making the multimedia version both a productivity tool and a training guide in one package. Even better for business users was that the CD-ROM could run on a network, allowing several employees to share it.

A few months after starting at Lotus, I'd been promoted as promised, to head up the multimedia development team. So the job of creating what we called 1-2-3 Multimedia SmartHelp fell to my team of four engineers. We worked in concert with a team of graphic designers, researchers, and writers.

1-2-3 Multimedia SmartHelp was a great learning experience for me and my team. And it was fun for us, too, like working for a software company and film studio rolled into one. Unlike other development teams at Lotus, ours expanded to include animators, voice-over artists, video technicians, and other experts in aspects of multimedia production. I felt like a kid in the proverbial candy store—a techie let loose with the hottest and latest technology. During the process of producing this first CD-ROM, my engineers and I also created tools that could be used in other products as well, like a sound recorder and player, a movie player, and a synchronization DLL, which synchronized animations with sound.

Possibly the hardest part of my job as team manager was convincing the team that created 1-2-3 to buy into the idea of a multimedia version and help us by sharing code. Big software companies like Lotus have multiple teams working on multiple products, and those teams are often nervous about sharing the software code they've written for their programs, since it takes so long to get it right. I had to be a savvy salesperson as well as an engineer, producing a demo to persuade the 1-2-3 team that an addition to their already wonderful, fabulous, groundbreaking, unsurpassed, best-selling product was a sound idea and that it would make sales of the program skyrocket.

It was a hard sell, though, and one that taught me an important lesson about collaboration. The very next time I had to convince a team to back a multimedia project, I did it with humor. When my team started to work on the multimedia version of Freelance 2.0, Lotus's presentation program (code-named O'Keefe) I decided

to create a demo presentation that used humor to demonstrate all the multimedia tools that we could provide. First, I digitized some videos showing the launch of *Brasilsat-I* and my interview on national TV in Brazil. Then I included some funny animations and added sound effects that would play while the slides were loading. People used to seeing static slides in presentations were blown away by what they considered different and innovative.

The result was that the O'Keefe team backed us up immediately, eager to incorporate multimedia tools into their product. Tim Davenport, the vice president of the graphics division of the company, personally came to my office to congratulate me.

"So tell me, Soraya," he said before he left, "what can my guys do to help your guys?"

My team finished its first product on time, which is a real feat in the software industry. Unfortunately, the company's marketing department wasn't sure how to sell 1-2-3 Multimedia SmartHelp and failed to put any promotion money behind it. I learned months later, after we had already started development of Freelance 2.0 with multimedia, that our CD-ROM version of 1-2-3 was a commercial flop. Not because it didn't work as expected or wasn't a good idea, but because too few consumers knew it existed. It's a frustrating aspect of big business that so much money and time and labor can go into development of a product—whether it's a software program, a film, a book, a game, or even a toaster—and then it can die for nothing more than lack of visibility in the marketplace.

I did eventually get to see products I worked on at Lotus become successful. We not only created multimedia extensions for Freelance 2.0, but also for Notes 2.0, the popular business software that incorporates messaging, scheduling, database management, and forms into one tool. In 2000, *Network Computing* magazine named Lotus Notes the tenth most influential product of the past decade.

Even more interesting for me, though, was working on a

brand-new product that Rob dreamed up out of sheer desperation. He was worried about the sorry state of his R & D team's profit-and-loss statements after our 1-2-3 project bombed with consumers. We were spending more than we were bringing into the company, and we badly needed to justify our existence with an item consumers would snap up off the shelves. Rob realized the product couldn't be a tool that only worked in conjunction with someone else's program, like 1-2-3 Multimedia SmartHelp did, but had to be one that could survive in the marketplace on its own.

"What if we created a tool," Rob wondered, "that would let people make their own multimedia files?" And that's how ScreenCam was born.

As always the case in software development, we didn't start the new product from scratch, but instead looked around to see if anyone else had a product that we could buy to give us a jump-start. Rob located a company called Farallon, which had made a name for itself in the Macintosh multimedia market. But the company's owners decided they weren't making enough money in multimedia, switched their focus to hardware, and put their code up for sale. We started talking, and after long negotiations, Lotus purchased the source code for what eventually became ScreenCam.

Still popular today, ScreenCam turns the user into the director of his or her own films. Businesses snapped it up to help them create product demos, as well as tutorials and training films for their employees.

Through my affiliation with Lotus and its products, my own reputation in the industry began to grow. I found that I had considerable clout when I attended conferences and trade shows and handed out my business card stamped with the name of one of the country's most successful software companies.

Once, even Microsoft came calling on me. An engineering and business development team spent several days talking to me and other executives at Lotus about new Microsoft technology, still in development, called Windows 3.0 Multimedia Extensions,

which would include a voice recorder and player. Microsoft needed to get software developers to create programs that would use the new technology or else it would be completely useless to consumers. Initially, Microsoft actually wanted to charge developers a fee for the privilege of using their technology.

"But my team is already developing similar technology," I said on the first day. "Why should we pay for yours? Thanks, guys, but no thanks." I made it clear that Lotus was well on its way to becoming a leader in multimedia, that we were creating tools that could be used on their own as well as with other products. But in the interest of camaraderie, I shared our demo of 1-2-3 Multimedia SmartHelp, which I was certain would impress them.

"See what I mean?" I said, thinking the Microsoft guys would finally get it. "We've got the skills right here."

But the Microsoft team still persisted. Their job, after all, was to make the sale, and they were hesitant to go home without achieving that. They kept insisting that theirs would be a superior product, but I wasn't convinced. What at first had just annoyed me was, by the last afternoon, making me mad. Still, I kept my temper and opted to act cocky instead of angry.

"Hey, I've got a great idea," I suggested. "Why doesn't Microsoft pay to license our technology? It's gonna be a hell of a lot better than anything your guys put out."

After the Microsoft team had finally given up and left in a taxi for Logan Airport, I complained to Eldridge, one of the engineers on my team who had also become a good friend. "Can you believe how pushy those guys were?" I said. "They really thought they were something."

"Yeah, I can believe it," Eldridge said with a grin. "Hey, they work for Bill Gates, and he's the pushiest guy on earth."

I didn't know it then, but I found out something else about that team years later when I was, in fact, working for Microsoft. As soon as the engineer who had led the Microsoft team got back to company headquarters, he walked into the Human Resources Department and tossed the business card I'd given him onto the director's desk.

"What's this?" the HR director asked. "Who's Soraya Bittencourt?"

The engineer didn't say much, but what he said proved fortuitous for me.

"She's someone Microsoft needs to hire," was his reply. "We could use her on our side."

8

Image Art

"April 6, 1992: Microsoft ships Windows 3.1 with over 1,000 enhancements. The new version creates unprecedented user demand with over 1 million advance orders placed worldwide."

—Key Events in Microsoft History

As soon as I had a good job in my field and Lucila had found work as an accountant, we were much happier in our adopted country. We liked living in Somerville, too, where there was a visible lesbian and gay community.

Still, I occasionally found myself daydreaming about running my own company, being the boss—Soraya Bittencourt, President and CEO. Maybe I'd never be another Bill Gates, but I wanted to be a success just the same, someone who could take a big idea and see it through to fruition.

I'd gotten my first taste of independence as a young woman, when I ran my timer manufacturing firm in Brazil. Even though that venture ended badly because I picked the wrong person to trust, I knew I'd do a much better job the next time around. And there would be a "next time around," I was sure of that.

A big idea did come to me at the same time that I decided to interview for the job at Lotus. The idea for my own business originated when I realized I had to update my resume, revamp its layout, and print it out on vellum paper.

Because I didn't want anyone at the office to see me in the process of working on my resume, I went to a store near Harvard Square called Laser Designs. The store rented state-of-the-art computers by the hour, and the machines were loaded with all the latest desktop publishing software. I'd made use of the store several years earlier, when I was trying to hone my DP skills so I could get a job with CompuTemps, the temp agency.

Every time I'd been to Laser Designs, the place was hopping. Desktop publishing was the hottest new technological advance, one that was transforming the way businesses did marketing and publicity. It was also becoming popular with home computer users, who used it for everything from resumes to invitations to greeting cards, but the hardware and software required were still too expensive for average consumers. So clients would come to Laser Designs and pay by the hour to either do the design themselves, or, if they weren't proficient with software like PageMaker and Adobe Illustrator, have store employees do it for them.

The evening I picked to work on my resume, I had to wait twenty minutes just to get a computer station because there were so many students printing out term papers and resumes. While I was waiting, I struck up a conversation with the manager.

"You do a terrific business here," I commented, taking a flyer with a list of their hourly rates on it.

"There's nothing else like it anywhere else in this neighborhood," he remarked. "We've cornered the market. You just can't beat this location."

"What service do people want most?" I asked.

"Conversions," he said without hesitating, meaning that customers could get Mac files converted to be read on a PC, and vice versa.

That got me thinking, as I took the T home that night: Would a store like Laser Designs work in Somerville? Lots of students

lived in the neighborhood, as well as many lesbians and gay men, because the rents for housing were so cheap. All I needed was a space, a few computers to start, and software. And, of course, an employee, since I wouldn't be able to work there full-time right away. I thought I could probably talk Lucila into running the store during the day, since her employer, an educational research firm in Cambridge, was downsizing and she was looking for work.

Just for the fun of it, I decided to get off the subway in Davis Square instead of at my usual stop, because I remembered an empty storefront for rent right near the entrance to the subway. And there it was, a great space wedged between The Yogurt Place and a thrift store. I peered through the storefront's window and saw ladders, toolboxes, and drop cloths left by workers who had apparently been remodeling and repainting.

I jotted down the number on the "For Rent" sign and called the next morning. To my disappointment, the owner wanted $900 a month, a lot of rent for 1990. When I tried to negotiate, he just laughed at me.

"Why should I make a deal?" he asked. "I've already had at least a dozen callers about the space. This is a prime location."

Because of the high rent, I tried to put the place out of my mind so that I could concentrate on my Lotus interview. But soon after I took the new job, which came with a substantial pay increase, I began fantasizing again about the freedom of running my own company and not having to wear a suit to work every day. I even made an appointment for Lucila and me to tour the interior of the store after work one day.

It was a great space, with two full floors and a lot of light from the big picture window. The last tenant had used the basement for storage, but all I could see in my mind when I looked around downstairs were half a dozen computer stations where customers could work in quiet. And pay by the hour.

"It's a lot of space for the money," the owner pointed out. "And a terrific location."

"I have to think about it," I said. "It's a big decision."

"Don't think too long," he warned me. "I got a hardware guy and a card store lady interested, too." I noticed that he no longer seemed to have dozens of callers, so I thought I could spend a few extra days making up my mind.

In fact, though, I had already decided to take a chance. I just had to convince Lu, who was nervous about being the store's one full-time employee. "I don't know anything about desktop publishing," she said. "I only know accounting."

"You can learn," I assured her. "You learned 1-2-3, didn't you?"

"But what if a machine breaks down?" she asked.

"If there's something you really don't know how to do, like fixing a computer, you can leave it, and I'll do it in the evenings."

"What if we don't get customers?" she wondered. "How are we gonna pay the rent?"

Now that was a big worry of mine, too, since I knew that the rent would come out of my savings, and, when those were depleted, out of my salary. But I tried to push the fear out of my head and Lucila's.

"We'll get customers," I said confidently. "Trust me. We'll have so many customers, we won't be able to keep up with them!" The next day I transferred most of my savings into my checking account so I could make my first rent payment, and that was when Image Art was born.

It took about three months and $7,000 before Image Art was ready to open. I spent many nights and weekends getting the computers set up, installing the software, and purchasing and arranging the furniture. What took the longest was that I had to create a network to link the computers. Image Art started small, with just two Mac SEs with monotone screens and one Mac with a color screen. I had been doing some freelance work as a developer for Apple, so I got the Macs at a big discount. Although I knew that Macs, with their speed and power, would be more popular for graphic design, I also bought one PC for flexibility. Because I couldn't afford to buy four printers, one for each station,

I built a network from scratch that connected all of the machines to both a black-and-white laser printer and a color printer.

To start, I outfitted the Macs with state-of-the-art software: not just PageMaker and Illustrator, but Photoshop, Quark, Microsoft Word, Works, and all Microsoft Office applications, and WordPerfect, still popular back then. And I didn't forget converters, since the manager at Laser Designs had told me what a big business his store did converting Mac and PC files so they could be read on both platforms.

Over time, as our business grew, we added four more SEs, another color Mac, a second PC, more printers, a scanner, and a CD-ROM writer. We also invested in a frame grabber, which could capture displayed screen images and transfer them to a file on disk. But all that came further down the road.

We picked Saturday, October 10, 1990, a beautiful, cool fall day, for the grand opening of the store. In preparation, we publicized the store through college newspapers and flyers that we distributed all over campuses like Tufts and Harvard, and we took out an ad in Boston's lesbian and gay newspaper, Bay Windows. We decorated the store inside and out with red, black, purple, and white balloons and streamers. That morning, members of the Somerville Chamber of Commerce, as well as the town's mayor, joined us for a ribbon-cutting ceremony and a photo op. It was a very proud day for both Lucila and me.

And then the hardest part of the business started—actually running the store. The first day was pandemonium, with all of our friends dropping in to support us, and lots of foot traffic— mostly people checking out the new store to see if we were offering any grand-opening freebies.

But after the initial rush, the first weeks were lean ones, with too many days in a row when only a few people wandered into the store to send a fax or asking to make a photocopy. We hadn't anticipated needing a copier, but we knew pretty quickly that we should purchase or lease one.

It took a lot of flyers, which we wheat pasted in the neighborhood and on college campuses, a lot of newspaper

advertising, and a lot of word-of-mouth publicity before things began to pick up. The first thing we did that helped the business flourish was to stay open seven days a week, nine to nine, which gave us a competitive edge. To do that, though, meant that Lucila and I relinquished virtually all of our free time. Lucila worked nine to six alone, while I was at my day job at Lotus. She'd arrive early, turn on all the machines and test them, then pick up any faxes for customers that had come in overnight. After we'd been in business a few months, she'd usually find people waiting for her to switch on the neon "Image Art" sign. Her schedule was jam-packed the minute she unlocked the front door, from helping customers with the software to making scans to sending faxes to keeping track of accounts payable and receivable. She barely sat down until I arrived at about 7 P.M., having quickly changed out of my suit and stockings and grabbed something to eat.

The minute I got to the store, Lucila would take her dinner break. During the day, she had compiled a list of chores for me to get started on while she was out and on the worst nights, the list might be even longer than this:

Soraya—

1. Mac #2 downstairs won't turn on.

2. The network went down twice today and we couldn't print. Help!

3. I found a virus in Mac #4.

4. The PageMaker upgrade came in today and needs to be installed on all the machines.

5. There's a stack of Mac files to be converted to PC by tomorrow morning.

6. We got an order for a logo design—due next Monday.

7. Love you.

Lucila

Theoretically, the store was supposed to close at 9 P.M., which meant that after straightening up and finishing various odds and ends, we would be on our way home by 10. But because there were often stragglers who swore they were "almost finished" and begged us to stay open "just a few minutes more," and because our income depended on a lot of $6—(for the black-and-white computers) or $8-an-hour (for the color) rentals, Lucila and I were often tied up at Image Art until midnight or later.

Our reputation for accommodating customers, especially when I jumped in to offer my computer expertise without charging extra, was what made our little business grow as quickly as it did. An offshoot of the store, which we called "PC Doctor," helped a lot, too; customers could call for emergency in-home repairs of their computers, and while Lucila staffed the store, I'd make house calls.

It wasn't too long before Image Art developed a core following, a group of about 840 customers who used the store on a continuing basis. Our space gradually became a local gay hangout, too, a kind of ad hoc community center. People started coming in not just to do computer jobs or send faxes, but to socialize with each other and with us. They would grab a cup of coffee at The Yogurt Place, then head next door to work on their resumes or newsletters. Sometimes, a whole group of friends arrived together, and the store took on a party atmosphere. It didn't bother us; in fact, Lucila and I appreciated the fun after all the long, hard days we'd worked with almost no breaks. Through Image Art, we made some very good friends, people who helped us out later on when we needed their support and expertise.

Because of our loyal customers, by year three we had a large

enough profit margin to hire a part-time employee, Eve, who expelled us on the weekends so we could finally have time to rest up and spend some relaxing time together. Since we'd opened the store, we'd had very few hours or even minutes that weren't swallowed up by work, work, and more work. Hiring Eve gave us a break to boost the romance in our relationship.

One step I took to bring quality romantic time back into our lives was to plan a special night for our 10th anniversary—February 12, 1983. I told Lucila I had something to do at home and asked her to manage the store by herself until closing time. She wasn't thrilled about that prospect, until she realized I had a special surprise up my sleeve.

"What are you up to?" she asked, smiling. "We already had our party." We had, in fact, already celebrated a decade together with a big party with our friends.

"You'll have to wait and see," I replied. "Just don't be late closing up. If anybody tries to get you to stay, turn out the lights on them and go."

I planned that night carefully. After I finished work at Lotus, I shopped and then hurried home to cook—a rare event. It's not that I'm bad in the kitchen—in fact, I'm a good cook—it's just that I have rarely found the time to plan and prepare a meal. That's been Lucila's province more than mine.

But that night, I fixed a spectacular French meal with four courses. I got a bottle of cabernet sauvignon from 1983, the year I decided to leave my husband and move in with Lucila. As final touches, I adorned the table with romantic candles and a vase overflowing with red roses, then added some mood-setting incense and Tom Jobim music playing softly in the background.

Lucila got home about 9:30 and couldn't believe how beautiful everything looked and how elaborate the meal was. We started with Piedmontese rice, which is cooked in milk and cheese with garlic and herbs. Then we moved on to the entrée, filet mignon cooked in red wine. After that came the salad.

"Did you really make this," she asked slyly, "or do you have some chef hiding out there in our kitchen?"

When I announced that it was time for dessert, she protested. "Oh, I'm too full," she said. "The food was so rich, and I drank so much wine. I couldn't eat anything else. Let's just have coffee."

"No, it's a special dessert, you have to eat it," I insisted. I came back from the kitchen with her dessert plate, holding it behind my back so she couldn't see it.

"Soraya, I can't," she said again, then recanted. "Well, maybe just one little bite . . ."

"Wait, let me say something," I interrupted. "We've been together all this time, ten years tonight, and it seems like we've always been saving for something—to move to this country, to start Image Art. We've never really had any extra money. Well, now we do. And in this country, it's traditional that a woman gets a diamond when someone proposes to her. I know it's late, Lucila, and I know we're already married, but it's high time you got your ring." On the dessert plate sat a stunning one-carat diamond ring in a gold setting. Although the stone wasn't large, it was what jewelers call a VSS I, E. A D is a flawless diamond an E has one imperceptible impurity. VSS stands for the clarity and VSS I means colorless and very brilliant, in summary the best.

It was Lucila who suggested we skip the chocolate truffles and strawberries that I'd planned for dessert. With glasses of cognac in hand, we moved to the bedroom, where we enjoyed another kind of dessert—all that night, and for the two nights that followed.

That third year in business, Image Art grossed $350,000. It may sound like a lot of money for a small business, but it was really just enough to pay for rent and utilities, upkeep on the machines, and Lucila and Eve's salaries. My dream of being my own boss still wasn't fulfilled, because there wasn't enough left over to pay me a decent salary so I could quit working for Lotus. I was a boss who had to work two jobs—not my idea of independence.

To have the financial freedom to quit Lotus, I knew I needed another source of income. Maybe, I thought, Image Art could

become a chain, with branches in different parts of the city. We'd have to start small, though, the way we did in Somerville, opening a second store in a good location, maybe close to Boston College or Northeastern University.

But there were two immediate problems with that idea. Because we couldn't afford more employees, especially if I quit Lotus and didn't have that income coming in, I'd have to work the second store all by myself, twelve hours a days, seven days a week. That might go on for several years, until we could hire someone. I have always been more comfortable with machines than with people and dreaded the idea of facing the public day after day, hour after hour. It is not that I do not have people skills, I do have them. My problem was that in a retail environment, you cannot really have the type of experience I was used to. My daily thrill and fulfillment at Lotus and other companies I worked for was to have an idea, create a product that would help or change the way people do their tasks. That was what excited me everyday.

Lucila, too, would have to work on her own with no help from me in the evenings. She was a whiz at digitizing and fine-tuning images, and she kept our accounts in terrific shape, but there were parts of the business she couldn't handle on her own, like repairing the network or fixing broken machines. On top of operating the second store, I realized I'd have to moonlight at the Somerville store.

The other, even more serious problem with expanding Image Art was that, by 1993, a store that specialized in desktop publishing didn't have a big future. Hardware and software had become much cheaper than they had been when we'd started the store, and I suspected, within a very short time many more households would have a computer with the capability to handle their design needs and a high-quality color printer, too. Oh, we'd always have customers—people who didn't want to invest in a scanner or a frame grabber because they only occasionally needed to use them, or others who ran into viruses or hardware problems they couldn't fix on their own. But the notion that we

could ever gain financial freedom through running a desktop business evaporated. I began to realize that it wasn't expansion that my business needed, it was a change of direction.

The idea that would eventually lead me to Microsoft and make me a millionaire came to me while I was away on a business trip for Lotus in early 1993, attending an important Silicon Valley trade show. The Eighth International Conference and Exposition on Multimedia and CD-ROM (known more casually in the industry as "Intermedia") was a glitzy event that attracted a lot of big names, like John Scully of Apple, Bill Gates, Barry Diller, and the movers and shakers of Intel, Sony, and IBM.

But it wasn't the celebrity speakers who got me thinking; it was the exhibition hall full of the latest multimedia authoring software, which had come down in price and was making it possible to produce great visual and sound effects on a small budget. In addition, computer hardware for using multimedia was cheaper and easier to install than ever. Tandy offered an internal CD-ROM drive that went for just a few hundred dollars, putting it in the affordable range for many consumers.

As a result, the number of CD-ROMs going into the consumer market was mind-boggling. Microsoft had bought a minority share of Dorling Kindersley, a British publisher, and was producing multimedia versions of DK's popular and lushly illustrated books, Eyewitness Guides. At Intermedia that year, Microsoft unveiled a gorgeous CD-ROM that particularly appealed to me; it was called Musical Instruments and had been published in book form in 1989. Compton's NewMedia showed off an equally beautiful line of CD-ROMs, including Compton's Interactive Encyclopedia and the *Dictionary of the Living World*. In fact, everyone from large entertainment conglomerates like Disney to small independent startups were launching new CD-ROM titles. The buzzword at Intermedia was that 1993 was the "Year of the CD-ROM."

"We should make our own CD-ROM," I told Lucila on the phone from San Jose. "In fact, how about a line of them?"

Lucila was tired from a long day and night at Image Art by herself. "Wait a minute, Soraya. We have enough work as it is," she said. "You have two jobs, and I'm here twelve hours a day. How are we gonna make a CD-ROM, too?"

"We'll just work harder," I said. "Maybe for a year at most. We could make a lot of money. This is the up-and-coming thing, Lu. If you were here, you'd see what I'm talking about."

"The up-and-coming thing, huh? That's what you said about desktop publishing," she groaned. "And what will this CD-ROM be about anyway?"

That I couldn't say. Not right at that moment, on the spot. But a few days later, an idea struck.

I was working in the store when a customer asked, "Are you from Brazil? I love Buenos Aires. Such an interesting place. I saw pictures of it in National Geographic Traveler."

"I am from Brazil," I said. "But actually, Buenos Aires is the capital of Argentina. Brazil's capital is called Brasilia. And Lucila and I come from Rio de Janeiro."

"Oh, the carnival city!"

"Yes," I replied, smiling a little to myself. How many times had I heard people say the exact same things since I'd immigrated? I realized how little Americans seemed to know about Brazil, simply lumping all the South American nations together as one. And yet Brazil is such a big, beautiful country, with so many different geographic regions and types of people!

"What if we did a line of CD-ROMs dedicated to travel?" I asked Lucila while we were eating breakfast. "Travel books are big sellers. And no one here learns about Brazil. We could guide people through our own country, like we're guides bringing them on an insider tour. If the Brazil CD-ROM works, then we could expand to other countries."

"Would it sell?" Lucila asked, with her accountant's concern for money. "How many people would really be interested in Brazil? And why wouldn't they just buy a travel book?"

"Because a CD-ROM is better than a travel book," I went on. "It has videos and narration and music to give you a real taste of

the country. You can actually immerse yourself in the country, even hear the language being spoken."

By now Lucila was looking even more intrigued, but cautious. "What exactly will we put on this CD-ROM?" she asked.

"We could get our families and friends to help us find content. Photos and maps and videos—stuff like that," I added.

"Hm," Lucila said, picking up the morning newspaper and fiddling with the pages nervously.

"What does 'hm' mean?" I pressed her. "That you're interested? That I'm crazy?"

"'Hm' means I don't know anything about CD-ROMs except what I hear from you," she explained. "You say 'we're' going to do this, but it sounds more like you than me, Soraya."

"That's what you said about the store," I pointed out. "And look at you now—scanning photos, making OCRs, troubleshooting for customers. You're on your way to being a real techie."

"Just what I always wanted to be," she said with a wry twist of her mouth. "Give me one really good reason for taking on a project that's just gonna add to my already heavy work load."

I considered that carefully for a minute or two. "Think of it this way. With a successful product, it won't matter where we live. We could move anywhere, even San Francisco."

The mention of California got Lucila's attention. Neither of us had ever adjusted to the brutal winters in Boston and like many people, we'd left our proverbial hearts in San Francisco on a vacation there. She folded the paper in front of her.

"San Francisco," she sighed. "Okay, go ahead—tell me just what we'd have to do to make a CD-ROM about Brazil."

9

An Exotic Journey

"March 23, 1993: Microsoft Encarta, the first multimedia
encyclopedia designed for a computer, is available."

—Key Events in Microsoft History

As soon as Lucila had agreed to the CD-ROM project and was
already dreaming about leaving Boston, I came to a panicked
realization. Lucila could scan and crop photos, and I could teach
her to do other important tasks for the project, like using Freehand
to outline the icons. But I couldn't teach her to write code, and,
besides that, she didn't want to learn. That meant that after a full
day at Lotus and an equally full evening at Image Art, I'd be coding
all night and on the weekends if we wanted to create a CD-ROM.

"Well," Lucila sighed when I raised the issue, "it was a good
idea."

"There's got to be a way," I insisted.

"Maybe we could hire someone to work in the store at night."

A light bulb flashed on. "Or we could hire someone to write
code."

Lucila frowned, knowing very well how much money skilled
programmers commanded. "How can we afford that?"

"We can't," I admitted, deflating. Then after a few seconds, I added, "Unless we hire someone who needs us as much as we need them. Say, someone who's highly skilled but new to the country."

We turned to each other with big smiles and said in unison, "Marco!"

Marco was Lucila's youngest brother, who lived with their mother in Rio. He was just 23 years old, a tall, athletic, movie star-handsome guy, who was also very smart and ambitious. At that time, he had graduated from the university and secured a job as an animator for a top advertising agency in Rio. Using 3D Studio, the best animation tool for PCs, Marco had created nifty ads for McDonald's and other international firms.

Marco liked his job, but every time we talked to him on the phone, he was awed by my position at Lotus, my contacts in the industry, and the fact that I was making so much money. "Engineers from Microsoft tried to sell you multimedia extensions for Windows?" he asked. "That is so cool. Next thing you know you'll be meeting Gates himself!"

Given Marco's enthusiasm about the American computer industry, Lucila and I had the same thought: What if we sponsored Marco's immigration and brought him in on the ground level of our new multimedia company, hiring him to write code for the CD-ROM?

Coincidentally, Marco was coming to visit us in Boston. He arrived in February on a typically cold and snowy day. Although he wasn't happy about the weather, he was impressed with the progress we'd made with Image Art and how our profits were growing steadily. "It's clear that you two have had a lot of opportunities here that you didn't have in Rio," he commented.

That observation provided the opening to pop the question about immigration. At first Marco was completely silent. He took a slow, deep breath and then let it out loudly, like we'd just asked him to go in with us on a bank robbery. "That's a big decision," he finally said. "You know, I've got a really good job at home."

"I had a good job when I left Brazil, too," I pointed out. "But

Brazil's a dead end, Marco. America is the place to be; it's where all the really exciting stuff is going on technologically. You know that."

He did know that, of course, but we were still asking a lot from him. We were asking him to give up security for a good idea that might or might not pan out. He'd have to say goodbye to his steady salary and make do with a small, token one. He'd have to work very long days and many nights, longer than he was used to working, because we were a small team and we needed to finish the product in time for exhibit at the 1994 Intermedia trade show.

"Why should I give up everything to do this?" Marco finally asked pointblank. "What's in it for me?" The question made me smile, because it was so much like Lucila's reaction when I first broached the subject of a CD-ROM. "Give me one really good reason," she'd said, "for taking on a project that's just gonna add to my already heavy work load."

On the plus side, I explained to Marco, Image Art would sponsor him for an H1B visa, which is for temporary workers in highly specialized occupations. He could have free room and board at our house, which meant he wouldn't need to worry about money. We would offer him a percentage of the CD-ROM company and its profits, insuring that his hard work would pay off down the line. He'd gain valuable experience with CD-ROM technology, which was the wave of the future. And when our project was completed, if he wanted to stay, I could help him land a job with a company like Lotus that would sponsor him for a green card.

Another long silence. "I'll have to think about it," he said. "Let me go back to Rio and think about it. I need to evaluate all the risks, decide if it's worth it for me. Then I'll call you."

Later that night while we were reading in bed, Lucila closed her book suddenly and sighed loudly. When I asked her what was wrong, she said, "He won't do it. I know him. He's always been such a cautious kid. He'll hang on to the sure thing, I just know it."

"Don't give up hope yet," I advised. "He said he'd call us back. You were cautious back in Rio, too, but it didn't stop you from coming to America with me."

It was a full month before Marco called, but he did call. Lucila got to the phone first. Although I was in a different room of the house, I could tell right away by her euphoric tone and rapid-fire Portuguese that Marco was saying yes.

"I'll get your room ready!" I heard her say excitedly. But in fact, it took Marco another two months to settle everything in Brazil and get on a plane for his big adventure in Boston.

When you're preparing to work on a CD-ROM, the first and most important question facing you isn't about the technological aspects of the project—"What will the interface look like?" or "What tools will we use?" The most important question is, "Where will the content come from?"

Content is the story the CD-ROM tells, the narrative that educates and entertains the user. Even if you have the most terrific-looking animations and the highest-quality videos, the richest interface, without good content that's interesting, well-written, and informative, you've simply got a pretty product that no one will buy. Customers want a satisfying experience, not just nifty technology.

Research and writing take a long time, however. Microsoft had gotten around the problem of content by buying a minority share of British publisher Dorling Kindersley, with an eye to producing multimedia versions of DK's Eyewitness Guides. In its 1991 deal with DK, Microsoft got content and visuals ready-made and the CD-ROM development team's job became simply the creation of an appealing and usable interface to showcase them.

But we were just small fry and couldn't afford to license content. So we were up against the problem of creating it from scratch. Until I called my mother, that is.

My mom, who dropped out of high school to marry my father and only got her college diploma after all her kids were raised, has held many different civil service jobs in Brazil. In one job, she worked for an organization that took care of poor people, especially single mothers, orphans, and the disabled. That had

brought her into frequent contact with Brazil's First Lady, Marlene Sarney, who was especially interested in helping the less fortunate.

"You should contact government officials," my mother suggested on the phone when I told her about our content problem. "I bet Embratur would be happy to furnish you with pictures and travel brochures, free of charge." My mother explained that in the last couple of years, media reports about escalating high crime rates in Rio and Salvador had scared away visitors, including many from the United States. Embratur, the official Brazilian tourist office, had embarked on a multi-year campaign to increase the number of Brazilian hotels and improve the country's transportation facilities in order to double the number of foreign travelers.

"You're brilliant!" I said. Even better than her idea was her willingness to call Embratur herself to try to locate content for us.

"We need books, too," I told her. "Lots and lots of big illustrated books about Brazil."

"I can buy them for you," she offered, "but I don't know how to get them to you. It'll be expensive to ship them fast, and anything else will be too slow."

Lucila and I decided it would be easier and in the long run, cheaper, for me to make a trip back to Rio to buy books. At the same time, I could set up appointments with Embratur and other government agencies to outline the idea and see if they could help me secure photos and videos of tourist locations.

But we didn't want to focus just on the traditional tourist destinations, like Rio, São Paulo, and Brasilia. What about other cities, we thought—like the historic city of Salvador, or the town of Teresópolis, a picturesque resort in the mountains outside of Rio? What about the Pantanal, Brazil's incredibly beautiful wetlands? Or the Iguaçu Falls, which surpass Niagara in height and power? We wanted our product to encourage travelers to wander off the beaten path.

Keeping that in mind, Lucila contacted her cousin, Eugenia Moreira, who worked for TV Globo, the biggest broadcast company

in Brazil. Eugenia offered us her own collection of video clips of places overseas tourists rarely ventured to, simply because they didn't know about them. "Believe me, when people see our footage of the Piaui opal mines and the surrounding area," Eugenia assured us, "they'll want to get on a plane."

When my mother heard of my plans for a content-gathering trip to Rio, she set up a meeting for me in the marketing office of Varig, the largest Brazilian airline. Right before their overseas flights land in Brazil, Varig flight attendants play short travel videos to whet tourists' appetites about various locations. These were films my mother thought the marketing team might be willing to share if our CD-ROM promised to aid Brazil's sagging tourism business.

With all these prospects lined up, I headed home to Rio for what would be a bittersweet stay. From my first moments back in Brazil, my senses exploded with the beauty of the country I hadn't set foot on for several years. There were all the gorgeous women on the street, wearing clingy fabrics, their hips swaying. The happy squeals of kids playing soccer in the street. The soft slide of white sand under my toes. The lush spurt of tropical fruit juices in my mouth. The savory smell of feijoada cooking on my aunt's stove.

But at the same time, I found myself noticing other, less pleasant sensations that had simply been part of the fabric of life before I left—like the endless blare of traffic on the streets; the shacks on the hills overlooking Rio, practically collapsing in on themselves; the hundreds of poor people struggling to buy simple things that Americans take for granted.

Even worse, I was a stranger in my own family. How could I have never noticed before how many rude remarks about gay people members of my family could make without stopping to think how they might hurt me? Like my aunt insisting that I "became" gay because I had problems with my father. Or one of my cousins telling a funny story about some "fags" he saw at the beach and everyone in the room laughing.

Most of all, I felt like a freak for wanting a better life for

myself, for Lucila. Since I left Rio six years earlier, not much had changed for my mother, my father, my sisters, and my cousins. Their lives seemed stagnant to me. They were all in the same jobs, following the same routines, without much hope of moving forward. My life in Boston, on the other hand, was constantly moving in an upward spiral. In Rio, it felt like I'd stumbled into an earlier, slower century.

On the business side, the trip was a complete success, and the meetings my mother had set up for me paid off well. Embratur officials donated photos, video, and data on Brazil's geography, natural resources, major cities, and primary industries. Varig pitched in their in-flight videos, a friend of mine donated wonderful pictures from southern Brazil, and Eugenia came up with forty minutes of video footage of rarely visited locations all over the country.

In the end, the photos, videos, brochures, maps, data, and books I accumulated in Brazil filled three suitcases to overflowing. The customs officer at Kennedy Airport was very curious about my acquisitions.

"I'm doing some heavy duty research on Brazil," I explained as he sifted through the stash in my luggage.

"Ever heard of the public library?" he asked snidely, slapping one of my suitcases closed.

When Marco arrived in Boston, he dragged with him an additional two suitcases packed with oversized, illustrated books. By that time, the content for the CD-ROM had pretty much taken over the study of our house, with stacks of material piled high on the floor and desk and spilling off of the bookshelves.

"Think we've got enough content to work with?" Lucila joked.

"I do," I smiled, pleased with how much we had to work with and that permissions for most of it had come to us for free. "So let's get started." In my eagerness to dig in, I didn't bother to consider such "minor" details of setting up a multimedia software company as establishing a business plan, a projection of sales, partnership agreements, or marketing ideas. What we did have plenty of were determination and a desire to change the way people traveled.

Excitement alone isn't enough though, as we soon discovered. Like any other software development team, large or small, ours started to fight almost immediately. Or I should say, Marco, the designer and animator, and I, the program/product manager, started to fight over the interface.

Interface refers to the visual display of content so that it's both appealing to look at and easy for the customer to use. For example, what kind of icons will appear on the screen? What typeface will be used for the text and the headings? How long will it take the animations to load? How will the user move from one screen to another? Making these decisions requires not just an attractive design but an understanding of the product's potential audience, the machines we were targeting to run the program, and the technology that would deliver it.

"The interface has got to be really responsive, really fast," I announced at a team meeting to discuss how to proceed. We were sitting at the dining room table with notes and sketches and flowcharts spread out around us. "That's the most important thing—speed."

"Speed means nothing if it doesn't look good," Marco challenged me, shaking his head. "We want a rich interface, or nobody will want to use it."

"Just how 'rich'?" I asked skeptically.

The three of us had already agreed on a branching tree structure for the CD-ROM. We'd decided that this would accommodate not just a CD-ROM on Brazil, but future CD-ROMs on different countries, too. Here's how it worked in a nutshell: The software would open on a map of Brazil. The user could then click on a general geographic region, such as the Southeast, and from there on individual states, like Rio de Janeiro or Minas Gerais. Within each region or state, icons allowed users to delve more and more into climate, natural resources, culture, visitor attractions, accommodations, and so on, through photos, videos, music, and narration. I felt very satisfied with this structure and was worried about Marco's

zoom idea slowing down the program, because rich interfaces take a lot of computer memory.

"Well, for example, here's something that would be a fabulous effect," Marco said, sketching quickly on a pad in front of him. "When you click on, say, Bahia, you'll immediately zoom into that region."

"That'll be too slow," I said. "The user will have to wait maybe ten seconds for the animation to load! Ten seconds is a bad user experience. And a bad user experience is just unacceptable to me."

"A flat interface is unacceptable!"

"Look, the zooming won't work, Marco, believe me. Director's animation engine is just too clunky." At that time, there were still a limited number of multimedia authoring tools on the market and the one we chose to work with, Director 3.1, loaded animations into memory first, then played them after they were loaded. That added unwanted (and in my mind, unnecessary) seconds to the interval in which the user clicked the mouse and then waited to view the next screen.

"If you don't trust my opinion, why am I even working on this project?" Marco demanded, pushing himself away from the table. "I thought you said you needed my expertise in animation! But you just want me to accept your ideas."

Lucila was sitting at the table with us, and she hadn't said a word so far. Her head turned left then right, from me to Marco, like a spectator at a tennis match. Finally, she whistled for us to stop.

"Time out!" she said. "I can't believe I agreed to work with two Aries. What was I thinking? And not just any two Aries, but my brother and my wife!"

Her tone was joking, but she looked worried about our loud squabbling. Over the years, Lucila had often teased me about my astrological sign, which is associated with Mars, the god of war. By contrast, her own sign, Pisces, tends to be a peacemaker, a good listener with great sympathy for different sides of an argument—which describes Lucila perfectly. Our two signs

together had always worked fine in our relationship, because we balanced each other out. But now she had to manage not just one, but two assertive, stubborn, headstrong, competitive rams, and try to keep them from killing the project, each other, or both.

"Somebody's going to have to give in," Lucila announced.

"It's too slow," I muttered. "It won't work, I tell you."

"It will work," Marco insisted. "Let me show you before you dismiss it all together."

"Okay, enough," Lucila cut in. "You're gonna have to compromise. You can't just keep saying 'It won't work' and 'Yes, it will' over and over. We'll run out of time before we even get started! Marco, Soraya says Director is too slow delivering the animations. Is there any other product we could use that would be faster? Or something that would work with Director to speed things up?"

"I don't know offhand," he admitted. "You know, Director's a great product, and I don't see why . . ."

She interrupted her brother's objection and turned toward me. "Soraya," Lucila said, "if Marco can find something to speed up the loading of the animations, would you give his ideas about a rich user interface a try?"

"Well, yeah, I guess so," I said slowly. "But, believe me, he's never going to find . . ."

"Then it's settled," Lucila pronounced. She got up from the table. "Well, don't just sit there. We've got work to do! Marco, you better get started finding an animation engine. And Soraya, isn't it time to sift through all that content you brought back from Rio?"

To my surprise, Marco did find a product to solve our problem. He spent weeks doing research in trade magazines and publications and located a tiny firm, the Company of Science and Art in Rhode Island, that offered a program called PACo Producer, capable of compressing and streaming CD-ROM animations to load quickly and play smoothly. Although I was still skeptical, I agreed we should buy it, and just as Marco thought

it would, it worked like a dream. We had our compromise: rich animations that were fast-loading, too.

When we'd accomplished all the initial planning and hammered out many of the technical questions, it was time to actually start production—in other words, the grunt work. I was the team member chosen to write the scripts to accompany the video clips and slide shows and the text that would appear on the screen, since my English was still much better than Lucila's.

Lucila would scan the 1,200 photos we chose and then crop, compress, and manipulate them, because we figured she could squeeze that in between helping customers in the store. She would also help Marco create the 72 icons that we estimated we would need, outlining them first in Freehand and then turning them over to him for animation. Besides creating the animations that would make the interface spring to life, Marco would undertake the laborious task of writing code.

But as efficient and hardworking as we were, we realized that we couldn't get by with just the three of us. In big companies, every multimedia team is an assemblage of writers, designers, artists, programmers, and marketing pros who bring different strengths and skills to the project. We couldn't afford people full-time, so we had to hire contractors to round out our team.

Although I could write the script and text, I made a lot of grammatical errors and my vocabulary still had big holes in it. So we hired two freelance copy editors to fix up the script and make sure the narration and screen text flowed effortlessly.

Then we needed a voiceover artist to read the script. We all agreed that we wanted someone with a rich-bodied, pleasing voice, but that alone wasn't enough. The narrator had to be fluent in English and also speak Portuguese without an American accent, so the user would get the real flavor of the language. My ears can't take the hard "R" Americans use when they say "Rio de Janeiro." Luckily, one of our customers at the store, Heloisa, knew a woman named Flavia Smith, who was American born and had lived in Brazil and was fluent in both English and Portuguese.

Flavia was looking to make some extra cash and so was a perfect fit for our project.

We hired more family members to help us out, too. Lucila's older brother, Zé Luis, a jazz musician, scored the original music. My mother, who had made all the initial contacts about content for us in Brazil, followed through by securing permissions and processing the extensive paperwork. And Selma, a cousin of mine, offered valuable marketing advice when the project was close to completion and we needed to think about exhibiting at trade shows.

I also engaged friends of mine at Lotus to pitch in, like Eldridge, one of the guys on my engineering team. He spent hours after work helping me to test the software and fine-tune the text on the screen.

Other friends from Image Art aided in the testing phase, too. No matter how well you plan a design when you're creating software, you always have to check in with real users during the process so they can tell you if they like it or not. Once the interface was assembled, we started having usability sessions at the store to see how easily customers could figure out how to use the product. We offered anyone who would try the product two free hours of computer rental in the store, and we accumulated a lot of valuable information about what worked for users and what didn't. That helped us fine-tune the final product. One thing we discovered was that kids just loved the CD-ROM because of all the animations (thanks to Marco) and because the interface was very easy to follow.

Talking to customers also helped me realize a flaw in the CD-ROM idea that could damage its chances on the market. "It's really cool," one user said, when he tried it in the store. "I love the zoom effect. But I'm not sure I really get the point. Why would I buy a CD-ROM instead of, say, a Fodor's Guide?"

"Because the CD-ROM literally comes to life," I replied. "You've got audio and video that a regular travel guide can't offer you."

"But I can't bring it with me," he pointed out with

disappointment. "So I need a book, too. And if I have to buy a book anyway, do I really want to spend money on a CD-ROM, too?"

He was right, of course. Although there were already plenty of laptop and notebook computers on the market in 1993, none of them had built-in CD-ROM drives yet, making our product something customers could only utilize before leaving for Brazil, not while they were there. It was clear that we needed to offer users something else, something unique—a compelling reason to purchase software they couldn't bring with them on their trip.

And then it hit me. After you decide where you want to travel and when, what's the first thing you do? You need to start booking your trip. You want to find the best price on plane tickets, a good hotel at a reasonable cost, a rental car, and a place to exchange currency. What if our CD-ROM could assist them with that? Wouldn't that make it unique as a travel tool?

"Now you're going too far," Lucila chided me when I broached the subject. "How are we gonna connect to hotels and airlines?"

I had heard about a new online service called easySABRE that computer users could access through Applelink, Prodigy, or Compuserve. It had evolved out of SABRE, a reservations system that professional travel agents used to make bookings. The easySABRE service allowed consumers to research airfares and make reservations all by themselves in real time. (It eventually became Travelocity.com.)

"But it's not so great to use," I explained. "I tried it out to see. It doesn't have a graphical user interface. You just type to a command line, and it's very confusing. Still, if we could make it possible for our users to, say, click on an icon and connect to easySABRE, they could search for reservations without going to a travel agent or making calls to individual airlines and hotels. They could root around for the best deals and save time and money. And that's more than any old travel book can offer."

There was an even better part to the plan. If I could negotiate a deal with easySABRE for throwing business their way, our company could get a cut of every transaction that customers made

through the CD-ROM—an additional (and potentially very lucrative) source of income for us.

"Well," Lucila said wryly, "that's just what we need—more work! But I'll admit it, Soraya, you could be onto something."

In fact, I had finally found "something," and it was the big idea I'd been looking for, the one with the potential to make a major impact on the software industry. It was bigger than Image Art, bigger than the original idea for the CD-ROM. In fact, this idea had the potential to transform the travel industry.

But because of its "bigness," the idea would require more money and time for development and testing. Unfortunately, we were strapped for cash and time. As our one and only marketing plan, we'd invested thousands of dollars for an exhibit at Intermedia '94 in San Jose, where we planned to launch the CD-ROM in grand style. We had to finish everything—especially getting rid of all the bugs—by early February so that 3M, with whom we had a contract to reproduce the CD-ROM, could meet our production needs.

My idea about a new way of delivering travel information was too good to let pass by, though. If I didn't do it, certainly someone else would, since many in the computer industry already knew that the future of technology was online. So I decided we could ship some preliminary code inside our CD-ROM, letting users know that they could download the finished code to their machines at a later date and make the connection to easySABRE. It was a gamble on my part, but one that proved to be worth it not long after, when my life at Microsoft finally began.

Microsoft had been actively courting me for months—ever since the meeting at Lotus about multimedia extensions for Windows, in which I proved I could play hardball with the big boys. But I had no interest in working for the company. Everyone in the industry knew Microsoft was the Evil Empire, and the guys I'd met at the Lotus meeting did nothing to change my impression. The Microsoft team had been overbearing, insistent, and arrogant—just like, I suspected, the rest of the Gates crew.

But I kept getting phone calls from Scott, the Human Resources recruiter who had gotten my business card from the Microsoft engineers I'd met with. To describe Scott as solicitous would be an understatement. "You're just what this company needs, Soraya," he cajoled. "Besides, you're wasting your time at Lotus—this is where the big opportunities are."

When he offered me an all-expenses-paid trip to Seattle for Lucila and me so that I could interview with the company, I decided to accept. I have to admit I was curious about how Microsoft ran its operation, compared to Lotus.

Microsoft put us up at a very classy hotel in downtown Seattle. While Lucila took long baths and went sightseeing, I had a battery of meetings with HR executives and with members of various product development teams. True to what I'd heard through the grapevine, the day-long interview was grueling.

In the first session, an intense-looking engineer drew a circle on a presentation board, signifying a CD-ROM, and made two marks on it, representing sensors. "The circle rotates to the left and to the right," he said in his no-nonsense way. "Where should the two sensors be located to capture each rotation? I want you to write the code you will need to detect each rotation and then change the rotation direction to retrieve nonsequential data from the disk."

I thought for a several minutes, then proceeded to the board and marked where the sensors should be. Then I worked out a small computer algorithm that described the routine of sensing the data, calculating it, and delivering the results.

"That's, uh, good," the guy said, nodding—the most praise I got from an engineer all day.

The next interviewer was a nerdy-looking guy with a smug grin I didn't like because it said, "You'll never get this one." He posed a brain teaser about a chicken crossing a bridge, which he thought was extremely clever.

"You have a river and a bridge that links the two riverbanks," he began. "On one side, you have a chicken, a bag of corn, and a fox. You have to get them all safely across the river. But the

chicken wants to eat the corn, and the fox wants to eat the chicken. You can't carry them all at once—what do you do to get them to the other side without the chicken or the corn being eaten?"

That took slightly less time than the algorithm had, as I ran through the possibilities in my head. "First you take the chicken and the corn," I said. "Then . . . then you drop the corn on the other side, and carry the chicken back with you." I hesitated and looked up, trying to read his reaction, which was impossible to do. "You drop the chicken, pick up the fox, and carry it to where the corn is. The fox won't eat the corn, because it wants the chicken. Then you return one last time and bring back the chicken." I smiled proudly, and the guy looked disgusted that he hadn't stumped me. "I'm right, right?"

There were other brain teasers, a few more algorithms, and then finally an HR meeting in which I was asked about handling stress and crises on the job. I liked being given concrete problems instead of questions about hypothetical chickens. I was able to quickly and easily solve a problem about an unforeseen, last-minute setback with code—handling production problems, stressed-out employees, and tight schedules were what I prided myself on.

At the end of the day I met up with Lucila at the hotel.

"How did it go?"

"I'm not sure," I replied, collapsing on the bed.

"What do you mean? When you got home from your Lotus interview, you knew right away you had the job."

"This is different," I explained. "These guys play tough. Sometimes I knew I did well, and other times I thought it was all over."

"They don't tell you how you did?"

"They don't tell you anything."

"Well, that sucks," Lucila said.

Not long after we got back to Boston, however, I found out how I'd done, because Scott was on the phone offering me a job with the Font Publishing team. The salary was pathetic, almost laughable, and I politely turned him down. Still, I left the door open to him calling me again.

This is exactly what he did several months later. Again, it was a job I wasn't very interested in, at a pitiful salary I couldn't afford to take—not when the CD-ROM project was eating up both my savings and thousands of dollars in profits from the store.

When I turned Microsoft down that second time, a basket full of gourmet delicacies from Washington state arrived at our house. "Hoping you'll change your mind—Best wishes, Scott," the card read in a scrolling hand.

"Hey, this is really good stuff," Lucila commented, as we explored the basket, taking out item after savory item—salmon, scones and jam, cheeses, a bottle of wine. "I bet they don't send this stuff to just anyone." She was right: I found out later that the company only wooed the very top candidates with gourmet gifts.

"I hope he keeps calling you and offering you jobs," Lucila laughed. "Maybe we could get a whole year's worth of baskets!"

It was only after some problems began mounting up in my career in Boston that I decided I should take a serious look at the offers behind Microsoft's gift baskets. First, Jim Manzi, the head of Lotus, held a meeting with my team in which he issued a surprise mandate: from that moment on, we would halt our work on multimedia titles and refocus our energy on developing the technology for Notes, Lotus's business applications program.

"But why?" I ventured to ask. We had just launched ScreenCam, and it was a hot item in the market. It seemed that we had finally found a product that could put Lotus on the multimedia map. "Why pull the plug when the team's doing so well?"

"Why?" he asked. "I can tell you in one word—Microsoft. They're blowing us out of the water in almost every area of the software business, especially multimedia. But they haven't found a way yet to surpass Notes. The only chance we have of surviving is to keep developing Notes as the number one software for business. And that's exactly what you guys are going to do."

After the meeting, my team and I left the conference room dejected. We loved the multimedia products we had worked on, and we had thrived together as a team by being able to learn about and

develop new technology. Although we all liked Notes as a program, the prospect of working on it full-time was unappealing. One by one, the team started to disband, as the engineers took other jobs or found different projects to work on within the company.

About the same time, Lucila, Marco, and I came to a particularly frustrating period in producing our CD-ROM—testing and debugging. We didn't have the testing equipment we needed in the shop. Neither did Lotus. Our CD-ROM was being designed to run on the Mac, since at that time there was very little multimedia being produced for PCs. Lotus wasn't in the Mac market and so did not have the machines we needed for testing.

We were almost finished with the product, but bugs kept cropping up and tormenting us. Marco would no sooner fix one bug then five more would crop up, each requiring extensive additional coding. Many evenings I'd come to the store and find him bleary-eyed, hunched over a Mac, swearing at the machine in Portuguese.

So when I picked up the phone one day and it was Scott again, urging me to come for another interview, it seemed like Microsoft might be an answer to all my different problems. I could start over in a new company—an exciting prospect, since my work at Lotus had come to a dead end. I could use Microsoft's resources to finish the testing on our CD-ROM so that we could make our February production deadline. Best of all, I could get to Bill Gates and try to interest him in my ideas about the future of online travel. Maybe he'd buy the rights to our product.

Scott must have known I was on the verge of finally accepting, because at that interview, he pulled out all the stops. Not only did we fly first class and stay in a luxury suite at the Four Seasons, the ritziest hotel in Seattle, but I got to meet personally with Craig Mundie, a company vice president, who was well-known in the industry for being in charge of the interactive television initiative at Microsoft.

"He almost never meets with candidates," Scott informed me in a conspiratorial whisper. "But he very much wanted to meet you."

When I was back home, having aced the interview again, Scott dangled a tantalizing offer in front of me—a spot in the newly formed interactive TV division, developing multimedia technologies and content. Although my salary would still be smaller than at Lotus, Microsoft sweetened the deal with a big signing bonus, a relocation package, a condo and a rental car for a month, and a fat stack of shares in the company.

Hearing about the shares, Lucila looked up their current trading value in the business pages of the newspaper. Then she whipped out her calculator and went into accounting mode. "My God," she said, after she punched in some numbers and showed me the total. "That's a lot of money, Soraya."

My eyes got big. "Wow. That is a lot of money."

"You'll never see that kind of money at Lotus."

"No, I won't." But Microsoft didn't let you take your shares and bolt after a few months or even a year or two; they made sure they got a lot of work out of you before you became eligible to leave and take your stock with you. "But I'd have to stay four and a half years to be vested," I pointed out. "That's a long time in this business. I could get very bored. I've never worked that long in any one company. I don't know if I can. And what if the CD-ROM takes off?"

Lucila is a much more evenly paced person than I am, who has never felt the kind of raw impatience I've experienced most of my life. But she knows me too well and knows how anxious I can be to move on to the next challenge, the next opportunity. "Then we'll be rich and we won't need Microsoft's stock," she replied shrewdly. "Bill Gates will be jumping to snap up shares of our stock."

It was the perfect thing to say. In fact, it got me to call Scott back and accept the job.

PART III

1993-1999—Seattle

10

Microsoft Empire

"December 6, 1993: Microsoft is named the '1993 Most Innovative Company Operating in the U.S.' by Fortune magazine."

—Key Events in Microsoft History

The hardest thing about leaving Boston was that Lucila couldn't come with me—at least, not right away. We hadn't been separated for more than a couple of weeks since we'd first gotten together.

What happened was that when I accepted the job at Microsoft, I had to agree to report to work within a month, which wasn't nearly enough time to wrap up our lives on the East Coast. There was Image Art to close, our house in Somerville to sell, and most importantly, the CD-ROM to finish. We'd already spent a bundle of money on an exhibit booth for Intermedia '94 in San Jose and signed a contract with 3M to reproduce the software, so the project had to be completed by early February—even if it killed all of us. And in fact, it almost did. We had reached the most stressful part of the project—testing and debugging—and I had to leave Boston right in the middle of it.

"We can finish the project long distance," Lucila assured me. "Marco can send you disks by FedEx for testing, and then you can fax back the bugs for him to fix."

"Yeah, but what about us?" I moaned. "What's going to happen to our relationship? I'll miss you too much!"

"We'll visit each other every month," Lucila said to calm me. But "every month" sounded as bad as if she'd said "every year."

"I'll put the house on the market right away, and we'll be living together again by March. You'll see," she said. But, in fact, March would come and go and Lucila would still be in Boston, tying together loose ends.

My move, however, was easy. Human Resources had rented a furnished one-bedroom apartment for me in a modern condominium complex called Hampton Greens, a short drive from Microsoft's beautifully landscaped 260-acre "campus" in Redmond, Washington.

The town of Redmond sits on the outskirts of Seattle in an area called Eastside, which extends from just east of Lake Washington to the foothills of the Cascade Mountains, the beautiful range that includes Mount Rainier. In addition to Microsoft, other high-tech companies like Nintendo call Redmond home and account for the 300 percent increase in the town's working-age population since 1970. I found that living close to the Microsoft campus was ideal for me, because rush-hour traffic from Seattle to Eastside could be brutal.

The relocation deal I struck with Microsoft included everything I needed for my first month on the job. I didn't even have to buy a phone or set up a cable TV account—all that was part of the package. I even got a rental car. Basically, I just had to get on the plane to Seattle and start working.

But the loneliness I felt in that new apartment, in a new city, on a new coast, was the most intense I've ever experienced. There had always been people around me—first my family, then my husband, and finally Lucila. Now I was completely alone.

The first night in Redmond, I wandered from room to room, reorganizing the few possessions I'd brought with me from Boston,

trying to make the place feel like home. Every so often, I forgot where I was, expecting to hear Lucila's keys in the front door or her humming to herself in the kitchen as she prepared dinner. "Soraya, we're all out of garlic. Could you go to the store and . . ." But it was just my imagination.

During the days, of course, I had a lot of work to keep me busy—first, getting used to a new job and second, staying after hours to test the Brazil CD-ROM on Microsoft's Macs. Unfortunately, I couldn't ignore the ache of returning home to an apartment that didn't have Lucila in it. The pain gnawed at me like a burning ulcer, until I got myself into big trouble: I met another woman.

I had accepted the job at Microsoft with the understanding that I'd be developing a new way to deliver content for interactive TV, and I was looking forward to the challenge and to learning new things. What I didn't realize when I accepted the position was that Microsoft reorganizes and disbands teams on a routine basis, whenever the company doesn't have a good plan for launching a product and making money on it.

So imagine my anger when I arrived on the corporate campus the first day, reported to Human Resources, and discovered that the entire interactive TV division had been disbanded. The word was that they could not pull off a business model to make money from the initiative. The reality was that the technology was way ahead of its time. It took time for Gates and Mundie to start signing deals with cable companies to develop interactive TV, but it was not in time for me to take part as I'd wanted to.

"You'll be in the Windows '95 Multimedia Group instead," Scott from HR informed me casually. He didn't look me in the eye as he spoke, and I wondered if he felt a twinge of guilt because he'd hired me for a job that no longer existed. "The Windows team really needs a multimedia expert like you. They're good people, you'll like them a lot. You should report to Heidi Bresslauer in Building 4."

What was happening in the industry in late 1993 was that

Intel and other hardware and chip manufacturers were launching devices that would allow customers to play and view movies on their computer screens—something we now take for granted. But Windows didn't include the software needed to make the viewing devices run, and Intel had been forced to develop its own toolkit, which it wanted Microsoft to ship inside each box of Windows. Microsoft would only agree to do this if it could determine that Intel's toolkit was a good product that could be used on a wide variety of computers, not just those with Intel chips.

My job, then, would be to direct the project (called DCI, for display control interface) on the Microsoft end. I'd be working with the Intel engineers further developing the toolkit, testing and retesting it, and making sure it worked on many different machines before it could be shipped inside the Windows box.

"But that's not what I signed on to do," I protested to Scott.

"Oh, you can do it, Soraya, don't worry," Scott said.

"It's not that I can't do it," I corrected him. "Of course I can do it. I could probably do it in my sleep! But I don't want to. I would have never left Lotus if I had known about this change."

Scott tapped his pen against the desk impatiently. "Look, just give it a try and if you really don't like it, you don't have to stay," he assured me. I immediately perked up—that is, until he finished his thought. "You're free to apply to another team after a year."

"But that's an eternity!"

Scott was unsympathetic. "Every employee has to spend at least a year with the team they're assigned to before applying for a transfer to another," he pointed out. "If we didn't insist on that, we'd have complete chaos. People would be hopping from team to team, and products would never ship."

So I was stuck. Unless, I thought, I could cut a deal with Heidi, my new boss on the Windows team. I asked her how long it would take to finish and deliver the DCI project.

"A year if you're really lucky," she told me. "A year and a half if you're not."

"What if," I said, "I can deliver it in less than a year?"

"You won't," Heidi said shaking her head.

"But just say I do," I pressed her. "If I deliver DCI in less than a year, then can I move to another team?"

"Well, yes, I guess so," she agreed reluctantly. "But I wouldn't count on it if I were you. You'll never do it, Soraya, I'm sure of that."

At that time, I'd only worked at Microsoft a few weeks, and Heidi didn't really know me very well at all. If she had, she'd have realized that "you'll never do it" is just the sort of challenge I can't resist.

My first months at Microsoft were one of the hardest times of my life. I hated my job, because it wasn't the one I'd left Boston to take.

In addition, finishing the CD-ROM long distance was producing a lot of tension. The testing and debugging of our CD-ROM, which we had named "Brazil: An Exotic Journey," was in full force. Every week, Marco sent me a CD via overnight mail, and I would spend evenings and weekends testing it on the machines in the Microsoft labs. Invariably, there were bugs—those maddening errors in coding that make the program malfunction. I faxed the bugs back to Marco, who would do a clean-up job and send me a new disk. But the clean-up always produced even more bugs, and we repeated this painstaking process many times over the next several months.

Marco and I had screaming matches over the phone because I didn't understand why we couldn't get rid of the bugs. Lucila and I argued a lot, too, but for different reasons—mostly because we had to live apart.

Besides being separated from my lover, I also had no friends. At the young age of 33, I was, by company standards, "old." Many of the other engineers were Bill Gates wannabes, annoying white guys under the age of 25 that I didn't really want to hang around with. It was no wonder the HR department had been so eager to hire me—Microsoft was in dire need of seasoned managers who weren't just out of Waterloo, Stanford or MIT.

Unhappy with the corporate culture, I decided to try to find people more like me. While I was still in Boston, I had read in *Deneuve*, the lesbian magazine that's now called *Curve*, that Microsoft had a gay and lesbian group with the acronym GLEAM, which stood for Gay and Lesbian Employees at Microsoft. (We later added "Bisexuals and Transsexuals" to the name, to be more inclusive, but kept the same acronym.) A small number of Microsoft employees had gotten together because they were tired of being surrounded by all the Gates clones on campus and wanted to be able to meet and hang out with other lesbians and gay men. GLEAM held regular get-togethers and even marched under a Microsoft banner in Seattle's annual gay pride march.

After a few weeks of nagging loneliness and isolation, I searched the company address book for GLEAM. The group had its own e-mail list, so I posted a desperate message to it: "I'm new in town, just hired, working as a Senior Program Manager in Windows Multimedia, a lesbian with a long-term relationship, originally from Brazil, looking to make some friends. sorayab@microsoft.com."

Before long, e-mail messages started stacking up in my box, asking me to have lunch. I was thrilled and started making dates immediately. One of the responses, from a woman named Paula, particularly interested me: "I'm Brazilian, too, in an eight-year relationship. My lover Gisele and I came here in 1986 together. I'm also a Program Manager, but a junior one. I'd love to meet you!" I could hardly believe my luck—another Brazilian, and one who had come to this country with her partner in the exact same year Lucila and I did. After a brief e-mail exchange, we met for lunch on campus.

Paula and I clicked from the start. She was a mulatta from São Paulo with dark eyes and skin, thick curly hair, and a charismatic smile. I was immediately struck by how intelligent and charming she was, and I couldn't wait to tell Lucila that I'd made a new Brazilian friend.

"Get to know her partner, too," Lucila said excitedly on the phone, "then we can all do things as couples when I get there."

I met Gisele not long after, when Paula invited me to their house for dinner. I liked Gisele a lot, too, but she was still a student and I had much more in common with Paula because of our jobs at Microsoft. Paula and I started calling each other up at work and sending long, chatty e-mails every day. Lunch together, when we could spare the time, became a habit.

In retrospect, it's odd that I didn't think very much about how close we were getting. That is, not until Paula called me at 8:00 on a Thursday night and asked if I wanted to go dancing. "There's this great bar in Seattle, and tonight's lesbian and gay night. It'll be a lot of fun."

I glanced down at my cozy cotton pajamas, which I had just put on. I was just about to head into the bedroom with the latest Naiad Press mystery. "I'm beat and ready for bed," I told her. "Maybe some other time."

"Oh, come on, Soraya," she coaxed. "You'll meet a lot of new people, and we'll have a good time, I promise you."

She was still at her office at Microsoft, and I said I'd think it over and call her back soon. I realized after I hung up that it was a good idea—I could sleep in the next morning, because my meetings would start late, and I might make some new friends. Plus the dancing might relax me—I'd been so tense over my job and the CD-ROM. I called Paula back within minutes and told her to come pick me up.

She arrived about half an hour later, all dressed up in a beautiful black silk blazer and gold jewelry. "Where's Gisele?" I asked, because I could see as we approached her car that Gisele wasn't in it.

"Oh, she hates to dance," Paula explained. "And she has a paper to write this weekend."

I didn't like the sound of that. Ever since Lucila and I had been together, neither of us had ever gone out dancing alone with another woman. I could hear Lucila's voice in my head as Paula drove us into Seattle: "What do you mean, Gisele stayed home?"

Paula had been right: The club was terrific, and we had a

great time dancing. We both liked to dance nonstop and were young enough that we could do it.

"You're a really good dancer," Paula said, leaning toward me and whispering into my ear. I got a shiver from her warm breath, and I pulled away.

"Just like any good Brazilian," I joked to break the sexual tension that I'd been feeling with her all evening.

We didn't talk much on the drive home. I was scared of what either of us might say, so I just stared out the passenger window and wondered why I was there with her, when I had such a beautiful, funny, smart lover. Did I miss Lucila that much I had to find a substitute? Or was I feeling a real and powerful attraction to Paula?

About 1:00 A.M., Paula pulled up in front of my apartment building and parked. I had to stop myself from asking her in; she kept staring deeply into my eyes, almost willing me to do it. We'd been speaking in English most of the night, but now she slipped back into Portuguese: *"Você vai sair sem me dar um beijo?"*

I looked into her intensely dark eyes, kissed her as she'd asked me to, and then hurried out of the car. In my haste to be anywhere but there, I accidentally caught my coat in the car door and had to open it to release myself. "See you Monday," I said lamely as I closed the door again.

For the next few hours, I lay awake in bed, alternately remembering the silky touch of Paula's lips and then scolding myself, "What the hell are you doing, Soraya?" I turned the picture of Lucila that I kept on the nightstand toward me and then quickly away from me again. I felt too guilty to look at her, even in a photograph.

At about the same time that I was getting into trouble on the personal front, I was also cooking up a scheme on the professional end. I was desperate to figure out a way to meet Bill Gates and introduce him to my CD-ROM, since that was one of the two big reasons I'd taken the job at Microsoft to begin with.

Now that our CD-ROM was nearing completion, Lucila, Marco,

and I faced yet another daunting challenge. We could create a beautiful interface, we could have interesting content, and we could iron out all the bugs . . . but if no one knew about our product or they couldn't find it on the shelves, "Brazil: An Exotic Journey" was sunk. I thought that if I could interest Gates in our project, maybe it could become a Microsoft product, with all the marketing force and power that goes with that—and with lots of money for us, too.

In retrospect, it was a naïve idea, but it was rooted in reality. I knew that Gates was very interested in expanding the company's multimedia line, because Microsoft had more than a dozen CD-ROM titles in the works, including its mammoth encyclopedia, *Encarta*. He had decided that Microsoft should beat everyone else to defining the multimedia market and then completely take it over.

So I hatched a plan. "Which building is Bill's office in?" I asked Paula when she was walking me back to my office after lunch. Everyone at Microsoft knows who you mean when you say "Bill."

"Eight," she replied. "Right over there. Second floor."

"Where on the second floor?"

"It takes up half of the 'X'. You can't miss it. The hallway outside his wing is loaded with photos of the history of the company." She looked at me slyly. "What're you up to, anyway?" But I just shrugged and didn't respond.

Of course, as I've already related, I didn't actually intend to break in. I just wanted to casually run into Gates, so I started hanging around Building 8. And, like all the other opportunities that have happened in my life, I saw an open door and walked through it. Only in this case, the door led to Gates's office, where I dropped my CD-ROM on his chair so that he couldn't miss it when he sat down. That break-in was my only bout with "criminal" activity and in this case anyway, crime did pay.

It took several months to get a response about my CD-ROM, but finally it came. Not from Gates himself, of course, but from Mary Ord in the Consumer Division, who sauntered into my office

one morning and told me that Microsoft planned to move ahead in the travel market. My idea, it seemed, had coalesced with an idea for a travel-planning CD-ROM that people in Consumer had been kicking around for quite a while. But until then, no one had considered the possibility of merging content with an application that could also sell tickets or make reservations. Consumer now wanted to merge the two ideas and was already beginning to set up a team.

Microsoft is a large company made up of lots of small teams that function like little companies or start-ups. Each one has a Product Unit Manager, or PUM, who acts like a mini-CEO, with three to five people reporting to him or her. Eventually, more people come on board when the business plan and prototype get the go-ahead from Gates. He then approves "headcount"—a specific number of bodies to complete the work. The larger the headcount, the more important the project.

"We've already hired Richard Barton to head up marketing and prepare the business plan," Mary informed me, "and now we need people to start working on a prototype. You interested in interviewing for a senior program manager position?" She knew that I was nearing the end of the DCI project, which I had worked on at break-neck speed so that I could transfer to something more challenging and appealing.

But I was confused by Mary's question and disappointed that I obviously wasn't being considered for PUM. "I have to interview?" I asked. "Even though it was my idea? I mean, I was hoping Microsoft might want to buy it . . ."

"Microsoft doesn't buy ideas from its employees," Mary said matter-of-factly. "It doesn't have to. We're paid to generate ideas. Any ideas you bring to our attention belong to the company."

As I let that sink in, I was already wondering how to tell Lucila and Marco that my efforts to get Gates interested in our project had unwittingly doomed it to a short life. A Microsoft CD-ROM based on my idea would blow "Brazil: An Exotic Journey" out of the market. We'd completed our project with $64,000 and had no money left for marketing. Microsoft, however, earmarked

several million dollars for each of its multimedia titles and put its full muscle into promoting them. I couldn't believe I'd been so naïve about how big business worked. Still, there was no question that I would want to be part of the team. "Of course I would like to interview for the job," I finally replied to Mary. "Just tell me when and where."

I had to endure yet another grueling Microsoft interview, but I got the job as senior program manager of Microsoft Travel, the project that eventually became known as Expedia. For PUM (Product Unit Manager), Gates tapped Greg Slyngstad, a 14-year veteran of the company and a highly experienced manager, who had worked on the early versions of Microsoft Word in the 1980s. Greg was actually in retirement when Gates asked him to come back to head up the travel team. Greg's wife worked as a travel agent, making Greg familiar with the ins and outs of the travel industry.

Also hired for the project was Mark Consuegra, a program manager who would work hand-in-hand with me on creating the specifications, storyboard, and prototype. Later on, I was promoted to Group Program Manager after the project was approved and Mark Consuegra left the team.

Within a little while, we added Byron Bishop as development manager, in charge of all the programmers working on the software; Roxanne Lehmann as product designer; and Mark Morris, a travel writer, as content editor.

Marketing manager Richard Barton was the first of us to study the travel market, which enabled him to write a vision statement outlining projected costs, sales, and strategic potential. Then Mark and I took his directives and wrote specs that described all the software's features, including a projection of how the final product would look and work. Based on our specs, we had to build a slide presentation and a prototype to show at our review with Gates, which was several months down the road and which would determine whether or not the project went ahead or got the ax.

A Gates review is the most important moment in the career of any Microsoft employee. It can make or break you and your project. Gates is the ultimate competitor who prides himself in knowing something about everything, and he's notorious for finding even the tiniest flaw in a business plan or prototype. He's also known for verbal volleying with his employees, often ripping their work to shreds rather than simply pointing out mistakes. The anticipation of a Gates review has turned some very experienced employees into quivering masses of nerves.

So our team spent several months preparing for our review, going through a couple of dry runs first with Charlotte Guyman and Patty Stonesifer, who was VP of the Consumer Division at that time. The project was based on the basic idea behind "Brazil: An Exotic Journey": a line of CD-ROMs on countries around the world that would be like coffee-table travel books, with lots of illustrations, maps, videos, and information. In addition, we'd build in a way to connect to an online reservations system through Microsoft Network (MSN), so that customers could purchase airline tickets and reserve rental cars and hotel rooms in real time.

By the morning of our Gates review, we were confident that we had a good plan and a great-looking prototype. We had chosen to feature France in the demo, because Richard's research had uncovered the fact that more travel books are sold about France than any other country in the world.

In December 1994, just a year after I'd started at Microsoft, my first Gates review took place in the corporate boardroom, which comfortably seated twenty people around a spacious mahogany table. It was right across the hall from the lobby entrance to Gates's suite, the site of my break-in. Greg, Richard, Mark, and I arrived first, followed by Charlotte and Pat. We had already set up the computer to run our demo, and I had a glass of spring water from the wet bar to keep my throat from closing up with dry nervousness.

Last of all came Gates himself, who sat down and brought the meeting to an immediate start. True to form, he found the flaw in our presentation within seconds.

"Okay, who's providing the content?" he asked, flipping through our handout.

"We have a few really good possibilities," Greg began enthusiastically. "Fieldings" is definitely high on the list." Fieldings had fallen behind Fodor's and Frommer's in the travel market and was badly in need of an influx of cash and a boost in prestige.; hence, the company's interest in a deal with Microsoft. At the time of the review, though, we still didn't have a contract with Fieldings or anyone else.

Gates's face contorted, as if our team was so pathetic it caused him physical pain. "You mean you don't have a signed contract yet?" he said in amazement.

"We're doing our best, Bill, but it hasn't been finalized," Greg continued. "Fieldings has read the initial contract and made some changes, and now our lawyers are working on it. We should have signatures pretty soon."

Then Gates grilled Greg on what type of license we were getting, if it would cover electronic rights for more than one product, and how we would handle updates. Greg assured him that the contract would handle electronic rights to Microsoft's advantage, but that we'd have to pay for updates for individual countries.

Gates nodded, as if that was a reasonable stipulation. But then he dug for other flaws in the plan. "And what happens if Fieldings doesn't sign?" he demanded, visibly irritated. "What's your back-up?"

Greg named a few alternate content providers whom we could fall back on, but Gates was still agitated. "Look, I just don't want you to lose any time," he said. "This is a good idea, and you should close this deal ASAP. We want to be the first to market with this."

After content, we opened up the issue of online ticketing and reservations and the way we expected to handle them. Greg outlined how we were pursuing deals to hook up with one of the five computer reservation systems (CRS) in the world—SABRE, Galileo, World Span, Amadeus, and Apollo. All five were run by major airlines.

"Wait a minute," Gates interrupted. "I thought we were going to build everything ourselves. I want to own every piece of the software. Then we control the entire supply chain. I don't want to be paying fees to airlines."

Everyone looked down the long table at me, since I was in charge of how the software would work. "That's not really possible right now, Bill," I said, my voice remaining steady even though I was shaking inside at the idea of having to contradict Bill Gates. "We investigated that thoroughly. The reservations system is extremely complicated and it's subject to very strict federal controls. If we tried to develop it all, it would take us at least three years, possibly as many as five, and a lot of headcount to make it happen. We'd be facing costly negotiations with the FCC and strong opposition from the airlines."

Unbelievably, Gates nodded and conceded the point, at least temporarily. "Well, things could change," he insisted. "So keep that in the back of your minds as you're working on this. Now let's see your prototype."

At that time, every single product in the multimedia division had to utilize character technology—that is, a cartoon figure that would lead novice computer users through the multimedia experience. The new technology (later released in a product called "Bob") had been developed by the team led by Melinda French, Gates's girlfriend and later, wife. Bob was eventually eliminated from most Microsoft programs because there were serious cultural limitations in choosing one specific character for a product that would be sold internationally. For example, *Encarta*, the encyclopedia, originally employed an owl as its animated guide. In America, owls signify wisdom, but in some Eastern European countries they're a symbol of death. In addition, testing showed that a cartoon animal guide made users feel like they were being talked down to. Another major issue at the time was hardware limitations. The software required a fast machine with a lot of memory to run properly and computers at that time were not advanced as today nor that affordable either. Obviously, Bob had

problems, and the only place the technology still exists today is in Microsoft Word's Office Assistant, the animated paper clip that offers help and suggestions (whether you want them or not). It was another example of an idea way ahead of its time.

Because Bob hadn't been scrapped yet, however, we had to use character technology in our prototype, and so we chose a bird, which was named Chanticleer by our designer. I personally had to animate the bird because the company we hired to produce the prototype wasn't able to finish every piece of it on time for our Gates review.

The demo began with an audio of "La Marseillaise," the French national anthem, and an undulating French flag waving slowly across the screen. Then Chanticleer strutted into view, introduced himself, and proceeded to lead users through a questionnaire about their travel likes and dislikes. After the user entered all of his or her choices, Chanticleer grabbed a corner of the screen and pulled it back to reveal the Main Menu, a beautiful image of an old desk with a postcard of Paris, a map of France, a trip planner, a hotel key, and tour brochures arranged attractively across the top. Users could click on each and be led to other screens in their area of interest.

If, for example, the user chose the map of France, he or she could then click on individual provinces like Normandy and Alsace and bring up more screens listing facts, attractions, hotels, and restaurants in that particular area.

Gates liked it. I could see immediately that he liked it. He was leaning forward in his chair, smiling like a kid and making appreciative comments and noises. All the team members glanced at each other around the table and smiled, too. We knew for sure that despite the glitches Gates had found in our presentation, we'd get the headcount and the budget we needed to proceed.

After the review, Mark and I stayed behind to carry the computer we'd brought with us and all the leftover handouts back to my office. On the table, I found a small notepad with a message to me scrawled across it.

You should feel so good about this!

So much progress . . . great presentation . . .
great prototype.

There was no signature, no indication who had left it for me. I knew it couldn't be Gates: He would never write such an encouraging note, nor, in fact, would any guy that I'd ever met at Microsoft. It had to have come from either Charlotte Guyman or Patty Stonesifer. I never found out who wrote it, but I still have that piece of paper, a souvenir of one of my best days at Microsoft.

11

Expedia

"October 22, 1996: Microsoft launches Expedia, its online travel service. Within four months, sales in air, hotel, and car bookings reach $1 million weekly."

—Telecomworldwire

During my first few months at Microsoft, Lucila and Marco wrapped up the production of "Brazil: An Exotic Journey" and flew cross-country to unveil it at Intermedia '94 at the San Jose Convention Center. They were both exhausted from working 18-hour days for the last leg of the project and badly needed a rest. But we couldn't afford to miss the largest multimedia convention in the country, and I couldn't possibly have worked it alone.

Intermedia carried an expensive price tag. Besides the airfare and the hotel bills, the exhibit space and convention expenses ran about $10,000. In addition, we decorated our booth with items that suggested Brazil, all of which I'd brought back with me from my trip to Rio, including sculptures and full-color posters. We had semi-precious stone key chains and pendants made up as giveaways to lure people to the booth. In addition, we rented a large-screen TV that we hooked up to the computer to show the

images on our CD-ROM to their best advantage. And finally, I'd purchased company "uniforms" in Rio, too—dressy black pants and shoes, matched with silky shirts in a colorful, tropical-looking print of leaves and birds.

"I won't wear that shirt," Marco frowned when I handed it to him to try on.

"Yes, you will," I insisted.

"I'll feel stupid wearing the exact same thing as you two, like we're triplets or something," Marco griped. "What if someone I know sees me? I'll just wear the pants with a black shirt instead."

"Who are you going to know?" I asked crossly.

"Well, I might meet people who want to hire me," he continued. "But they'll change their minds if I'm wearing that."

"We've got to look like a real company, Marco!" I shouted, losing my temper. "If we don't, nobody here will take us seriously and all the work Lucila, you, and I have done for the last year will be for nothing. Do you get it? Nothing!"

So Marco put on the shirt and wore it.

There were other frustrations, like the fact that our booth wasn't ready when we got to the convention center. We didn't have the tables and chairs we'd ordered, and I had to go searching for the boxes of CDs I had shipped separately. Worse of all, our sign read "3-ROM" instead of "3D-ROM," our company name. It took me several screaming matches with convention officials to get all the items we'd paid for, including a corrected sign.

For the next three days, I worked the floor at the convention like a madwoman, looking for a distribution company. But closing a distribution deal was a lot harder than I thought, because we were a new, unknown company and distributors were hesitant to take a chance on us. I came close to deals with two companies— one called Educorp and another called Library Video. But in fact, I didn't secure distribution contracts with either of them until several months after the convention had ended and I had repeatedly bugged them by phone.

Despite the distribution contracts I eventually negotiated, I still have about 800 copies of "Brazil: An Exotic Journey" sitting

in boxes in my garage. I'm proud of the fact that our CD got good reviews in specialty magazines as well as in the Boston Globe; it made the cover of *CD-ROM World* magazine, and it even won a National Educational Media Network K-12 educational award. But it never really found its market. By 1995, the CD-ROM industry had fallen apart, and everyone who had invested money in it lost out, including us.

Intermedia took a big toll on all of us, but especially on me. I snapped at Lucila; I picked fights with Marco. Several times, I felt like I was having a nervous breakdown. Part of what I was feeling was anxiety because the success or failure of the CD seemed to rest on a single weekend and on me. And I couldn't clinch a distribution deal no matter how much or how fast I talked.

And then there were my personal problems, too. Now that the CD project was finished; now that we'd had the closing on our house in Somerville; and now that Image Art had also been sold, there was nothing keeping Lucila in Boston, and she would soon be joining me in Redmond. That had always been our plan, what we'd been working toward since I took the job at Microsoft. We'd missed each other desperately, and our monthly visits always ended in tears or fights or both.

With Lucila's impending move in mind, I had put in an offer on a wonderful tri-level house near the Microsoft campus, and by the time she arrived in the summer, I hoped to be living in it. But there was one glitch: I had become confused and torn and no longer sure I wanted to live with Lucila.

What was happening was that Paula and I were seeing each other all the time, having quiet lunches together, going dancing several times a week. On one of those evenings, when Paula dropped me off at my apartment after a night out at a club, I invited her in. I didn't have to ask twice.

Things steamed up quickly. You know the line from that old Cole Porter song, "It was too hot not to cool down"? I wish I'd known that at the time. Paula and I started spending weekends together, taking trips to San Francisco and Carmel. In fact, the

weekend of Intermedia, she begged me to take her along, but I was able to convince her how crazy and self-destructive that would be.

Paula spent so much time at my apartment, we were practically living together. Once when Lucila called on a Saturday morning and I was in the shower, she even answered the phone.

"What is she doing there so early?" Lucila asked when I called her back.

"We're going to work together," I lied. "We were going to stop and have some breakfast first."

I knew I couldn't lie to Lucila for long, but I also didn't want to tell her about Paula over the phone. When Lucila came for a visit, I picked her up at the Seattle airport and she immediately guessed that something was wrong.

"What is it, Soraya? What's going on?"

"Nothing. Why?"

"Because that's not the way you kiss me," she said, shaking her head. "You're all stiff and uncomfortable, like you don't even know me."

"I haven't seen you in months," I explained. "It takes me some time to get used to being 'us' again."

"We've been 'us' for over 10 years," she pointed out. "What's to get used to?"

But I couldn't tell her there at the gate or in the car on the drive to Redmond. I waited until we were back at the apartment, where I poured each of us a big glass of wine, sat next to Lucila on the couch, and told her.

"You're leaving me for her?" she shouted. "And she's leaving her partner, too?"

"No . . . no . . . I don't know," I said, confused.

"Confusion," in fact, describes the entire affair with Paula. I didn't know why I became involved in it; I didn't know why I kept it up. Most of all, I didn't know for a long time that Paula had never told her girlfriend about us and had no intention of doing so. She kept assuring me that Gisele already knew and was just trying to get enough money together so she could move out of their apartment.

But the break up with Gisele never seemed to happen. I'd get fed up and tell Paula we were finished, but then she'd start calling me, coaxing me to come back. I'd say to myself, I'll see her once more and then that's it. She was like a stiff drink and I was like an alcoholic, always telling myself that the next one would be my last.

Finally, though, I got tired of Paula's hedging. I had to know where our relationship stood—it was only fair to me and to Lucila, who was trying to decide if she still wanted to move to Seattle, and in fact, if she wanted anything more to do with me. The only way I could get a straight answer was to bypass Paula and speak to Gisele myself.

It was crazy behavior, but then addicts don't act rationally. I drove over to Gisele and Paula's house one evening when I knew Paula had to work late finishing up a project. For about ten minutes, I sat in the car with the motor running, wondering if I should really go in or if I should turn around and drive home.

I should have driven home, but I didn't. I knocked on the door, and Gisele was surprised to see me, since we'd only met a couple of times. "Soraya," she said, "are you looking for Paula? She's still at work."

"No," I replied, "I was looking for you."

When I told her why I was there and what was going on between me and Paula, Gisele flew into a rage. "She told me she was through having affairs!" she screamed. "And I believed her!"

To my surprise, what I learned was that Paula had a pattern of having brief flings, breaking them off, and then bringing her ex-lovers around as pals for her and Gisele. But none of those affairs, Gisele explained, had been serious or had gone on as long as ours.

"This is the last straw," she said, holding the front door open for me. "Please leave. I've got something important to do now." I found out later, when an enraged Paula called me, that the "something important" Gisele had to do was to throw all of Paula's clothes out the second-floor window of their house to the yard below. And since it rains so much in Seattle, Paula's stylish wardrobe wasn't a pretty sight after that treatment.

It wasn't long before I broke up with Paula, and this time it was for good. I didn't see her for a long time and then one day she called me at work to tell me that she'd quit Microsoft and she and Gisele were moving back to Brazil—the very next day.

Amazingly, after this soap opera with Paula, Lucila decided to take a second chance on our relationship. Maybe she did it because of all we'd been through together—coming out, immigrating, practically starving together in that first studio apartment in Boston. Maybe she realized she couldn't just put ten years behind her that easily. Or maybe she recognized my affair with Paula for what it turned out to be—the biggest test of our love and our commitment ever.

Long distance, Lucila told me of her decision. "If I don't move out there," she said, "I'll lose you forever. It may be over with Paula, but you'll find someone else. And I'm not ready to give you up. I can't imagine my life without you." I knew what a sacrifice she would be making. Lucila was leaving her friends, her brother, the home we'd made together, to throw in her lot with a lover who seemed to have lost her mind—at least temporarily.

We closed on the house in Somerville, and I flew back to Boston to help her pack everything. It was an emotional time for both of us, putting all those years and all our memories into boxes and sealing them up tightly. Even though Lucila decided to move west to be near me, she also decided she would stay in the apartment that Microsoft had rented for me while I moved into the new house in Redmond alone. We had to start over from scratch, dating on and off for the next year, trying to get used to being "us" again.

In between the soap opera-style drama that consumed my personal life, there was my job. From the moment our Gates review ended, the travel team worked at a fast and furious pace to get the project rolling. Gates had insisted that our top priority should be closing the content deal with Fieldings, and we did that after a lot of frustrating back-and-forth negotiations. I guess the Fielding's people heard the name "Microsoft" and saw dollar

signs light up, but in reality, Gates is pretty tight-fisted. Like every other team at Microsoft, ours had to justify every penny we spent and show that we could earn it back for the company.

After the contract for content was in place, that was when my job really started. The best way to define what I had to do is this: I had to make the project happen. No matter what problems we encountered with design, programming, or personnel, I had to create and stick to a schedule, making sure the product shipped on time with the right features, at par with the quality a user expects from all Microsoft products. And when we shipped, I'd be rewarded with an additional chunk of Microsoft stock.

Because our team was small at the outset, I ended up doing a lot of the preliminary work that someone else should have done. For example, I had to create a navigation structure that could accommodate all the topics that Fielding's books covered, from skiing to snorkeling. We would be creating CD-ROMs for many different parts of the world, including the United States, Europe, and South America, areas with vastly different climates offering diverse kinds of attractions.

But we hadn't yet hired a content editor to examine every single Fielding's book that we were going to use and to map out a draft of the content structure. So that job initially fell to me. Fortunately, we hired Mark Morris as editor before too much time had elapsed and I was completely overwhelmed by mounds of travel books. Mark was an experienced travel writer who took over determining how deep a user would be able to go into any topic. That was important to thrash out, because if we ever decided to switch from Fieldings to another content provider, the entire system still had to run smoothly.

When Mark came on board, I began tackling other pressing problems with the content. First of all was how to convert the material that came to us from Fieldings in desktop publishing format into files we could easily update and publish to a CD-ROM. After a lot of thought and research, I suggested using Structured Query Language (SQL), a computer language that secures, updates, and controls data stored in a database server.

A Microsoft team had been working on a version of SQL to launch in the market, and I thought that if we could build a database that followed our content structure, we could manage content through SQL and deliver it to any platform—CDs, paper, floppies, or eventually the Internet.

But as Byron, our developer saw it, there was one problem: Until then, no one had used SQL to save and manipulate large quantities of text content. So we had to build a tool that could do so, one that was eventually used for other Microsoft products, too. Today there are a number of products for content publishing you can use, but at that time there wasn't anything available.

The next big content problem also happened early on. Travel titles are useless if they're out of date, and our CD-ROMs had to contain the most current information when they shipped. So we had to get updates from Fielding's original authors, who lived all over the world. But none of the writers were working with the state-of-the-art equipment that we had at Microsoft. While we were using 486s with a lot of memory and built-in CD-ROM drives, most of the writers were back in the dark ages of ultra-slow 286s with monochrome screens. I wished we could furnish them with better equipment, but in lieu of that, we had to create an application that would extract information from the content database and export it to floppy disks so that each writer only received a small file that his or her old machine could read easily. They would edit them and send us the updated floppies to be uploaded into our database.

But the biggest challenge to Microsoft Travel, the one that pulled the rug out from underneath us and left us scrambling to get to our feet, was yet to come.

The current buzz everywhere was around online services. America Online (AOL) was acquiring large numbers of users. Microsoft was late launching the Microsoft Network (MSN), the company's new online service competitor to AOL, and at the same time the market for CD-ROMs was changing dramatically.

One day, our division received a broadcast memo from Patty

Stonesifer: No more CD-ROMs. With the exception of games, all the titles currently in development had to be transformed into software to run on MSN. Patty was the current senior vice president of the Interactive Media Division. Stonesifer is credited with building Microsoft's position as the world's leading consumer and interactive media company.

What had happened with CD-ROMs was that the growth everyone in the industry had predicted never materialized. As I myself had discovered with "Brazil: An Exotic Journey," CD-ROMs were very hard to market. Neither bookstores nor computer stores—the two main outlets for CD-ROMs—ever learned how to sell them, and specialized CD-ROM stores never proved viable. As a result, all the companies that had invested heavily in CD-ROMs weren't making back the money they'd poured into developing the software.

The challenge our team now faced was enormous—much, much bigger than when we were ordered, first, to incorporate "Bob," the character animation, into the software and then later to take "Bob" out. This time, we had to scrap just about everything we'd done up until that point to make use of a technology that was in its infancy. No more rich user interfaces, no more videos or beautiful photographs, everything needed to be delivered online via a 28.8K modem. Not only redesigning everything will be hard, training the whole design team on the limitations of the new technology would be a ramp-up process. And how would we ever be able to deliver a good, rich experience in that narrow band environment?

We gathered ourselves, and my mantra became "Focus focus focus . . ." "Guys we can do it. I know we can. Let's get together and figure out what we can deliver," I said to my team.

Our interface had to be lighter, visually appealing and at the same time interactive.

There were other issues beyond design changes. Although we'd completely switched platforms, we didn't get to add any

days to our already tight schedule. In addition, our original business plan needed a massive overhaul. Now that we were working on producing a service rather than a CD-ROM that would sell in stores, we had a lot of lost revenue to make up for. We knew that registration to the site had to be free: Subscriptions were proving not to work, because users didn't want to have to pay to view content online.

There were a few possible solutions to the problem of revenue. One was creating a revenue stream from the sale of ad space to hotels and car rental agencies, whose banners would appear on the screen tempting customers to check out their deals. And of course, there was real-time ticketing, which we had always intended to incorporate into the software but which had not been initially planned as our main revenue source. If we had to rely almost exclusively on ticket sales for revenue, Microsoft Travel had to go far beyond being a content provider and become a virtual travel agent.

Well, three months later, when we were feeling that we could deliver the code in this new environment, another major change happened.

In May of 1995, an internal memo bearing the return address of "billg@microsoft.com" appeared in the e-mail box of every Microsoft employee. Nine pages long and titled "The Internet Tidal Wave," Gates's document proclaimed that, from that moment on, we were all to "assign the Internet the highest level of importance . . . I want every product plan to try to go overboard on Internet features." A few months later, Gates held a press briefing in Seattle in which he proudly stated that "the Internet is pervasive in everything that we're doing."

Gates's new mandate was pretty much inevitable. MSN was due for release that summer but its proprietary nature was already doomed even before its release; it, too, would have to change to become Internet based. In fact, a link to the service would be included within the much-anticipated Windows 95 software.

At that time, a lot of companies were scrambling to capture the online market share, and Gates was upset that Microsoft had

let itself fall behind of America Online, Prodigy, and Compuserve. Now he was determined to leave everyone else in the dust.

Shortly after Gates's memo, we received a second memo from Patty Stonesifer: No more MSN proprietary technology. All consumer titles currently in development had to be transformed into software to run on the Internet.

It's hard to imagine, but in 1995 there were no good tools for building Internet sites. As a result, the few sites that existed were mostly content and some pictures. At least using the MSN technology, we could deliver a Windows based program and deliver an interactive experience specially for our virtual travel agent. Using HTML only, the standard Internet language that only allowed text formatting and pictures to become visual pages, we had yet another big challenge ahead of us.

Having to switch gears again, we placed content as a second priority, and focused on the virtual travel agent. We knew that at least the Internet could handle content, meaning text and pictures, but interactive features was a very different story.

Designing the Travel Agent feature of the site took more time, experimentation, and testing than we ever anticipated. We had made a deal to hook up with Worldspan, one of the five computer reservations systems (CRS) in existence. But each CRS used a language that only travel agents could interpret. We had to create an interface and a language that users could easily understand, which meant translating into layperson-speak all the knowledge travel agents have at their fingertips when they assist customers.

If you don't know exactly what a travel agent does or how he or she does it, then it's impossible to create a computer program that mimics that person's job. We decided that the Microsoft travel team had to train as travel agents.

Like many large corporations, Microsoft contracts the services of an independent agency to book all the flight and hotel arrangements for its employees. Because Microsoft had so many employees, an American Express travel agency maintained an office and a small staff right on our campus. Several members of our team spent time sitting in the AmEx office, monitoring actual

calls that the agent on duty took from clients. Our software had to go far beyond the basic fields of information like "number of tickets" and "date of departure" to deal with real-life situations that would crop up.

Say, for example, a woman wanted to go to the Bahamas for a late September vacation. Any travel agent worth his or her salt would tell her that fall is hurricane season in the Caribbean. How could we make the software deliver that advice before the user actually purchased her plane ticket?

Or say a man was flying from St. Louis to Los Angeles with his wife and two small children, one of whom was a newborn infant and one of whom was five. A travel agent would know immediately that infants fly for free, while children from two to thirteen get a reduced rate. How would the software know that?

Maybe a woman wanted to bring her poodle to Paris. A travel agent could recite the restrictions on traveling with pets, including the kind of crates needed to transport them. But could our software do that, too?

Our software had to be able to cover all these scenarios and more as quickly and efficiently as a living, breathing travel agent would handle them. But in the end there were just too many possible scenarios. We had to prioritize the questions our team drew up after its crash course at the AmEx office, and we acknowledged, reluctantly, that the old maxim is true: You can't please all of the people all of the time. So while we agreed that it was extremely important for clients to be able to get accurate information about the different airfare rates for children, we abandoned the issue of traveling with pets—though with resistance from the dog and cat owners among us. If Pierre the Poodle was going to Paris, the team finally decided, his owner would have to resort to picking up the phone and dialing a travel agency.

Today, when almost anyone can create a Web site with WYSIWYG software, you go to Expedia.com and type in your name and other personal information and have absolutely no

idea how many long days and nights, how many weekends, how many hundreds of grueling hours of testing it took our team to design and develop such a remarkably easy-to-use service.

Let's say you want to see where the New Yorker Hotel in Manhattan is located. You choose the "Maps" tab at the top of the Expedia screen, a simple move, and just one click of the mouse. But in 1995, there was no easy method for mapping hotels online. We knew we could probably use Java, a programming language first introduced that year. But the problem was that Java was new and not every Internet browser—the program that allows users to access Web sites—could read its code. That meant that some unlucky users wouldn't be able to see our maps if we created them using Java, and they'd leave the site frustrated, unhappy, and mapless.

For revenue purposes, we needed all the users we could get, and so every user's experience had to be a pleasant one. We couldn't risk letting people get an off-putting "Your browser does not support Java" error message. "There has to be an HTML solution," I insisted, referring to Hypertext Markup Language, the standard Web language that all browsers can read and interpret. But my fellow team members were skeptical. Finally, however, one of the developers helped me unravel the problem. Using HTML, he designed an ingenious table that mapped the streets in the background and overlaid the location of the hotel on top, so that Java code didn't have to be used. It wasn't easy to create, but when it was in place, it worked really well.

It took almost two years to perfect what was eventually named Expedia.

How it became Expedia is an interesting story. The name was the idea of a marketing company that Richard, our marketing manager, hired and paid $50,000 to come up with something catchy. Their first effort—"Microsoft Travel Services"—was so lame that I started laughing when Richard told me proudly that the marketing people had "delivered."

"You're kidding, right? We paid $50,000 and waited a month for that?" I said. "Tell me you're not going to take that name to Bill."

"Of course I am," Richard replied coolly. "I trust these people. They're complete pros, and they know what they're doing."

"Yeah, they're taking Microsoft for one big ride. Richard, this will not work." I said it again. Well, needless to say "I told you so". As soon as Gates heard it he screamed.

"What are you thinking? I am paying money for someone to tell me this? Go back and tell them to work more, and you better come up with something unique, something defensible, that I can trademark and use!" It took another month for the marketing crew to come up with several more options. Among them was "Expedia," a name everyone liked, including Gates.

Microsoft Expedia released to the Web on October 22, 1996, but without a lot of fanfare. It was Microsoft's first service product, and we weren't sure what unforeseen problems might crop up with operations and customer service.

So Expedia debuted very, very slowly, over several months, allowing us time to fine-tune the site's operation before requests for tickets and reservations flooded the system—which, of course, they eventually did. By February of 1997, Expedia was selling a million tickets a week. A year later, its monthly sales exceeded $12 million. Projections suggested that online travel sales would reach the billions by the new millennium and in fact, that came to pass. With Expedia in the lead, travel very quickly became the hottest area of e-commerce.

I was never so proud of anything I had done before, not even the launching of *Brasilsat*, the telecommunications satellite. "I did it!" was what I said when I called Lucila the day of Expedia's release. She knew immediately what I meant. More important than the fact that I did it was the fact that I had done it right.

Unfortunately, the story of Expedia had an unhappy ending for me. The software may have been a huge success; I may have received great personal satisfaction, as well as more shares of Microsoft stock than anyone else on the team. But I also made a huge miscalculation that eventually sent me searching for another job—I didn't play the game, the one the old boy network is so good at.

All the days and nights and weekends I was working on Expedia, trying to make it the best product it could possibly be and struggling to launch it on time despite the change in platform, I kept pretty much to myself and to the members of my immediate team. I took myself and my job very seriously—maybe, in retrospect, too seriously.

"This is very important work," I often told fellow team members. We weren't just creating software, we were on a mission to change the average person's relationship to travel. "The entire travel industry could change—just because of what we're doing!"

In the meantime, Richard, the marketing manager of the travel team, was taking a different route. After our Gates review, Richard never participated in any of our gritty design or product update meetings. Because he never took part in any of the hard decisions, he didn't have arguments with anyone on the team. Everyone liked him. I routinely heard my co-workers saying, "Richard is such a great guy," but I didn't think too much about it. I myself rarely had any contact with him, since he never came by my office or responded to the e-mail messages I sent to the team.

Richard's approach was to spend most of his time hanging around our boss, Greg. On the weekends, when I was running endless tests of the software, Richard and Greg went golfing together. And then, because Greg and Pete Higgins, Senior VP of the Consumer Division, were friends with Gates, Richard eventually got invited along on golf foursomes with him.

After Expedia launched, Greg decided to leave Microsoft to start his own travel-related business. He decided to invest in a business area that Expedia did not cover, like tour packages and rental properties. He opened vacationspot.com that same year. He knew that if he succeeded, there was always the possibility that Microsoft would someday buy his company to add services to incorporate into Expedia. But for that to happen, he had to start laying the groundwork immediately, which involved Richard.

I very badly wanted a promotion to Product Unit Manager,

because Expedia was my baby. I had proven myself capable, and it only seemed fair that I should head the team that would go on to design and release updates of software that had been my idea in the first place.

But I started to get worried that the promotion wouldn't materialize when I began reading the official press on Expedia. In September, a month before Expedia launched, the magazine *Travel Agent*, one of the leading in the business, ran a cover story called "Enter the Giant," about Microsoft's foray into the travel industry. A well-thumbed copy of it landed on my desk with a routing slip from Greg: "Hey guys—Isn't this great? Congratulations!" On the first page of the piece was a picture of the exceptionally clean-cut Greg and Richard, wearing "Expedia Travel Products" polo shirts and smiling over a notebook computer. Throughout the article, the two enthused about the bright future of online travel and Microsoft's position as leader of the pack. As I turned the pages, my stomach twisted into a tight knot: There wasn't even one mention of my name.

Microsoft's in-house two newsletters, *Pathways* and *Micronews*, did interview me for an early 1997 piece about the building of Expedia, but I came off as just a member of the team. The article's tongue-in-cheek lead paragraph, which left the origins of the project purposely vague, made me grind my teeth in anger: "Then someone said, let's create a new interactive travel product with a rich GUI; one that lets users book their own travel. Bill heard the idea and said, 'It is good.'"

But it was at the meeting where Greg informed us of his decision to leave Microsoft that my dream of heading the Expedia team died once and for all. "I just found out that Bill has approved my replacement," Greg announced, beaming at Richard. "All I can say is—Rich, you deserve it, buddy."

There was some embarrassed clapping, and team members offered congratulations to Richard while avoiding the hurt look in my eyes. There was also an announcement that Byron, our development manager, was being promoted and transferred to lead another team.

"You have a reputation for being . . . demanding," Greg told me, when I asked him privately about my promotion. "You push people too hard."

"And that's bad?" I asked. "I do what needs to be done to ship products on time."

"Your style doesn't sit well with people, Soraya," he said, shaking his head. "You should try acting . . . I don't know, nice."

I was seething, since Greg himself had a reputation for being demanding. We all admired him for his ability to insist on and get the best work from his employees. "We can do better than this," was a favorite line of his when he handed back specifications. His demanding reputation had taken him to an executive level at Microsoft, because, after all, Gates was renowned for being demanding, too.

But I was supposed to act "nice." I couldn't believe it—it was like a Hollywood movie where the woman who does all the work keeps getting passed over for promotions that go to less qualified men.

Just a few days after Greg's announcement about Richard, I told him that I wanted to transfer out of the Expedia team. "It's time for a change," is all I said, while inwardly I was still fuming about being passed over because I didn't play the game like Richard and the other guys did.

"I think it's a mistake," Greg said. "But whatever you want."

Immediately, I started applying for other jobs inside Microsoft, but no one would hire me. This was virtually unheard of—a manager who successfully released a new product, one that was bringing millions of dollars into the company within a very short time, couldn't get hired by another team. I couldn't fathom why, but I had a few theories.

"What do we do now?" I sighed deeply as I commiserated with my friend, Mary Ord, who had also been passed over for promotion and was considering her employment options.

"Learn to golf?" she said sarcastically.

I shook my head at the suggestion. "The closest I get to golf," I quipped, "is the Dinah Shore Open." Mary was a straight woman

and didn't understand the joke. The Dinah Shore Open, held every March in Palm Springs, is a lesbian paradise, an extravaganza of pool parties and dancing. Most of the women who attend couldn't tell a driver from a putter.

In fact, I suspected that being a lesbian had something to do with why I couldn't get promoted at Microsoft. Although the company has a nondiscrimination policy and was one of the first to grant domestic partner benefits, you don't see any lesbians or gay men rising to the top ranks. The upper echelon is reserved for Gates and his clones. And at that time, I was as out as I could be, serving on the board of GLEAM and organizing the company's contingent for Seattles' annual gay pride parade.

Foreigner, Latina, woman, and dyke—the combination of my identities made the company's glass ceiling extra low.

Unfortunately, I hadn't been at Microsoft long enough for my stock to be vested. I had to hold out for at least one more year before I could leave the company.

Once again, I got lucky. I interviewed with the head of the Finance Internet Technology team, a woman named K.D. who was honest and straightforward with me. She scanned my resume and then placed it to one side of her desk. "You look terrific on paper," she said. "But the word is you're not very easy to work with."

"Excuse me?" I said, amazed. "You're telling me that Greg did not give good references about me after what I did for Expedia?"

"No, no, of course not. He can't say that outright, because if it got back to you, you could sue him. But I'll tell you this off the record—he has a way of subtly suggesting that if anyone hires you, they'll regret it."

"But I launched one of the best products Microsoft has! And I did it on time!"

K.D. shrugged. "Doesn't really matter," she said. "It's obvious that Greg wants his pal Richard to get the benefits of heading up Expedia without passing along any of the hassles. And one very big hassle would be trying to replace you."

I let the import of her words sink in slowly, while she went on, doing all the talking. "I need someone to organize the Finance team," she told me. "Thirty-two people. Do you think you could do that?"

"I know about developing and delivering products," I replied, "not about finance. But I'd really like to learn."

"Okay, here's the deal," K.D. said. "You teach my team how to build products, and I'll teach you all about finance."

She was the best manager I ever had—paranoid as hell, but fair, detailed, and meticulous. K.D. taught me profit and loss statements, balance sheets, budget forecasts, purchasing, and many other aspects of running a business. Lucila was amazed at what I was learning. "Your job's starting to sound like mine," she said.

I would have stayed with that team and served out my time at Microsoft, but unfortunately, K.D. left to manage another group. Her replacement, Jim, was an unabashed homophobe. I could have filed a harassment complaint against him for the things he said to me, but I only had a few months left before I could leave the company, and I chose not to rock the boat. Instead, I looked for yet another job within Microsoft.

From Finance, I transferred to the team that was building Microsoft TaxSaver. It was never clear to me why such software was being developed in house.

"Wouldn't it be better," I asked my future boss during my interview, "to cut a deal with H&R Block for TaxCut and then go after TurboTax? I mean, do you really hope to take on both of them?"

"Of course," he insisted. "We've already bought code from an Australian company, and we're building a super-looking interface."

I learned pretty soon after joining the team, however, that a super-looking interface isn't what makes TaxCut or TurboTax dominate tax software; it's the content. The U.S. tax code is extraordinarily complex, and both TaxCut and TurboTax had managed to keep the tax information inside their programs as

up-to-date as it could be. Much of their success came from making it possible for users to automatically update their tax forms and tax law information as soon as they were released by the IRS and state agencies.

But because my boss didn't get the importance of content, TaxSaver was doomed from the get-go. The project development actually lasted a year and a half, but I did not stay on the team for the duration. TaxSaver was shipped, but lasted only six months in the market before Microsoft pulled it out.

At this point in my Microsoft tenure, I was mostly going through the motions. Once again, I built a team from scratch, hiring everyone from program managers to tax analysts. Once again, I tackled the problems of interface and content. Once again, I had to deal with managers who were out of the office more than they were in, young male co-workers taking credit for my work, and a boss who refused to go to bat for my promotion.

"Maybe in your next review," he told me.

As soon as I became vested, I knew what I had to do.

One day in September 1998, I came home from the office with a nervous smile on my face. Lucila and I had been reunited for several years and were living together in the house that I had found for us. From just inside the front door, I could hear the familiar, comforting sound of her chopping something in the kitchen, preparing one of her vegetarian specialties.

She looked at me sideways while smashing garlic cloves and said, "You look like the . . . what's that saying? The cat that swallowed the mouse?"

"The cat that swallowed the canary," I corrected her gently, used to her occasional slip-ups with American idioms. I sank into one of the dining room chairs in exhausted relief.

"Lu," I announced, "I quit."

Epilogue

Red Mustang Cobra

It's October 1998, and I'm cruising south on the scenic coastal Highway 1. I've quit Microsoft. Just like many other former Microsoft employees, my shares in the company have made me a millionaire. I've bought a custom-built, shiny red Mustang Cobra convertible that I've named Flash, and I'm driving to California with the top down. The sky over my head changes gradually from gray to bright blue with dots of puffy white clouds. Finally, I'm leaving the gloom and rain of the Pacific Northwest behind for good. I'm headed for my new job and my new home in the Silicon Valley, the heart of the Internet revolution. Lucila will join me soon, and we'll be living together in paradise.

I am, I'm convinced, the happiest girl geek in the world.

Maybe my transition out of Microsoft wasn't quite as idyllic as that, but it wasn't that difficult either. The hardest part of quitting was convincing Lucila that it was the right thing to do.

"You've lost your mind," is how she put it when I told her, reminding me, for the first time, of my family. Her main objection was that I had no other job waiting for me and that quitting meant I had to leave some of my valuable Microsoft shares behind because they had not yet vested.

In fact, the company is famous for keeping employees around in "golden handcuffs," which work like this: Microsoft bestows shares on its employees every year as a bonus, but those shares take four and a half years to vest and become the property of the employee. If you decide at that time to exercise them, you pay a hefty amount in taxes to the government, effectively reducing the value of your shares by about fifty percent. And we are not counting the capital gain taxes you have pay when you decide to sell them.

Lucila's skeptical response to my decision made me suddenly question the wisdom of it. Had I jumped the gun and quit too soon? Would my work situation have improved if I'd just stuck it out a little longer? My boss was often sick—if he left, would I have finally been promoted?

But when I began to enumerate my reasons for quitting out loud to Lucila, I felt more confident that I'd done the right thing. It had gotten to the point that I hated going to work in the morning. I was tired of cocky young guys taking credit for my work. I was frustrated by the old boys' network, which insured that men occupied the top rungs of the corporate ladder. No matter how hard I slaved over my computer screen, promotion to level 13, the highest level below becoming a vice president at that time, didn't seem to be in my future.

It was hard to believe, but I'd hit the proverbial glass ceiling once again. This time, it hurt even more than it did when I was 25 and I realized that I'd never get very far as an engineer in my native Brazil. Now I had to ask myself some painful questions, like if I was really fit to continue trying to get the job I wanted, or if the price I had to pay to get there was way too high for me.

"Besides all that, I want to see some goddamn sunshine for a change!" I said earnestly. "I'm so depressed living in a place where you only get sunshine three months out of the whole year! I want a company to pay me to move to some beautiful, sunny spot."

Lucila looked at me sympathetically. "Okay, okay, I

understand," she said to calm me down. She liked Seattle a lot more than I did, and she had made friends she didn't want to leave. Still, the idea of living in a sunny climate again was not unappealing to her. When she asked, "Where would we go?" I knew that she hadn't completely dismissed the idea of moving. But this time, I'd have to promise her we'd stay put for a long time, maybe forever.

At first, I thought we should live in San Diego—all that sizzling sunlight, all those fabulous beaches. Unfortunately, there weren't many software companies in southern California, and the prospects of finding a satisfying job in my field there didn't seem hopeful. So I turned my sights to the northern part of the state instead—to the Silicon Valley, where thousands of tech companies and dot-coms littered the landscape and, as a Microsoft alumna, I would have my pick of jobs.

With my credentials in hand, it only took a few weeks for me to find a good position with a medium-sized software company. They offered to pay my relocation costs and put me up in an apartment for a month, until I could find a place of my own.

But in fact, it was much harder to find a house than a job, because the housing market in the Silicon Valley had gone nuts in recent years. I've read that people in jobs making $60,000— a decent salary almost anywhere else in the country—can't find affordable housing and are living in their cars. I was making a lot more than that, but I still had to cash in a portion of my Microsoft stock in order to afford the house I wanted.

It was the first house the real estate broker showed me. "There are four offers in on this beauty," he informed me, "so you haven't got much of a chance. I only brought you here to see if this is the kind of place you're looking for."

The house was a stunning, Spanish-style ranch with a lush garden filled with roses, oranges, and palm trees, and surrounded by a fence crawling with grapevines. I could envision a hammock tied between two sturdy willow trees, with Lucila and me swinging lazily in it together, drinking something tall and frosty. Just behind the garden was a large, in-ground pool and a basketball court.

The best feature by far, though, was that all the rooms were drenched in sunlight.

"Yes," I sighed, "this is exactly the kind of place I'm looking for."

After that, everything else the broker took me to see looked like a shack. I began to despair that we'd ever find a house even half as nice as the one we'd left behind in Redmond. I was a millionaire, but I was still living in a one-bedroom, furnished apartment.

Then one Sunday I spotted a real-estate listing that sounded familiar. "Lu!" I said, jumping out of my seat to grab the phone. "This is the house! Our house! It's the same one I saw a few weeks ago and fell in love with, I'm sure of it."

My broker confirmed that it was the exact same place. It seemed that the buyer had backed out at the last minute, and the ranch was once again on the market.

"Meet us there in thirty minutes," I instructed the broker. "If Lu likes it, we're putting in an offer."

And that was how, over the Thanksgiving holiday in 1998, we closed the deal on the house of our dreams.

It may not surprise you to hear that I didn't stay with the company that initially brought me to California. I have a certain wanderlust when it comes to jobs. This time, however, it wasn't my boredom that caused my leaving. As sometimes happens with smaller software companies, the division I had worked in was sold to a larger outfit, which was relocating to the East Coast. I had no desire to move anywhere, especially not back east, when I just set down what I hoped were permanent roots in California.

So, for the second time in six months, I quit my job. Luckily, 1999 was the height of the Internet start-up frenzy, when dot-coms were popping up everywhere you looked. Many of them had no business plans and no hope of survival. The challenge for me, then, was not finding a job, but finding a job in a company with staying power, one that could weather bad times, like the economic turmoil that was about to happen in 2000.

I figured out how to screen companies before applying for openings. It took a lot of research, but the Internet made the process easier. I devised a list of things to look for: who the company's venture capitalists were; what kind of success rate they had; who comprised the company's management team; and whether the product or service the company offered had any substance to it. In other words, could the company really turn a profit?

My screening process led me to WebEx, at that time a small company that was making a name for itself by offering Web conferencing. It wasn't exactly a new concept: Six years earlier, I had helped broker a deal between Microsoft and the company that eventually delivered what became NetMeeting, Microsoft's collaboration software.

But WebEx's conferencing application made innovations to the concept. Small businesses could access the site for online meetings, which were much more cost effective and dynamic than conferencing by telephone. With the WebEx software, participants in an online meeting could actually show each other documents, give a tour of a Web site, preview a video, or use drawing tools to make a point. The technology was excellent, and the people I met in my interview were enthusiastic and smart. When I was offered the job of VP of Product Development, I quickly accepted.

At WebEx, I completely revamped the application and the site's clunky user interface, creating a sleek UI that won a prize at COMDEX that year. Almost overnight, my name got better and better known in the Valley, and I found myself being aggressively recruited by other companies. It was a heady experience, something like when Microsoft wouldn't take no for an answer. But most of the companies that pursued me weren't worth changing jobs for. It took one very persistent headhunter to get me interested in a switch.

"I'm telling you, you've got to see this company," she told me. "It's called Obongo, and they're looking for a Vice President

of Engineering. They've got a fabulous product I think you'll like."

Out of curiosity, I went on the interview. And the headhunter was right: It was a very good idea. Obongo had created a personal Web assistant, a toolbar that sat at the bottom of a user's web browser and delivered a valuable service.

Here's how the Obongo bar worked: You're surfing online and you've forgotten the password or user name you established for yourself at a particular e-commerce site. You report it to customer service and then have to wait for the site to e-mail your password information back to you before you can log in and shop or place an order.

To solve this common problem, Obongo had engineered a very clever product. Every time a Web surfer changed sites, the Obongo bar traveled with her, logging her in with her stored password, filling in order forms automatically, and registering her credit card data in a secure way.

I liked the idea. I liked the people. I also liked the fact that at Obongo, I wouldn't run into what I'd unfortunately already been encountering at WebEx: a boss who tended to micromanage and wouldn't leave me alone to run my team.

I took the Obongo job in late 1999. By the start of 2001, the company had grown to three times the size it was when I started working there. They had over 500,000 installations of the Obongo bar, with users registered in more than 16 countries. I did not know then but everything was just about to change. 2001 was the year that marked the demise of the Internet gold rush era. Although Obongo was doing relatively well, delivering a good and innovative product, we still needed to go for a third round of financing. Our exit strategy was to go public or to be purchased by a larger company. Time was passing fast and the finance market basically shut down around March 2001. The race for gold had ended, the dot-coms became known as dot-bombs and started disappearing fast. Every day we would read the headlines:

Published on February 18, 2001, Page 1G, San Jose Mercury News (CA):

FUNDS NO LONGER GROW ON TREES SEEMINGLY INFINITE SUPPLY OF MONEY FOR START-UPS IS BEING PRUNED BACK

Source: MATT MARSHALL, Mercury News

Over the past five years, it seemed that the Bay Area's boom in venture capital investments would never stop, soaring to a total of $25 billion in 2000, a nine-fold increase from the $2.8 billion in 1996. Now clear signs are emerging that Silicon Valley's start-up juggernaut has slowed sharply, even foreshadowing tough times for venture capital firms.

Published on July 10, 2001, Page 12A, San Jose Mercury News (CA):

SOME WEBVAN INVESTORS LOST MILLIONS ONE OF COSTLIEST START-UPS IN HISTORY

Source: MATT MARSHALL, Mercury News

None of the major investors who pinned their hopes and cash on Webvan made any money. And many lost millions of dollars. Venture firms and the public pumped more than $800 million into the company, one of the most costly start-ups in history. All of it will likely now be written off with Webvan's filing for protection from creditors. Several months ago, Benchmark Capital—the young, aggressive Menlo Park venture firm—was the only one close to making money.

The daily news of companies shutting down or applying for

bankruptcy was just appalling. Suddenly the progress and growth of the Bay Area halted. Thousands of people were now looking for jobs. Silicon Valley was more like Death Valley than anything else; even the traffic got better with people moving out to look for opportunities elsewhere. At Obongo, we tried a number of venture capitalists and banks, we reached into the network of contacts, but all doors were closed.

Then I told our CEO that the only way we could survive, was to make a deal with Microsoft or AOL Time Warner. Our technology was perfect to complement Microsoft Passport product or to be a competitor to Passport. Passport allows users to sign into one site on the internet and be automatically signed in at all other sites that also support Passport. Passport means one user identification and password for any supported site on the internet. The benefits to the user are: entering sites easily, no more remembering multiple ids or passwords, and a more personalized experience while surfing sites.

AOLTW has a similar service called Screen Name, delivering the same benefits as Microsoft Passport.

I knew how Microsoft worked and although we talked to the Passport team first, my impression was that the best home for us would be with AOLTW. And so, after negotiations with both companies, we decided to close a deal with AOLTW.

Obongo was acquired on July 2001. We are now a product division of AOLTW, and I have to say that for the first time in my life I really love my job. I finally got the executive position I was looking for when I was working for Microsoft. I was always passionate about my work, but as we all know, nothing is perfect, problems always come up. Nevertheless, at AOLTW it seems like all the stars got aligned: I have the right job, an awesome boss, a great team, everything is working just fine. AOLTW is a wonderful company to work for. Their culture is more focused on the consumer, on how to deliver value to them and not about creating technology for the sake of technology. Besides, there are a lot of women in executive positions. I like that.

I've learned a lot of lessons in my career as an engineer but most of all, I learned that my relationship was as important to me as my work. I couldn't have accomplished my goals or gotten where I am today without Lucila's support. Luckily, even when I jeopardized what we had together, she stuck with me. I learned that I could never, ever compromise her trust again.

It seems fitting that this story comes back full circle to me and Lucila. On our recent anniversary, we held a party for our friends and family at our home. We dubbed it "Big 40, Big Green 17," because we were celebrating not just our 17 years together, but also our 40th birthdays (within two months of each other) and the Immigration and Naturalization Service finally granting Lucila her green card. It was a wonderful event with tents for outdoor dining, live sax music by Lucila's brother, Zé Luis, and more than sixty guests eating and dancing around our pool until the early hours of the morning.

"I cannot imagine my life without you," I toasted Lucila, as I gave her an anniversary present. "Through seventeen years of ups and downs, thank you for always being there, for never giving up on me or on us."

Lu ripped open the envelope I had handed her while our guests wiped away the tears my touching little speech had brought on. "Two tickets to Paris!" she squealed, as people *ooh*ed and *aah*ed.

"So," Lucila added with a mischievous smile, "I wonder who I should take?"